Art and Innovation

LEONARDO

Roger F. Malina, series editor

Art and Innovation

The Xerox PARC Artist-in-Residence Program

edited by Craig Harris

The MIT Press Cambridge, Massachusetts London, England

This book was set in Garamond 3 by Graphic Composition, Inc. using Quark Express and was printed and bound in the United States of America.

Library of Congress Cataloging-in-Publication Data

Art and innovation : the Xerox PARC Artist-in-Residence Program / edited by
 Craig Harris.
 p. cm.— (Leonardo)
 Includes bibliographical references and index.
 ISBN 0-262-08275-6 (hardcover : alk. paper)
 1. Xerox Corporation. Palo Alto Research Center. 2. Technological inno-
vations. 3. Art and technology. I. Harris, Craig, 1953 Mar. 8– II. Series:
Leonardo books.
T178.X47I5 1999
700'.1'050979473—dc21 98-25663
 CIP

This book is dedicated to my daughters, Maya and Lea, and to their elementary school contemporaries, who will be the real beneficiaries of the efforts revealed in this book.

Contents

Series Foreword

Editorial Board: Roger F. Malina, Denise Penrose, and Pam Grant Ryan

We are living in a world in which the arts, sciences, and technology are becoming inextricably integrated strands in a new emerging cultural fabric. Our knowledge of ourselves expands with each discovery in molecular and neurobiology, psychology, and the other sciences of living organisms. Technologies not only provide us with new tools for communication and expression, but also provide a new social context for our daily existence. We now have tools and systems that allow us as a species to modify both our external environment and our internal genetic blueprint. The new sciences and technologies of artificial life and robotics offer possibilities for societies that are a synthesis of human and artificial beings. Yet these advances are being carried out within a context of increasing inequity in the quality of life and in the face of a human population that is placing unsustainable burdens on the biosphere.

The Leonardo series, a collaboration between the MIT Press and Leonardo/International Society for the Arts, Sciences, and Technology (ISAST), seeks to publish important texts by professional artists, researchers, and scholars involved in Leonardo/ISAST and its sister society, Association Leonardo. Our publications discuss and document the promise and problems of the emerging culture.

Our goal is to help make visible the work of artists and others who integrate the arts, sciences, and technology. We do this through print and electronic publications, prizes and awards, and public events.

To find more information about Leonardo/ISAST and to order our publications, go to the Leonardo Online Web site at <http://www.mitpress.mit.edu/e-journals/Leonardo/home.html> or send e-mail to <leo@mitpress.mit.edu>.

Preface

An exploration of contents published in the last thirty years of *Leonardo*, the journal of the International Society of the Arts, Sciences, and Technology, reveals a deep connection between contemporary science, developing technologies, and the work of contemporary artists. A similar journey through the history of Xerox's Palo Alto Research Center reveals a long-term focus on the development of technological resources and a probing interest in such topics as design, language, cultural anthropology, networking, and new document genres. This book is about the convergence of these domains in collaboration, in cultural exchange, and in search of innovation.

Craig Harris

Acknowledgments

I would like to thank the following people for their contributions to making this book possible. Steve Harrison has provided many insights into the history of Xerox's Palo Alto Research Center, (PARC), and his persistence has been critical in facilitating completion of the book. Rich Gold recognized the importance of documenting PARC's Artist-in-Residence Program (PAIR) from the beginning and has been enormously helpful in conveying many details about the nature of PAIR and how it fits into Xerox PARC. Email and voice conversations with Leonardo/International Society of the Arts, Science, and Technology chair Roger Malina have been extremely beneficial in helping me to develop a balanced perspective about the complex issues that emerge at the intersection of art, science, and technology. And I am grateful for the dedication of the scientists and artists who contributed their insights about PAIR to this book and for the energy and creativity they brought to their individual chapters.

Introduction

John Seely Brown

Innovation is a necessary component of any contemporary corporation's success, and yet how to achieve innovation remains for many companies an irksome mystery. Innovation, it seems, comes from people's minds, and the brain has been a notoriously difficult organ to regulate. Demanding five new innovations a week may get you five innovations, but innovations are not commodities, and they are not all equal.

Different companies choose different strategies for finding innovation. Chester Carlson walked in the door of what was to become Xerox with his copy machine under his arm, and Xerox needed simply to recognize its potential (not an easy task: many other companies turned it down) and buy it. Innovations also can be found in universities, and lately large companies have been buying startup companies to acquire their venture capitalist-funded research.

Xerox sought a different source of innovation when it built the Palo Alto Research Center (PARC), in the hills of what was to become Silicon Valley. The idea behind PARC was simple: if you put creative people in a hothouse setting, innovation will naturally emerge. You might not be able to demand innovation, but you certainly can nurture and cultivate it—though I might add here that harvesting ideas turned out to be at least as difficult as cultivating them.

Creating innovations from an internal research center has several nonobvious advantages over methods that rely on outside innovators. First, if you set up your research center (as PARC was set up) to be not only multidisciplinary but also interdisciplinary, you get innovations that could never have occurred in the highly focused environments of startups or in the segregated

environments of university departments. Second, and even more important, such a research center has an immediate and real-time effect on the company itself. The company changes not just from the end results of the research but from the process of doing the research. In this sense, the research center acts as a continual organ of change for the larger corporation.

Two problems are inherent with internal research centers, however, particularly as they grow and mature. The first is how you keep the hothouse fertile—that is, how you keep researchers creative, alert, generative, and innovative. The second is how you keep the research on track and relevant to the needs of the corporation and frankly the world. The power of a corporate research center is, as researcher Dr. Mark Weiser points out, its ability to surprise its parent company, which means that it must continue to produce innovations and that these innovations must be relevant enough to raise eyebrows in the boardroom.

The PAIR program—the PARC Artist-in-Residence program—is one of the ways that PARC seeks to maintain itself as an innovator, to keep its ground fertile, and to stay relevant to the needs to Xerox. The PAIR program invites artists who use new media into PARC and pairs them with researchers who often use the same media, though often in different contexts. The output of these pairings is both interesting art and new scientific innovations. The artists revitalize the atmosphere by bringing in new ideas, new ways of thinking, new modes of seeing and new contexts for doing. All of these innovations mulch the soil and plant new and unexpected seeds. Who knows what wonders will grow when two complex, well-established intellectual traditions meet? The cross-fertilization between both disciplines seems to occur at almost the genetic level. This is radically different from most corporate support of the arts, where there is little intersection between the disciplines and no expected change within the disciplines. It takes a bit of faith on both sides, and a belief that both science and art can use a little shaking up, to engage in such a partnership.

But how does PAIR help PARC stay relevant to the needs of the corporation, which is the second difficult problem for ongoing research centers? Here, perhaps, PARC has an unfair advantage over other similar research centers that might want to work with artists. Xerox is, after all, The Document Company, and what artists fundamentally make are documents, particularly new forms and genres of documents. Artists are really document researchers discovering new kinds of documents, new uses for documents,

new ways of constructing documents, new ways for documents to look, sound, and behave, new methods for constructing documents, and even new definitions of what constitutes a document.

We cannot expect the documents of ten or twenty years from now to look like the documents of today. Only five years ago there was no such document as a homepage or an internal Web site. For each new document type or genre there is a coevolution of technology, social structure, and design. Besides making the place more lively, having artists at PARC allows Xerox to get a jump on this coevolutionary process by projecting into the future what tomorrow's documents might be like.

In trying to make this leap, artists put tremendous pressure on current technologies. "Why can't we do this with this printer?," "Why can't we use this program in this way?," "What if we did this with this scanner?" are all questions that flow from artists who confront what the rest of us think are good pieces of technology. But for the artist who is looking into the future and seeing entirely new forms of documents, this current stuff isn't quite right. We benefit from paying attention to these demands, for what artists pioneer often becomes the norm. Unusual art pieces of today can become core media models not many years from now.

Aesthetics and the technology for creating those aesthetics are tightly intertwined. They develop simultaneously as one pushes and pulls on the other. PAIR allows the aesthetic element to be present even as new document technologies are being conceptualized. Just as technology is influenced by its potential use, aesthetics or content is molded by what is possible. Together, new artistic movements can be born, and new industries can arise. Once we realize that neither media nor aesthetics are constant, then we must pay attention to both.

The PAIR program is an experiment—one of many ongoing projects at PARC that are intended keep PARC both a leader in innovation and relevant to the corporation. But combining the humanities and the sciences in a way that the two can talk with each other might also be beneficial to our culture as a whole as we speed toward a millennium that we don't seem quite ready to encounter.

Art and Innovation

1

The Xerox Palo Alto Research Center Artist-in-Residence Program Landscape

Craig Harris

The Search for Common Territory

In the mid-1940s C. P. Snow posited the existence of a dichotomy in our society between those involved in the arts and those involved in the sciences. Snow navigated among literary intellectuals on one side and scientists on the other and expressed concern about an ever-widening rift between the two groups. In his essays *The Two Cultures and the Scientific Revolution* and *The Two Cultures: A Second Look,*[1] Snow discusses his fear that large segments within the society were not communicating with each other and were creating language, educational, and social infrastructures that reinforce the gulf between these domains. He points to the opportunities for creativity and innovation that are made possible at the point of convergence between the worlds of art and science:

There seems then to be no place where the cultures meet. . . . [A]t the heart of thought and creation we are letting some of our best chances go by default. The clashing point of two subjects, two disciplines, two cultures—of two galaxies, so far as that goes—ought to produce creative chances. In the history of mental activity that has been where some of the breakthroughs came.[2]

He further stresses the need to rethink current educational models based on what he refers to as "a fanatical belief in educational specialisation"[3] and to work toward a more comprehensive and integrated approach to education—toward the exchange of knowledge and understanding across traditional disciplinary boundaries. One might take issue with the division of an entire society into only two segments, but Snow did perceive a widening gulf among large groups within society, and he pointed toward communication and education as the means of building bridges between diverse sectors of society.

More than fifty years later, the canvas has changed, and nowhere is this more evident than in the activities of scientists and artists working with new digital media. Technological developments have transformed working practices and modes of communication. A large and extremely active group of artists around the world is working with new digital media and is interested in developing creative approaches to science. New understandings about education and new approaches to learning styles point to substantial benefits that can be gained from integrated, interdisciplinary education programs.

All of these factors converge to provide an opportunity to review some of the premises on which our educational and professional relationships are based.

An examination of the evolution of education programs in professional art academies and music conservatories highlights some of the changes that have taken place in this arena. Twenty years ago, computers had found their way into select research facilities in the United States such as the Massachusetts Institute of Technology, Bell Laboratories, Stanford University, Northwestern University, and the University of California at San Diego. But generally they had not found their way into the professional art academies and music conservatories. In the late 1970s, major developments in the realm of computer music were taking place in Bill Buxton's Structured Sound Synthesis Project (SSSP) at the University of Toronto across the street from Canada's renowned Faculty of Music, with no communication occurring between the two worlds.[4] Many of the relationships that did develop between artists and scientists were established on an informal basis and frequently had a strong focus on work that was directed toward the development of effective new media resources.

New media infiltrated art academies and music conservatories as the technology evolved and as more contemporary artists directed their attention toward employing the expressive potential of new media. The technology and education programs designed to train artists working in new media have exploded, and today comprehensive instruction in the use of new media is no longer an isolated activity. Though instruction in many traditional art practices remain isolated, new media resources permeate contemporary art education, accompanied by a concern for the cultural issues surrounding the impact of new technologies on society. New media resources have become indispensable in creation, presentation and documentation in contemporary art practices, and expertise in their use has become a requisite for employment in many academic, research, and commercial sectors of society.

The complexity of establishing functioning and effective new media studios that support comprehensive new media art education programs has led to the forging of numerous collaborations among academic, research and commercial organizations. Through this collaborative process, members of these organizations navigate each other's terrain, as artists explore the new media for their creative and educational potential and as scientists explore the needs and concerns of artists and create functional applications for the emerging new media.

Many people trained in various aspects of the fine arts have become integrated into the scientific community as programmers, designers, and users of sophisticated systems designed to service the development and implementation of new media resources. Their training in the development and use of digital media and their specialized expertise in the realm of art prepared them well to take advantage of opportunities in business and research and to explore a variety of issues that intersect with the development of effective new resources.

Similarly, many people trained in the sciences are now deeply involved in aspects of their fields that intersect with art, communication, and creativity. Although education programs in many of the traditional science practices remain isolated in discipline-specific departments, the number of interdisciplinary education programs has increased substantially, and many previously informal collaborations have become formalized and more integrated into the education system. Both scientists and artists are converging on an interest in such issues as artificial life, telepresence, and multimedia and immersive environments. In fact, many artists and scientists now have more sophisticated and integrated multimedia computing power in their home offices or studios than research facilities had at their disposal twenty years ago, a situation that Xerox Palo Alto Research Center (PARC) had a great deal to do with creating.

These circumstances have had an enormous impact on the divided-cultures perspective, and as a result the terms of engagement have changed. Pointing to the convergence of artists and scientists employing common resources, however, is not the same as declaring equivalency between the two worlds. This environment could easily create a body of artist specialists with expertise in new media and science and a body of scientist specialists with expertise in art. There remains a substantial difference in their backgrounds and perspectives, and exploring this terrain in the context of collaboration is the focus of the Palo Alto Research Center Artist-in-Residence (PAIR) program.

Common ground may be determined by a variety of factors, including using similar technology, employing a common language, and converging on a common purpose. The challenge in creating a program designed to explore the nature of the relationship between artists and scientists is to create circumstances that engender the kind of communication that leads to a successful exchange of knowledge and perspectives and to an opportunity to

explore new territory. The symbiotic merging establishes a pattern of exploration, development, and innovation, as each participant responds to the other's viewpoints and areas of expertise.

A potentially fruitful setting for exploring these issues would be an environment where creativity and collaboration is commonplace, and Xerox PARC is well established as being supportive in that regard. "There was art at PARC before PAIR," as Marshall Bern states in "Art Shows at PARC" (chapter 13), and PAIR should not be viewed as the organization's first interest in art and creativity. Before PAIR was established, many PARC researchers explored issues relating to the application of digital media to support creative needs. Mathematician and computer scientist Robert Flegal, one of PARC's first twenty-five employees, collaborated with sculptor William Bowman to develop the first bit-mapped graphics editor. PARC researchers John Maxwell and Sgvero Ornstein presented a music editing system called Mockingbird at the 1981 International Computer Music Conference, indicating an interest within PARC in exploring some of the issues relating to developing systems and languages designed to facilitate the compositional process.[5] Ranjit Makkuni came to PARC with a background in architecture and worked on several arts-related projects as part of his research. One such project was the *Electronic Sketch Book of Tibetan Thangka Painting*, a system that employed elements of Thangka painting as an index into video disks describing the craft of painting, the meaning of the parts, and the stories behind the composition.[6] The system was installed at the Asian Art Museum in San Francisco for several years. Stephen Pope became part of PARC's SmallTalk development team beginning in 1985 after spending several years as a computer music composer and researcher. During his time at PARC he developed a series of SmallTalk-based programs designed to create and manipulate computer music compositions.[7] Any long-term PARC researcher can convey many stories about these kinds of projects and about the supportive environment that allows people to explore a variety of creative issues at the facility. The difference with PAIR is that for the first time PARC has systematically organized and facilitated a long-term program that includes practicing artists in the research environment and that fosters collaboration among these artists and PARC scientists. Artists and scientists bring a broad spectrum of issues to the collaboration, and these issues evolve as perspectives and technologies evolve. Both scientists and artists benefit most when they can convey their worldviews, in search of what

Margaret Crane, Dale MacDonald, Scott Minneman, and Jon Winet refer to as "the third mind" in chapter 8 of this book.

If there is indeed something unique about working in new media that facilitates communication among artists and scientists, then we should find evidence in the activities of PAIR. The Xerox PARC PAIR project provides an opportunity to explore the nature of this intersection—to probe into whether participants experience a transformation at the deepest level or whether they merely shift orientation but remain within a strongly divided disciplinary segregation. This provides a chance to examine whether using the same media and the common language of technology establishes a foundation for fostering a significant exchange of knowledge and perspectives or whether it offers a mere illusion of similarity. Xerox PARC PAIR was created to explore these issues.

The AIR in PAIR

Establishing the relationship between artists and individual, commercial, or state sponsors has been part of the cultural equation for centuries, and today artist residency programs comprise a significant portion of the art patronage system. Some artist-in-residence programs provide artists with secluded work environments and uninterrupted time to create new work. Others provide opportunities to reside in an educational environment to intersect with students. Still others facilitate access to resources not ordinarily available—either human resources for those who require live performances or technical assistance or technological resources for artists working with expensive or new media. This last paradigm has been prevalent in the media arts domain, especially when the technology remained located predominantly in major research and development facilities.

In 1974 Pierre Boulez announced the aims and objectives of the Institut de Recherche et Coordination Acoustique/Musique (IRCAM), a new institute for musical research located in Paris. Its goals were to conduct multidisciplinary research in computers and acoustics regarding musical issues, to encourage composition and the production of new works using the results of the projects, to assist composers in learning digital technologies and languages that were not being taught in music schools at the time, and to establish relationships between the international musical and scientific communities. Well-known composers were invited to IRCAM to work with technicians who had specialized knowledge of digital music systems and to

create compositions, and scientists collaborated to explore aspects of composition, sound generation and processing, and music instrument design. The separation between artists and researchers remained clear, although the facility provided opportunities for many composers to have access to remarkably advanced technological resources, especially if they were facile with the new digital media. Scientists also had extensive and unique opportunities to work directly with the practitioners of the art that their resources were destined to service.

The Banff Centre for the Arts in Alberta, Canada, has a long history of offering artist residencies that provide room, board, and opportunities to work with other artists and performers to realize works. During the mid-1980s Michael Century launched the Intermedia program at Banff to explore creative applications of emerging technologies and to bridge the various discipline areas within the Centre's visual arts, music, theatre, and literary programs. The Banff Centre's Media Arts program evolved out of this initiative in 1990, offering project-based residencies for artists working in new media, associate residencies for technical practitioners working in artistic contexts, and workshops, seminars, and colloquia in the theory and practice of electronic media for all interested artists. Artists are provided with access to new media resources and work with associate residents to facilitate the creation of their work. In 1992 the Banff Centre established an applied research initiative, designed to develop new computer-based tools for artists who work in new media, and this has led to collaboration with the research and commercial sectors. This aspect of the Banff Centre's program was established to explore and develop new resources that support the needs of new media artists and to attract needed funding by justifying its work on research and commercial grounds. Although this model can produce friction when these two goals conflict, its collaborative artist and researcher residency program explored art and virtual environments, and culminated in several experimental artworks and in a published collection of writings that explored these works and the impact of emerging digital technology on culture.[8]

The emergence of several interdisciplinary media arts facilities provides further evidence of a growing interest in establishing creative collaborations among artists and scientists. The Zentrum für Kunst und Medientechnologie Karlsruhe (ZKM) in Germany and the Ars Electronica Center in Linz, Austria, are two examples of large centers that provide collaborative oppor-

tunities for both artists and scientists to work in new media and to explore new territory.

A discussion of artist residencies and initiatives to establish collaborations among artists and scientists would not be complete without a mention of activities at Bell Telephone Laboratories in Murray Hill, New Jersey, and Experiments in Art and Technology (E.A.T.), based in New York City.

Bell Laboratories scientists Max Mathews, John Pierce, and F. Richard Moore were laying the foundation for important developments in early computer music synthesis and composition language systems in the 1960s and early 1970s, while Kenneth Knowlton, A. Michael Noll, and Manfred Schroeder were carrying out the first experiments in computer graphics. Max Mathews developed the notion of adding musicians to his engineering department. The first composer to work there was James Tenney and, later, the French composer Jean-Claude Risset. Pierre Boulez worked with Mathews and visited Bell Labs as he was establishing the artist-scientist model on which IRCAM would be founded.

Billy Klüver, a scientist who worked at Bell Laboratories on crossed-field backward-wave magnetron amplifiers, began on his own to collaborate with individual artists in New York: with Jean Tinguely in 1960 and then over the next few years with Robert Rauschenberg, Jasper Johns, John Cage, Andy Warhol, and others. He enlisted the aid of colleagues at Bell Laboratories, who worked on their own time on these projects. During these years Klüver took dozens of artists, from Claes Oldenburg to Marcel Duchamp, on tours through Bell Laboratories.

In 1966 Klüver worked closely with Robert Rauschenberg to organize the large-scale collaborative effort, "9 Evenings: Theatre and Engineering," in which thirty engineers from Bell Laboratories worked with ten artists on performances presented at the 69th Regiment Armory in New York. It was this experience that led Klüver and Rauschenberg to the idea that a one-to-one equal collaboration between an artist and an engineer was the best way to bring technology to the artist, and that such collaborations would benefit both artists and engineers as well as society as a whole. Klüver and Rauschenberg, with engineer Fred Waldhauer and artist Robert Whitman, founded Experiments in Art and Technology in 1966 to provide artists with technical information, technical help, and opportunities to collaborate with engineers on their artwork across the whole spectrum of new technology. Its initial activities—weekly open houses, a newsletter, lectures on scientific

subjects for artists, a large art and technology exhibition, visits to industrial laboratories, a matching service for artists and engineers, and encouragement of local groups that sprang up spontaneously all over the country— were all aimed to recruit engineers who would be willing to collaborate with artists. By 1969 there were more than 2,000 artists and 2,000 engineers who were members of E.A.T.[9]

Artist Lillian Schwartz spent time working on numerous projects at Bell Labs and points to some of the challenges faced in building bridges between artists and scientists in *The Computer Artist's Handbook*:

I discovered at E.A.T. that scientists often wanted to be considered artists. A. Michael Noll, a scientist at Bell Labs, commented, "The most creative engineers and scientists have their own artistic ideas and aesthetic sensitivities which match those of a particular artist with probability zero."[10]

These projects are just a few of the programs and projects that have contributed to the development of a substantial body of new media resources and that reflect a massive amount of collaborative human energy directed toward creating a new set of resources to serve our need for communication and self expression.[11] An examination of the goals and design of each of these initiatives illuminates some of the characteristics and challenges inherent in artist residency programs in the new media arts. The PAIR perspective incorporates some of the elements contained in these program designs and distinguishes itself in some important ways as it forges a model that is particular to its own environment and consistent with PARC's long-term goals. Particularly central to the PAIR design are the importance of cultural exchange and the exploration of collaboration and the creative process. The nature of physical and psychological space, the working methods of artists and scientists, the design of projects, and the nature of the interaction among the participants are all factors in creating the PARC PAIR landscape, and these issues are addressed in this book.

Notes

1. C.P. Snow, *The Two Cultures and the Scientific Revolution* (Cambridge: Cambridge University Press, 1959); C. P. Snow, *The Two Cultures: A Second Look* (Cambridge: Cambridge University Press, 1963).

2. Snow, *The Two Cultures: A Second Look*, pp. 21–22.

3. *Ibid.,* p. 22.

4. William Buxton et al., "An Introduction to the SSSP Digital Synthesizer," *Computer Music Journal* 2, no. 4 (1979): 28–38. Reprinted in C. Roads and J. Strawn, eds., *Foundations of Computer Music* (Cambridge, MA: MIT Press, 1985). See also William Buxton et al., "The Evolution of the SSSP Score Editing Tools," *Computer Music Journal* 3, no. 4 (1985): 14–25. Also reprinted in C. Roads and J. Strawn, eds., *Foundations of Computer Music* (Cambridge, MA: MIT Press, 1985).

5. John Maxwell and Sgvero Ornstein, "Mockingbird: A Composer's Amanuensis," *Proceedings of the International Computer Music Conference* (San Francisco: ICMA, 1981), p. 422.

6. Ranjit Makkuni, "A Diagrammatic Interface to Database of Thangka Imagery," in *Visual Database Systems,* Kunii, Toshiyasu ed., (Amsterdam: Elsevier, 1989).

7. Stephen Pope, "The Interim DynaPiano: An Integrated Computer Tool and Instrument for Composers," *Computer Music Journal* 16, no. 3 (1992): 73–91.

8. Mary Anne Moser and D. MacLeod, eds., *Immersed in Technology: Art and Virtual Environments* (Cambridge, MA: MIT Press, 1996).

9. This summary of the founding and early activities of E.A.T. is based on material provided to the author by Billy Klüver. For a description of the collaboration leading to Jean Tinguely's *Homage to New York*, see Billy Klüver, "The Garden Party," in *The Machine as Seen at the End of the Mechanical Age* (New York: The Museum of Modern Art, 1968). For "9 Evenings," see Billy Klüver, "Theatre and Engineering: An Experiment, Notes by an Engineer," *Artforum* V (February 1967): 31–34; and for information on the early years of E.A.T., see *E.A.T. News* 1, nos. 1–4 and vol. 2, no. 1, published between January 15, 1967 and March 18, 1968; and Billy Klüver, *E.A.T. Bibliography 1965–1980* (New York: E.A.T., 1980).

10. Lillian Schwartz, *The Computer Artist's Handbook* (New York: Norton, 1992). See also A. Michael Noll, "Art ex Machina," IEEE Student Journal 8, no. 4 (September 1970): 12.

11. Craig Harris, ed., *The Leonardo Almanac: International Resources in Art, Science, and Technology* (Cambridge, MA: MIT Press, 1993). This volume provides details about a wide variety of activities in new media art and research, including the work of several artists, education programs, and research projects. Current information is available by visiting the *Leonardo Electronic Almanac* Web site, published by *Leonardo*/ISAST and The MIT Press. Point a Web browser to http://mitpress.mit.edu/LEA/.

2

PAIR: The Xerox PARC Artist-in-Residence Program

Rich Gold

Beginnings

1. PAIR (the Xerox PARC Artist-In-Residence Program) is an active program for bringing art and artists into Xerox PARC (the Xerox Palo Alto Research Center), an institution originally founded to study, invent, and design "the Office of the Future" and "the Architecture of Information."

2. PAIR is a project not for creating wonderful art or exciting science—because we are dealing with highly skilled, talented, and motivated people these things almost always happen—but for creating better artists and better scientists.

3. PAIR is a conscious attempt to boost, alter, nudge, and in a minor way redirect the creative forces of PARC by providing alternative viewpoints, theories, personalities, and methodologies within the halls, offices, and long corridors and around the steaming coffee pots of the community.

4. PAIR is an outstretched hand from PARC into the surrounding Bay Area (we focus almost exclusively on San Francisco artists) and helps PARC to join vibrant artistic community and to channel the creative forces that flow beneath the Golden Gate Bridge.

5. PAIR is a way for artists and scientists—two groups who consider themselves outsiders (the primary concern of artists is to express themselves whereas the primary concern of scientists is to discover the truths of nature)—to meet face to face.

6. PAIR is a way for artists and scientists—two groups who are the ultimate insiders (the artist's primary patrons are the wealthy, the corporation, and the government, whereas the scientist's primary patrons are the corporation, the government, and the university)—to meet face to face.

7. PAIR is a wonderful funhouse mirror into which two groups—artists and scientists—stand in their jeans and T-shirts and simultaneously stare at each other's superimposed energy, creativity, quirks, flaws, hypocrisy, honesty, and promise morphed together in a single overlaid image.

8. PAIR is a program based on the obvious but often neglected fact that most artists and scientists are adults and can be treated that way.

Structure

1. PAIR is a matchmaker—a yenta—that sets up marriages that can last a lifetime by knowing the clients, looking for sparks, realizing that all marriages are unique, and understanding that all marriages have their own rhythms and songs.

2. PAIR, although a matchmaker, is not a marriage counselor (at least mostly). Instead, it supports reasonably unmediated adult relationships that are as uncomplicated as possible and allows the two participants to determine the rules of their partnership.

3. PAIR does not turn artists into researchers or scientists into artists, but rather accepts and honors each profession's interests and goals within the context of a heterogeneous intellectual ferment.

4. PAIR is founded on the idea that the legal contract between the artist and the scientist should be so straightforward that it can be signed (or not signed) with a clear conscience. We worked hard on this point.

5. PAIR is also aware that a professional relationship between artist and scientist requires that fair compensation be paid to the artist, and so the contract includes full ownership of the art, a stipend, and all the copying anyone could ever want (the second part isn't in the contract but is true in practice, and PARC learns much from what and how artists copy).

6. PAIR provides a contract clause that states that the artist will be granted, if possible, a free, nontransferable (important), lifetime license to any scientific discovery resulting directly from the artist-scientist pairing for use in the artist's own work.

7. PAIR originally estimated that artist-scientist pairings could achieve maximal potential within one year (the contract term), but we have learned that because it takes a long time to develop a common language, the artists never really leave.

8. PAIR is most fundamentally a project within a corporate research center, and the most interesting conflicts (not many, really) arise not between artist and scientist but between the lifestyles of company employees and the lifestyles of independent, aesthetic workers.

Context

1. PAIR is deeply embedded within PARC—a native species to it—and it is not clear whether it could be transported to other environs, at least with its present genetic makeup, a makeup that is the result of a specific evolution within the PARC ecology.

2. PAIR is an organism that lives in the very real atoms-to-culture landscape of PARC, where one is as likely to eat lunch with a molecular physicist, computer scientist, anthropologist, philosopher, linguist, interface designer, mathematician, cryptographer, or artist.

3. PAIR, as an entity within PARC, is part of a rare ecology (within the United States, anyway) that values, in and of itself, intellectualism and creativity, and PAIR's niche can be categorized as being like a bee cross-pollinating the diverse flowers of this fertile field.

4. PAIR is lucky that the director of PARC, John Seely Brown, and PARC's senior staff immediately embraced and supported the program, although they did wonder whether any scientists would participate since the program was entirely voluntary and would have to be part of one's precious research time.

5. PAIR is the result of many forces, one of them being the External Advisory Panel (EAP) which was composed of twelve San Francisco Bay Area curators, editors, and art program directors (from major museums to hole-in-the-wall theaters), many of whom had never met each other before we brought them together (the arts being nearly as discipline-divided as the sciences).

6. PAIR was partly forged by the first meeting of the External Advisory Panel, where we got an earful and a half of complaints—from how dare we drag artists into a corporation, to who will protect the artists without mediating foundations and curators, to how careful we should be not to use the word quality when discussing art.

7. PAIR was partly forged by the second meeting of the EAP where each advisor enthusiastically proposed one appropriate artist (and they all were appropriate and actually wonderful), which started us on the right foot with an unexpected bounty of candidates from almost every artistic discipline.

8. PAIR is also the directed vector of PAIRCORE, the Internal Advisory Panel (IAP), which is composed of scientists from each of PARC's five labs who watched over the program and gave the ritual blessings to each new pairing. Many of these scientists had never met each other but have gone on, in many cases, to make their own scientific pairings.

Joinings

1. PAIR is based on the simple idea that we could use technology as a common language to get otherwise divergent disciplines to speak with each other and that once the conversation began, good things would follow.

2. PAIR is not based on the belief that each person must be both an artist and a scientist, though such people exist, but rather that there is a class of

extraordinary activity that a scientist and an artist can simultaneously engage in that is mutually beneficial to both.

3.　PAIR is not necessarily based on the model of scientist-artist interaction one finds in organizations like the American Computing Machinery Special Interest Group on Computer Graphics (SIGGRAPH), where scientists construct complex artistic machines for artists to use, but it doesn't exclude such interactions.

4.　PAIR is not necessarily based on the model of scientist-artist interaction one finds in, for example, performance art, where artists scavenge scientific effluvia, from fractals to laser beams, to create technocollages, but it doesn't exclude it either.

5.　PAIR is a believer in the truth of the proverb "Artists make art from the mud of the water that flows by their village," and since the San Francisco Bay is electrified and computerized, we had no trouble finding artists who were already making artifacts that looked at least somewhat familiar to the scientists who were scooping mud from the same banks.

6.　PAIR acknowledges that art has always used technology and that all art is technological—that even a painting is a precise road map of the history of Western chemistry—and we wrote a job description that ambiguously and loosely defined a category called *modern technology* and a category of artist who "used modern technology in a deep and fundamental way" (and waved our hands a lot to indicate the kind of artist we thought we were looking for).

7.　PAIR also acknowledges that since science is a creative act, PAIR could not be about bringing creativity to scientists or, for that matter, bringing formalism to artists. In some real sense, PAIR brings remarkably similar professions together for a close examination.

8.　PAIR is awake at a time when fascinating new genres of communication are forming, when the aesthetics of these genres are pushing against the sciences and technologies of various emerging media: a cusp when small activities can create large folds of culture in a not too distant future.

Troubles

1.　PAIR—a little thing in the context of a polluted and starving world—is a small attempt at an intelligent activity when all intellectual activity is at risk.

2.　PAIR acknowledges that, on the one hand, artists portray themselves as a moral force outside (and in some sense against) the current power structure,

while, on the other hand, their activities are financed by a small group of collectors and curators who are pillars of that same structure.

3. PAIR acknowledges the current crisis in science: on one hand, scientists portray themselves as a moral force working for the good of humankind by understanding the nature of nature without ideology, while, on the other hand, almost all science is funded by a small group of corporations, universities, and governments that have specific ideologies.

4. PAIR is not unaware of the irony of bringing artists into corporate hallways (the partnerships between artists and middle-class workers are perhaps the best unintended consequence of PAIR): the individualistic ethos that drives modern capitalism is not just reflected in Western art but actually derived from it.

5. PAIR has observed that modern corporations are dependent on science advancement and nervously wonder whether inviting artists into their research centers will dull their scientific edge or sharpen it.

6. PAIR is intrigued equally by postmodern postulations that science is no more than a myth and by industrial-era beliefs that only good flows from test tubes.

7. PAIR is as charmed by artists who claim that art is counter to their own culture (what an odd culture that would be) as it is to claims that art leads the culture (and hence might be useful to companies looking for new products).

8. PAIR, in the end, is a small community of humans on a slightly warming planet hoping to make a difference by communicating across a shimmering boundary.

PAIRings

1. PAIR includes artists Jon Winet and Margaret Crane, who work late through the night with computer scientists to create an innovative interactive Web site that allows mental patients to communicate with each other, their doctors, and their friends—and then find that the same technology is also useful in allowing corporate executives to communicate with each other, though for different purposes.

2. PAIR includes John Muse and Jeanne Finley, documentary filmmakers, who work with the PARC cultural anthropologists to create a film about how anthropologists study artists, while the anthropologists study the filmmakers creating a documentary about anthropologists watching artists—

and, well, round and round, while the methodologies and understandings of both are fundamentally altered.

3. PAIR includes the radical vocalist Pamela Z, who uses gestures to control banks of electronics that alter her voice, working with the video-gesture recognition scientists of PARC who have never worked with a "professional" gesturer before—and thereby altering their understanding of what is possible in this area.

4. PAIR includes the interactive sound sculptor Paul De Marinis, who works not only with the ubiquitous computing group creating the first ubicomp sound sculpture but also with a collection of print scientists who created unique PostScript programs that allowed Paul to form giant printed spirals that encoded "The Theme from Vertigo," which could be played by human-directed laser beams on spinning turntables creating a dizzy music.

5. PAIR includes net artist Steve Wilson, who creates, with the help of PARC interface scientists, one of the first alternative methods for surfing the Web—in this case, the *Road Not Taken*, which shows the Web sites you didn't click to, breaking open a flood of new browser possibilities and a kind of ennui as well.

6. PAIR includes interactive novelist Judy Malloy, who works with *LamdaMOO* scientists to develop a new genre of literature—the first interactive detective novel in a multiperson MUD space, as well as writing a hypertext novel with a woman scientist at PARC that looked at gender across the artist-scientist boundaries.

7. PAIR includes artist Perry Hoberman, who engages in long, complex discussions with scientists working on embedded and invisible data technologies and trying to understand the aesthetic implications of images that encode information as well as the technological pressures of artists who want objects with metaphorical and linguistic layers.

8. PAIR includes sound artist Tim Perkis, who works with media scientists at PARC to construct a real time sonic rain forest on the Internet that not only anybody could listen to but that any listener could add a few noisy animals of their own to.

Future

1. PAIR is (was) an opening for PARC to look at an interesting quartet of disciplines—art, design, engineering, and science—and to uncover the multitude of agreements and conflicts the four have with each other.

2. PAIR is an opening for PARC to study aesthetics as a field of research because the aesthetics of a culture determine what people want to make and what tools they might need: if you happen to make printers, for example, you might need to know what people want to print.

3. PAIR is an opening for artists to observe scientists in a direct and humanistic manner and not through the lens of popular literature, since the artistic representations of scientists are not neutral events (nor is the scientist's opinion of artists).

4. PAIR is a way to fund artists in a direct manner and not at the end of long fingers where the funders and the fundees never meet except at the bank.

5. PAIR connects PARC—in a strange but effective way—with other parts of Xerox and with other research facilities around the world because an artistic bridge is an unthreatening bridge to cross (and PAIR has made it possible to cross many of these bridges).

6. PAIR is an opening into the research of artistic expression, which, if the ultimate question is "How do we create a rewarding and meaningful life?," as it is at PARC, might not be a bad place to start.

7. PAIR is an opening into using some of the methodologies of art in scientific research, which is a creative activity itself and therefore is always on the lookout for new techniques to be borrowed from other professions.

8. PAIR is an opening for Xerox The Document Company to work with some honest-to-god document makers.

Speculations

1. PAIR is perhaps a pause before genetic engineering renders all of computer science a small blip on the twentieth-century radar screen and redefines not just what people think about but what people think with.

2. PAIR is perhaps a harbinger of an emerging corporate agenda that is more dependent on position, information, and arrangement than the control of molecules and space.

3. PAIR is (this is speculation) an early attempt to construct an art for and about the middle class, which has been essentially abandoned by the fine arts to the whims of Hollywood.

4. PAIR is a tantalizing breeze of the possibility of an aesthetic life wafting ashore our industrialized beaches.

5. PAIR is the mere suggestion that there might be a new emphasis on the creation of technologies that are designed not to replace humans but to work in conjunction with humans.

6. PAIR is a not-so-subtle reminder that neither art nor science is neutral but that each can cause destruction and enlightenment—unexpectedly and anywhere.

7. PAIR is a reminder that innumerable human-made objects on the surface of the earth were, in fact, designed by humans and that we might want to think hard about the future we want to live in before we design more.

8. PAIR is a suggestion that creating new stuff is not the problem but that different methods create different things and that finding an appropriate method may be our only hope for a charmed and lovely time on this planet.

3

The PARC PAIR Process

Craig Harris
with perspectives from
Constance Lewallen and David Biegelsen

An exploration of the PAIR process—conceptualizing PAIR, selecting the artist-scientist pairs, and implementing and guiding the programs—reveals a great deal about the nature of the endeavor. The value of the project was understood within certain parts of PARC, but the success of the project depended on the involvement of a variety of scientists and research groups. Within PARC, the responses to PAIR could potentially include casual or extreme interest, benign neglect, and perhaps even active resistance.

PAIR Director Rich Gold needed to make a case for the project's relevance in the same fashion that research projects generally obtain support from the organizational structure at PARC. This included creating a comprehensive project design, developing a group of interested scientists willing to participate as a guiding and evaluating body, establishing a process by which people outside of PARC could be integrated into a complex and secretive corporate structure, and generating an environment conducive to producing the desired results. Defining *the desired results* is particularly difficult for PAIR because the program's impact is not identified specifically but is suggested by the nature of the project. Xerox PARC has a long history of supporting research activities that do not have specific commercial products in mind, however, so having an unspecified anticipated result is not foreign to its research environment. The assumption is that PARC will benefit in some unspecified way by integrating artists into the research environment and encouraging artists and scientists to work together collaboratively.

One of PAIR's most telling design specifications is that the program is not directed specifically at creating artifacts or products or at simply supplying artists access to either technological or human resources that they otherwise would find difficult to obtain. The sociological or anthropological orientation of PARC's interest directs participants toward exploring new document genres and collaborative work practices and toward observing how different groups apply technologies created at PARC.

PAIRCORE: The PAIR Internal Advisory Panel

PAIRCORE is the Internal Advisory Panel (IAP) within PARC that is designated to oversee the PAIR project. As Rich Gold discusses in chapter 2, "PAIR: The Xerox PARC Artist-in-Residence Program," PAIRCORE is comprised of representatives from several research groups within PARC and facilitates the artist-scientist pairings. PAIRCORE sets the processes in motion and evaluates the progress of PAIR within PARC. PAIRCORE

members included Debra Adams, Marshall Bern, Dave Biegelsen, Andrew Glassner, Rich Gold, Meg Graham, Steve Harrison, Jim Mahoney, Dale MacDonald, and Scott Minneman. Cynthia DuVal (1993) and Natalie Jeremijenko (1994 to 1995) were at times partly or wholly responsible for acting as liaisons with the artists and for documenting their residency.

Steve Harrison went on to facilitate Joel Slayton's project, "Conduits: An Experimental Media Performance," and plays an important role now in facilitating PAIR's activities. Scott Minneman became a PAIR researcher in the Crane-Minneman-MacDonald-Winet collaboration. David Biegelsen's PAIRCORE perspective illuminates some of the challenges that PARC faced as they worked to integrate artists and the PAIR project into the PARC environs:

Cultural Repulsion or Missing Media?
David Biegelsen

As the PAIRCORE representative for the Electronic Materials Laboratory (EML), I encountered a pervasive problem. At the commencement of the PAIR program, no one I spoke with in EML could conceive of an area of mutual endeavor with an artist. Members of the EML develop large-area (human-scale) flat-panel image sensors and visible and invisible light-emitting laser diodes. We work with smart-pixel arrays and visualize arrays of individual atoms on crystalline surfaces. We fabricate small, jewel-like thin films in an attempt to convert one color light into another.

But where could an artist collaborate in such an environment? The researchers felt that their projects did not lend themselves to artistic interaction and that pairing would therefore be a time sink. I also sensed in many a disinclination or, more accurately, an air of uncertainty about engaging with an artist.

There evolved, nevertheless, at least two successful interactions involving EML people. The first grew from attempts I made to find a basis for a pairing involving our scanning tunneling microscope (STM). STMs are, in essence, exquisite record players. An STM scans a tip—or, more precisely, the most proximate atoms on that tip—over a sample of interest. By keeping the current of tunneling electrons fixed, those atoms are kept a fixed distance above the sample, approximately two to four atom diameters, as the tip is rastered over a region. The height that the tip must be retracted to maintain the gap constant

is, in turn, rendered on a television screen as brightness as the electron beam painting the television picture is rastered in synchronism with the tip.

Paul De Marinis, in presenting his artwork to PARC, described some of his pieces in which he senses the bumps on a rotating object and converts the sensed features to audible sound patterns. There was a natural affinity here that has blossomed into many subsequent stimulating conversations focusing primarily on extending human senses through intermediate means. For example, could we push individual atoms around and feel, with our fingers, the stick and slip of the atom as it encounters the local forces of its environment? Could we hear its travels? But most centrally, are there untapped sensory channels for interacting with the unseeable that enable powerful conceptualization? I think we both sense here the seeds of an important area of development. But wherein lies the art? Is this a case of cultural repulsion or absence of an appropriate medium?

A second success is a pairing that is just beginning. This research area seemed a natural for a pairing because the medium was graphical and visually pleasing. The heart of the graphical pursuit was the glyph—an array of glits, short strokes at plus or minus 45 degrees. The glits carry one bit of information—say, 0 or 1. A regular array of glits has a constant optical density because each glit, whether tilting left or right, contains the same amount of ink or toner. PARC researchers had pushed the applications far beyond their early, visually gray, data blocks. They had embedded glyphs in pictures and logos. They even varied the glit density to make glit-based halftone images in which the glyphs carried both digital and analog information simultaneously. Here is a new and malleable graphical medium. The researchers wanted to initiate a pairing, but the barrier was patent coverage and industrial secrecy. After two years of legal road clearing, a pairing has been established between David Jared and Noah Flores as glyphologists and Perry Hoberman as artist. Their work was not ready in time for publication here.

So what might we surmise from our local experience in pairing physical scientists and artists? Although there is little history to inform potential practitioners and encourage unions, we know that pairings depend on the existence and identification of a shared, natural medium. A common substrate is required on which to build an interaction. From our limited experience, we conjecture that to be most effective in nucleating artist-scientist pairings, we must look at the research community in terms of the generalized media represented.

The art of the pairing lies in the creativity of the researchers and artists in enlarging their views of the meaning and limits of their media.

The PAIR External Advisory Panel

The PAIR External Advisory Panel (EAP) was comprised of a wide range of participants—including an independent curator as well as representatives of established traditional and nontraditional art galleries and new media arts organizations. EAP members brought diverse perspectives to the discussion about how artists use new media, how artist-in-residence programs should be designed, and how participants should be selected. Potential EAP members were selected, interviewed, and shown the PARC facility before being invited to participate (table 3.1). The procedure had a curated flavor to it, in contrast with the more traditional artist-selection process based on an assessment of submitted proposals. This made it possible for PARC to determine more about the individuals and work of prospective PAIR artists, including background about their personalities and how they might intersect with a research environment.

The first meeting of the EAP group and members of PAIRCORE took place at San Francisco Art Institute's Walter/McBean Gallery on March 16, 1993, accompanying an exhibition of Paul De Marinis's work *The Edison Effect*. Rich Gold presented the background that brought the PAIR project into existence, addressing basic goals and fundamental principles. At this stage PARC was seeking input on program design parameters and was laying a foundation that would facilitate the intersection of PAIR (and PARC) with the surrounding Bay Area community.

EAP participants discussed such issues as how to design an effective artist-in-residence program in a research environment, how to define and balance technological sophistication and artistic relevance, and how PARC PAIR would respond to the Bay Area's diverse multicultural artist community, especially when only certain sectors of the artist community may have access to technology. In addition EAP members expressed concern about the PAIR perspective on ownership of creative artifacts, scientific discoveries, and the value of artists' participation in the experiment. There was concern that PARC would reap substantial benefits from the knowledge, creativity, and experience of the artists without acknowledging either these benefits or the financial needs of artists participating in the program.

Table 3.1 PARC PAIR External Advisory Panel Members

Andrea Juno, publisher/editor
RE/SEARCH Publishing
San Francisco, California

Beverly Reiser, president
YLEM/Artists Using Science and
 Technology
Oakland, California

Bob Riley, curator of Media Arts
San Francisco Museum of Modern Art
San Francisco, California

Chris Brown, director
Center For Contemporary Music, Mills
 College
Oakland, California

Constance Lewallen, associate director
Crown Point Press
San Francisco, California

Craig Harris, executive director
International Society for the Arts,
 Sciences and Technology
San Francisco, California

Dean Beck-Stewart, director
Theater Artaud
San Francisco, California

Don Day
California College of Arts and Craft
Alameda, California

Jeannie Wieffenbach, director of
 exhibitions
San Francisco Art Institute Art Gallery
San Francisco, California

Larry Rinder, curator (Matrix)
University of Berkeley Art Museum
Berkeley, California

Peter Gordon, chief curator
San Jose Museum of Modern Art
San Jose, California

Regina Moulton, independent curator
Oakland, California

Rene Yanez, director/curator
Mexican Museum
San Francisco, California

Following that first meeting, PAIR organizers distributed a list of basic selection criteria, including cultural and gender diversity, artistic variety, and identification of appropriate and willing scientists and labs within PARC. Organizers also acknowledged that they could not solve every initial concern at the expense of launching the project.

Dean Beck Stewart, then director of Theater Artaud, hosted the second EAP meeting on April 6, 1993, and requested that each EAP member bring

recommendations and work samples for two artists. All participants involved in this session viewed a large variety of artwork employing new media and also heard why the work of these artists warranted attention in this context. I was the executive director of the International Society for the Arts, Sciences, and Technology (ISAST) when I was invited to be a member of the External Advisory Panel. The intersection of organizational interests was clear from the beginning. ISAST creates the journal *Leonardo*, the Leonardo Book Series, and the electronic journal *Leonardo Electronic Almanac*, all of which are directed toward exploring contemporary art practices as they intersect with contemporary science and developing technologies. Since *Leonardo*/ISAST's first presence in the Bay Area in 1982, it has been looking for ways to support contemporary artists who explore science and technology in their work. Independent curator Constance Lewallen reflects on her experience as an EAP member:

An EAP Perspective
Constance Lewallen

I was the associate director at Crown Point Press, a premier printer and publisher of artists' etchings and woodblock prints, when I received a telephone call from Rich Gold about a project he was hatching for Xerox PARC. Gold was seeking advisors for his new project, dubbed *PARC PAIR*, teaming artists and PARC researchers for the purpose of developing projects of mutual concern and benefit. He thought someone associated with the fine-print world would be an appropriate artist nominator. Ironically, the technology of fine-art etching is anything but high tech. In fact, the process has changed little since it was invented in the fifteenth century. Woodblock printing is even older, going back to the golden age of China. However, I was and am very much involved in the Bay Area contemporary art scene as a curator, teacher, and writer and felt I could make a contribution. Gold invited each advisor to visit Xerox PARC before meeting together as a group with the PARC committee. Not being from the tech world and knowing very little about it at the time, I was overwhelmed. I could see what an extraordinary opportunity it would be for artists to be able to work with top-notch researchers in a state-of-the-art facility. Gold said that artists who would eventually receive a residency at PARC should have some technological sophistication but that, apart from that commonality, he wanted a group who represented a broad range of interests, aesthetics, and ideas.

The advisors came from various institutions—educational, nonprofit art spaces, theater, and so on—and met several times with the PARC in-house committee (PAIRCORE) to discuss the project. We were then asked to present the work of two artists to the committee. I selected Jeanne Finley, a professor at the California College of Arts and Crafts in Oakland, and Doug Hall, a professor at the San Francisco Art Institute. Both artists work in video but in vastly different ways. PARC PAIR offered a residency to Jeanne Finley, who brought John Muse into the project as a collaborator. Doug Hall was invited to take part in a shorter residency. PARC also offered a residency to Margaret Crane and Jon Winet, a collaborative team recommended by one of the other advisors. I subsequently became the project director of a public art series called Art in the Urban Landscape, sponsored by Capp Street Project and the Wallace Alexander Gerbode Foundation of San Francisco. Crane and Winet were among the six artists and artist groups who were selected to participate in the public art project, and they, in turn, used their PARC residency to develop an interactive public artwork titled *General Hospital*. They launched both a newsgroup (alt.society.mental-health) and a World Wide Web site (http://sandbox.xerox.com/pair/cw/gh.html) to explore mental health issues in the late twentieth century through the virtual community of the Internet. Though their previous projects had also centered on issues of social concern, this was the first time Crane and Winet worked in the new arena of cyberspace.

Unexpectedly, I was again connected to the PARC PAIR project, an apt demonstration of how PARC PAIR has become integrated into the Bay Area contemporary art dialogue. As the boundaries that have in the past separated various art media and disciplines are becoming increasingly blurred, the potential for further fruitful encounters would seem to be unlimited.

The PAIR Structure

Initially the PAIR design created two categories of artist-in-residence—long-term and short-term residencies. This was created to provide opportunities for PAIR to bring more artists into PARC, to raise the level of interest within the facility, to increase the presence of contemporary art in the environment, and to explore the potential in specific pairings before making an extensive, longer-term commitment. The model was successful in achieving several of these goals and in providing a path for John Muse and Jeanne Finley to find their true place at PARC as artists-in-residence. Ultimately, this structure gave way to the single, longer-term residency, as it became

apparent that the true value in the PAIR context was in the opportunities for artists and scientists to interact in a longer-term relationship. At the same time, PAIR artists were not hired as full time PARC employees. Establishing full-time positions for the artists to locate at PARC would admittedly have certain benefits in establishing their parity with the scientists and in reinforcing the significance of PAIR in the long-term PARC perspective. However, there was a concern that taking artists out of the domain of practicing their art would turn them into researchers, a factor that would alter the dynamics of the artist-scientist relationship and affect the results of the experiment. The PAIR design places enormous importance on identifying and establishing promising pairings and then lets the participants define their own challenges, projects, and process.

PAIR Documentation

The benefits that would result from creating documentation for PAIR became evident early in the project's evolution. As seen in the contents of this book, PAIR artists and scientists used the book project as an opportunity to explore many aspects of their collaborations. This process helped them to establish a more comprehensive understanding of what transpired during the course of a long-term activity and to reflect on its impact in their work and lives. PAIRCORE will use the documentation to evaluate the PAIR process as the program moves into the next phase of its development. Xerox PARC now has a broad overview of the program and has accumulated four years of data that can be studied to determine the program's impact on the larger organization and to explore potential fruitful directions of development. And creating documentation targeted for widespread publication extends the scope of PAIR outside of the PARC environment, illustrating the process and importance of the project.

As is the case in the PAIR project design, the goal of the documentation is to address more than a mere tabulation of creative artifacts and technology employed. The intent is to reflect the process of the collaborations and to provide insights into the cultural setting. The book explores the similarities and differences between the perspectives, approaches, and work practices of artists and scientists and the role that technology plays in facilitating their work and the collaboration. A balance needed to be established that would make it possible to create documentation of an evolving process without having the documentation drive the collaborations. To achieve this balance,

scientists and artists were encouraged to explore any construct that made sense for their particular situation—separately as individual artists and researchers or in concert—and to create some form of documentation destined toward compilation in a hard-copy publication. Within the constraint of hard-copy publications, the desire was to be flexible about the design for specific chapters, allowing contributors to explore an appropriate visual representation in service of best reflecting the content. The documentation became integrated into PAIR as another process, as characteristic of the collaboration, and as another opportunity to explore their experiences.

The results are as diverse as the pairings themselves and provide a kaleidoscope of windows into the PAIR collaborations and into life at PARC. Even when the mode of communication is similar, as is the case with the choice to use some form of dialog as a means of expressing the nature of the collaboration, the PAIR participants made it reflect their own voices. In chapter 11, "Artscience Sciencart," Michael Black, David Levy, and Pamela Z provide a vision into the kinds of conversations that frequently take place at PARC among researchers about a variety of topics. They shed light on some of their thoughts about the similarities and differences between artists and scientists and about concepts underlying the nature and definition of what determines an original versus a copy—something that has relevance in the worlds of both art and Xerox. Judy Malloy and Cathy Marshall created their interactive hypernarrative *Forward Anywhere* directly out of the email dialog that documented their intersection, presented here with additional reflective dialog in chapter 7, "Forward Anywhere: Notes on an Exchange Between Intersecting Lives." The statements, responses, and responses to the responses portrayed in chapter 5, "O Night Without Objects," embody the "turning and returning of the gaze" that characterizes the relationship among artists Jeanne Finley and John Muse and scientists Lucy Suchman, Jeanette Blomberg, Susan Newman, and Randy Trigg as they each manipulate the same medium in service of their own needs and explore the alternatives presented to them by their pair. Margaret Crane, Dale MacDonald, Scott Minneman, and Jon Winet combine forces to establish a kind of contemporary performance group. In chapter 8, "Endless Beginnings: Tales from the Road to 'Now Where?'" they explore both process and artifact, revealing a deep curiosity about each other and a determination to engage each other as they engage the technology and the public.

In other cases, chapters were created independently. Judy Malloy in chapter 6, "Public Literature: Narratives and Narrative Structures in *Lamb-daMoo*," mirrors her own search for a place at PARC as her characters strive to find their place in the multi-user dungeon (MUD). Paul De Marinis's chapter 9, "An Archeology of Sound: An Anthropology of Communication," offers his own search for a place at PARC, expressed as a series of intersecting anecdotes, descriptions of his installations, and reflections on topics evolving out of relationships developed in his PAIR residency. Paul presents a personal and historical perspective revealing a relationship with technology that clearly establishes it as raw material to be used as a medium for communication and reflection—as a "meeting ground of the physically possible with the humanly desirable." Joel Slayton's *Conduits* (chapter 12, "*Conduits*: An Experimental Media Performance") placed PARC in direct contact with the surrounding community in Palo Alto and identified PARC as one collaborating organization in a controversial, large-scale, multimedia public performance artwork.

Steve Wilson's chapter 10, "Reflections on PAIR," discusses a series of Web-based works that were created in collaboration with researchers Jock Mackinlay and Polle Zellweger and that explored the nature of collaboration and communication with a perspective that reveals a technology that evolves as the works themselves evolve. He sheds light on some of the fault lines that exist at the frontier of technology—the challenges that PAIR faced in simply existing in a corporate domain and in establishing itself within PARC as a viable and valuable activity. These windows into a kind of cultural friction provide opportunities for increased understanding of ourselves and each other. There is evidence of a transformation taking place in this regard during the course of the four years represented in this documentation. Steve Wilson points to his collaborators' concern that work done in PAIR would not be accepted in the broader context of their work at PARC, potentially jeopardizing the future of their work. Their PAIR project was one of the first projects to launch and ran through the course of their activities toward the end of 1995. Dale MacDonald and Scott Minneman indicate similar concerns early on but reveal a transformation within PARC that took place in 1996 resulting in the creation of a new organization with a charter to develop and explore new document genres—a circumstance that raised the visibility of their collaboration and helped them to link their work with the work of other researchers at PARC and to share their discoveries.

Steve Harrison explores the artists' use of physical space in chapter 4, "The Place of the Artist," examining the tools and spaces of scientists and artists and determining the relevance of physical space as PARC imports artists into its environment. The architectural uniformity at PARC is designed and optimized specifically to support science and research and not to facilitate art production and the reconstruction of physical space. Jeanne Finley and John Muse, however, transformed the space in service of their function, with dramatic results that clearly indicate that physical space can be a significant factor in the working practice when space is allowed to accommodate need and work practice is not forced to conform to a traditional workspace.

No single collaboration reflects the nature and diversity made possible by the set of circumstances that put PAIR in motion. Collectively, the chapters presented in this volume reveal a web of intersections—sometimes formal and sometimes spontaneous—among artists and scientists who are searching for a means of communication that affects PAIR, PARC, and the world outside of PARC.

Portability

The PAIR program is intricately woven into life at PARC and into the Bay Area/Silicon Valley new media art, research, and commercial environments. The connections and intersections made among scientists, artists, Bay Area contemporary arts organizations, companies, other research facilities, and the public are unique to what Rich Gold calls the ecology of that environment. Gold notes in his chapter 2 that "PAIR is deeply embedded within PARC, a native species to it, and it is not clear whether it could be transported to other environs, at least with its present genetic makeup, a makeup that is the result of a specific evolution within the PARC ecology." This raises an important question about the relevance of PAIR outside the realm of PARC. PAIR certainly is significant for Xerox PARC as an experiment and potential hotbed of innovation. It has definitely affected the PAIR collaborators and, perhaps less clearly but nonetheless importantly, affected others working at PARC. The issue of portability to other environments is worthy of some attention, though, if the project is to be viewed as more than a limited curiosity illuminating a particular set of relationships in a brief moment of time.

One might be able to duplicate many of PAIR's characteristics in another environment, but transporting its essence and efficacy is another matter. The structure of PAIR does have potential for widespread propagation if viewed as a model for collaboration and community building in the broadest sense. The strength of the PAIR paradigm is in PARC's understanding of itself and its goals, in PAIR's inclusive approach to activating the surrounding communities, in its willingness to take risks when no clearly definable outcome is evident, and in its acknowledgment that it is setting in motion a process and allowing the collaborations and intersections to evolve on their own. These fundamental premises are indeed portable, with each context creating its own ecology and therefore its own unique nature and impact.

4

The Place of the Artist

Steve Harrison

Palo Alto Research Center Artist-in-Residence program was established for the purpose of changing PARC. At the time, it was reasonable to assume that workspaces at PARC would change to reflect different ways of working—that artists taking a critical stance toward the dominant culture might alter their environment to spotlight certain issues. At the very least, artists might temporarily appropriate space for the peculiarities of a particular project. In fact, few of these workspace changes happened in the PAIR program, and those that did left no lasting impact on the spaces.

Why Are the Offices of the PAIR Artists Indistinguishable from Those of Researchers?

From the beginning, members of PAIRCORE discussed the idea of creating a studio space for the artists as part of the planning for the selection and support of artists in residence. It was not to be: while a space was eventually created for some shared equipment, PAIR did not create or even sponsor the creation of studio spaces for the artists and their researcher colleagues. In the end, all the artists who took up residency at PARC were housed like other visitors to PARC in unoccupied office space located as close as possible to the person and project that they were paired with.

What Is the Space Like at PARC?

PAIRCORE'S initial preoccupation with creating studio space was triggered by the decidedly unstudiolike environment at PARC. PARC is an office building. While the exterior of PARC aspires to expensive invisibility by covering its edges in large planter boxes and burying one side against a hill, the interior of PARC is a three-story rambling repetition of spaces. It is organized into six units (called *pods*) separated by courtyards. Offices are located on the exterior of the six pods with the generous interior space given over to rectangular spaces containing conference rooms, laboratories, copiers and printers, and areas constructed for informal gatherings often at or near small kitchens. This arrangement separates people by great distances.

PARC researchers usually have window offices along single-loaded corridors. Walls often have whiteboards and many book shelves. Even in small, shared offices, each worker has enough space for at least one personal desk with one computer. Most offices either look out on one of five identical courtyards or across patios and planter boxes to the roofs of other facilities and to the Silicon Valley beyond. While the exterior world is visible, it is

Figure 4.1
A typical PARC office

inaccessible: windows are not operable, and few doors open to the patios and courtyards. The effect is of a hierarchy of sealed spaces.

PARC has elements in common with academic facilities but is built to the standards of the modern corporation. So the offices, the (usually) windowless conference rooms, and corridors do not appear much different from those in, say, an insurance company (figure 4.1). Signifying both the practical differences and the social break between their realms, the floors in areas where "softer science" (such as linguistics, software, and anthropology) prevails are carpeted, but areas devoted to hard science (like physics) or hardware development have vinyl-tiled floors. In the few spaces devoted to support functions, like the air conditioning plant, the floors are bare concrete. All the floors are regularly cleaned, and in no part of the building are there stains that show wear or the detritus of work.

One distinguishing characteristic of each office is the number and kind of computers in it. The average researcher has at least two computers, and usually both are top-of-line workstations, often with multiple monitors. In contrast, the furniture that PARC provides to its staff is unremarkably similar

corporate furnishings supplied by the Facilities Management service of PARC.[1] As with the size of offices, the quantity and kind of furniture at PARC are determined by rank and function. Within the community of researchers, there is little variation. The standards-driven variation is more apparent when comparing the wood-grained Formica and painted metal of researchers' offices with the conservative dark oak of managers' offices. A few researchers break with the corporate aesthetic and personalize their space with rugs and comfy chairs.

What Happened When Artists Came to PARC?

PAIRCORE's first impulse was to create a single studio to house the artists, although it was concerned that a special studio space might stigmatize the artists and that a PAIR studio located in one end of the building might isolate artists from their researcher colleagues at the other. The real determinate was practical: it quickly became clear that the competition for office space and the expense of converting offices to studios would prevent PAIR from creating a permanent studio modeled on inexpensive loft space.[2] Because of PAIR's cross-organization structure, laboratories did not want to commit to permanently housing the enterprise but nonetheless agreed to give up the two offices needed to create such a studio. This also greatly relaxed the constraints on scheduling PAIR artist residencies since we would not be constrained to sequencing them through a studio.

So PAIR relied on the standard method of housing visitors to house the artists—putting them in an available office and giving them standard furniture and a standard computer. With one notable exception, the artists ended up using these standard spaces much in the same way as the researchers.

PAIR's initial image of artists and their needs was wrong — at least for the artists who were selected. The misconception was that the artists need special facilities not found in an office.

Although the artists come from a variety of circumstances, most had worked in nonstudio situations already: a few had academic positions, some had office day jobs, and most did art that involved sitting at computers or multimedia terminals. What is more important, the selection process favored computer-based projects and the offices at PARC were designed to support personal computing.[3] Thus, they had no functional need to alter the spaces. No clear explanation has been provided about why spaces were not

modified to distinguish them from researchers' offices, to explicitly express artistic production, or to mark them in very personal ways.

As PAIR artist Margaret Crane said:

> Why change the environment? Context is everything.
>
> I was interested in seeing how the culture and atmosphere of PARC interacted with the work that Jon [Winet, Crane's co-PAIR artist] and I were doing. And the physical site is obviously part of that atmosphere. Transforming the studio space was certainly an option, . . . but I think that both of us found that interjecting our ideas into the environment was more conceptually satisfying than manipulating the physical setting. We use office technology in our work anyway, . . . so finding ourselves in an officelike setting with lots of tools available was just fine with us.
>
> When I first arrived at PARC, the culture of technology was completely foreign to me, but it was fascinating, and I wanted to learn about it. Keeping the setting in its typical form was, for me, one of the keys to understanding the culture. At first, the artifacts of office culture and technology contributed as much to the narrative of my experience at PARC as the people did. Personalizing or altering the setting would have been like going to Europe and only eating at McDonald's.

Personalizing a Studio

There was, as I mentioned before, one exception to this nonpersonalizing of workspaces. John Muse and Jeanne Finley (paired with the anthropology team led by Lucy Suchman) were assigned a nondescript laboratory space located on a back hallway in the most remote of the pods. This space was windowless, carpeted, and substantially larger than a typical office.

They transformed the space into a studio, creating a well-defined place that was independent from the laboratory context and redefined it. They treated the corporate-standard walls, carpet, and furniture with some abandon—after first covering them with large sheets. Large images and collages were hung about the space, and images covered the walls. Lighting was enhanced and altered with photoflood and halogen sources. Because all these items were frequently moved, a ladder became a permanent part of the studio furnishings (figure 4.2).

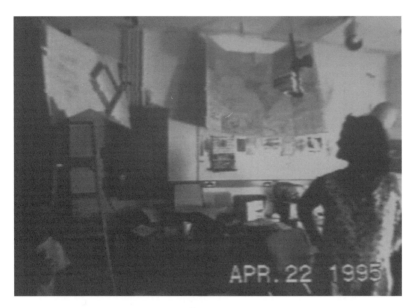

Figure 4.2
The workspace of John Muse and Jeanne Finley

In the adjacent hallway, the artists hung banner-like graphics (made by gluing together images enlarged on copiers) that invited play and beckoned people into their studio room. This was not a decorative act so much as a marking of territory—an announcement that something interesting was going on in the laboratory space. This studio became part of the regular tour of PARC given by the public relations staff and eventually came to stand for the entire PAIR program (figure 4.3).

Place is a social construction: in this case, place was what the occupants made of it. The artists often worked over ideas in long discussions with researchers in nearby conference rooms and not in the studio. The personalization of their space had its limits, too: when the artists' active tenure ended, the space reverted to standard office use, and the energy seeped out of the place.

The PAIR Studio

Eventually PAIR did acquire some equipment that came to be housed in a room used by PARC's many student interns as well as by PAIR.

A PowerMac for image processing and digital video editing was set up in the last cubicle of a space of temporary office spaces. Called "PAIR Palace,"

Figure 4.3
The hallway outside the workspace of John Muse and Jeanne Finley

"PAIR-a-site," and "PAIR-a-dice," this location was isolated from most of the researchers, from the offices assigned to PAIR artists, and from the nearest hallway. The rigidity and cool-blue hues of the systems furniture spoke volumes about the corporation's relation to the occupants of the space.

It was alternative only in the sense that it was the "other office": a number of projects heavily used the equipment at various times, and some of the artists came to use this computer workstation as a kind of de facto office after the official work pairings ended and their offices were reclaimed for other uses. While the succession of users could have modified the space, none did more than rearrange the equipment connected to the computer (figure 4.4). Little marked the work that went on in this location as different from work that was carried out in any other cubicle at PARC: it was *a* PAIR place but not *the* PAIR place.

Did the Space Matter?

Space didn't matter: but it could have been better. It is worth speculating on what might have happened if the the researchers and artists could have car-

Figure 4.4
The PAIR studio

ried out their projects in an identified PAIR studio. Would it have been used? Would the PAIR program have been more inclined to bring in artists who depend on studio spaces in which to work?

One thing that marked PAIR project was the degree to which they were more private and more personal—on the part of both researcher and artist—than standard research projects. Having projects carried out in a place that supported this private dialogue while allowing other PARC researchers enough of a glimpse to better frame their own understanding would have greatly aided the building of legitimacy for PAIR and its projects. From the temporary example created by Muse and Finley, such a space would also have generated good PR.

When the locus of work is a tool common to home and office—the computer—there are going to be similarities among the spaces that house that equipment. This is a central aspect of the ongoing blurring of form and place: offices look more like homes, and homes look more like offices. To what degree does the work one does with a computer define the space that it is in? As knowledge work becomes creative work, there will be a further blurring between studio and office. If PARC is prototyping the future, then

the creative space of tomorrow probably will look more like the office of to-day than the atelier or loft.

Notes

1. The only exception to this is a conference room that has bean-bag chairs that suggest a 1970s aesthetic of nerdy hippyness.
2. Creating cheap loft space turned out to be too expensive. It was also a confusion of the appearance of artistic experience with the spatial needs of the enterprise.
3. Most artists noticed first the overwhelming amount of equipment—and not the offices—and equipment continued to be the focus of their comments.

5

O Night Without Objects

Jeanne C. Finley
John Muse
with
Lucy Suchman
Jeanette Blomberg
Susan Newman
Randy Trigg

Figure 5.1
Images of John Muse and Jeanne Finley at work on site and studio

John Muse and Jeanne C. Finley have worked collaboratively since 1989. Our installations, single-channel videotapes, and book projects often utilize documentary elements and tactics, though usually in order to undermine their authority. The theoretical and practical problems of nonfiction compel us, as do the challenges that attend crossing the borders between reportage and fable, the evidentiary and the invented. With our work we attempt to submit these borders to the troubling forces of humor, rigor, and passion.

At Xerox Palo Alto Research Center we were paired with members of the Work Practice and Technology (WPT) area, a small group of anthropologists and computer scientists who study work and the practices by which workers take up technologies in creative and necessarily unpredictable ways. WPT also uses video, interviews, and observation in its research. We share not only technologies but also a concern for the ethical implications of using technology to create and distribute images, texts, and stories.

When we began our residency, we were in progress on an experimental documentary videotape. Entitled *Based on a Story,* this work examines the well-publicized encounter between Lincoln Nebraska's Ku Klux Klan Grand Dragon Larry Trapp and Jewish cantor, Michael Weisser. Trapp had harassed Weisser by telephone and mail and on cable television programs. And yet after a series of telephone conversations and meetings, Trapp renounced the Klan and eventually became close friends with Weisser. We were particularly interested in how media technologies were used to disseminate fear and yet also made possible Trapp's transformation.

We came to the PAIR program to explore how recent innovations in digital and Internet technologies might affect artists who work with nonfiction elements. With WPT members we decided that they would use their technologies and expertise to document our activities while we were working at PARC to produce our tapes. We became the objects of their observation so that we could mutually explore the relationship of video technologies to the documentary artist as both subject and object of the work.

Documentary theory and practice have always been linked to technological innovations. The crystal-synch camera facilitated cinéma vérité, and the Hi-8 video camera radically changed the aesthetics of documentary recording. By contrast, digital technologies seem to be having a minor impact on the act of recording but a huge one on how the images are edited, disseminated, and stored once captured. For inspiration we began to look for artists

who were using hypermedia and interactive strategies for documentary works. We searched the Web for such projects and found few. But the experience of the search taught us more than the projects: the data were overwhelming, the paths difficult to navigate, and the technologies obtrusive. Our passion for traditional narrative time and space was frustrated. We were not seduced by these materials because the very process of using the technologies upset the traditional pleasures of total immersion. It was impossible to become "lost" in this material as one can when simply reading text or watching film or video.

We aren't sure whether this is the good news or the bad news. Much avant-garde (but by now mainstream) documentary theory calls for the documentarian to explicitly critique the rhetoric of objectivity by breaking with the seamlessness of traditional storytelling. Disrupting narrative continuity and calling attention to the "hand of the maker" was to reveal the fiction and constructedness of ostensibly nonfiction works. Such disruptions allow artists and audiences to examine the power relations between documentarian and subject. These techniques also sought to problematize spectators' desire for the truth. However, we realized that the new technologies with which we were working continually broke continuity through a more ubiquitous and even "natural" disruption: the distractions of Internet navigation and hypertextuality seem to have foreclosed some possibilities of rupture by hyperbolizing them.

At PARC we shifted from linear to digital editing systems but also set aside the desire for a radical break with our prior commitments to traditional forms and distribution networks: we would make a single-channel videotape and turn our attention to WPT's attempt to document us. But we began to think more thematically about the problem of continuity, discontinuity, and narration and determined that continued work on *Based on a Story* would give us the opportunity to address these issues. Our interest in the story shifted from how media technologies disseminate fear to the phenomenon of conversion experiences. Conversion poses the problem of continuity and disruption. Generally understood to be a radical break with the past, conversion is never absolute and depends for its power on the past that it seeks to leave behind. As we worked, Jeanne recalled her own childhood conversion to Christianity at a Baptist camp where the instrument of conversion was an extremely low-tech, low-voltage electric chair. The chair was both seductive

and terrifying and played on the imagination of this twelve-year-old girl, motivating her conversion.

We developed this story, which we called *Time Bomb,* into a tape and subsequently decided to incorporate *Based on a Story* and the latter into a trilogy in which we could explore continuity and disruption through several instances of conversion. The trilogy, entitled *O Night Without Objects,* combines an autobiographical narrative (*Time Bomb*), a documentary (*Based on a Story*), and a performance-driven work that stages the administration of a psychological test to a young girl (*The Adventures of Blacky*). In each of the three components, narratives cohere and seduce according to traditional schema, and yet these individual works should simultaneously break continuity through their correspondences and intertextuality.

What follows in this chapter is the most materially accessible artifact of our mutual collaboration: there are scripts of the first two sections of *O Night Without Objects,* records of a dialogue that took place between ourselves and WPT as we worked together, images from these pieces, and a WPT analysis of a few of our production artifacts.

> O night without objects. O obtuse window outward, o carefully closed doors; arrangements from long ago, taken over, accredited, never quite understood. O stillness in the staircase, stillness from adjoining rooms, stillness high up against the ceiling. O mother: o you only one, who shut out all this stillness, long ago in childhood. Who take it upon yourself, saying: Don't be afraid, it is I. Who has the courage all in the night yourself to be this stillness for that which is afraid and perishing with fear.
> —RAINER MARIA RILKE, *The Notebooks of Malte Laurids Brigge*

Part 1: Time Bomb

On June 18, 1995, the San Francisco Cinematheque screened Jeanne C. Finley's *Conversations across the Bosphorus* and premiered Finley and John Muse's *Time Bomb,* the first installment of *O Night Without Objects,* a three-part work being completed during their residency at Xerox PARC. A presentation by

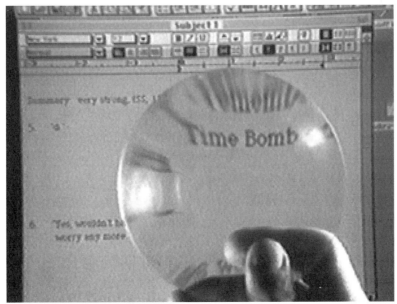

Figure 5.2
Lens, from *Time Bomb,* 1998

Figure 5.3
Lens with words, from *Time Bomb,* 1998

O Night Without Objects

Figure 5.4
Chair seat and chair on stage from behind, from *Time Bomb,* 1998

Jeanne C. Finley and John Muse et al.

Lucy Suchman of Xerox PARC's Work Practice and Technology Area on Finley and Muse's activities as artists in residence followed *Time Bomb.*

Below is the voice-over script to *Time Bomb.* The citation from Rilke scrolls at the head of the tape immediately following the *O Night Without Objects* title sequence.

Time Bomb

But to me she would suddenly turn (for I was already a little bit grown-up) and say, with a smile that cost her a severe effort, "What a lot of needles there are, Malte, and how they lie about everywhere, and when you think how easily they fall out...." She tried to say this playfully; but terror shook her at the thought of all the insecurely fastened needles that might at any instant, anywhere, fall into something.

—RAINER MARIA RILKE, *The Notebook of Malte Laurids Brigge*

When I was seven years old our next-door neighbors invited me to join their daughter at a mountain Baptist camp over Christmas vacation. They were a quiet family and seemed concerned for my welfare. I enthusiastically accepted the invitation, and camp proved to be great fun. I slept in a cabin with other girls my age, and my friend's parents were leaders of many activities new to me such as hiking, bobsledding, and skating.

Since I was a camper without my own family, each dinner I was assigned to a different family table. After the meal we would walk through the snow to the big cabin for evening festivities. There the entire camp participated in rowdy clapping and singing in praise of the Lord. Every night, a solo gospel singer, in the deepest and most beautiful voice I have ever heard, electrified the air. His songs were about the tranquillity and peace of paradise. Then one of the camp leaders would speak about the fires of hell, with specific details about the pain of burning flesh for those who did not accept Jesus as their savior. Following this, there was an empty silence and prayer.

Then the games began. There were many games, but the only one I can remember is Time Bomb. I was exceedingly shy and terrified of electricity. Time Bomb energized the crowd. The rules were quite simple and relied purely on chance. A round, black, lacquered ball—just smaller than a bowling ball and a bit lighter—was passed as quickly as possible from person to person down one row and back to the next. The bomb was battery-powered, and at an un-

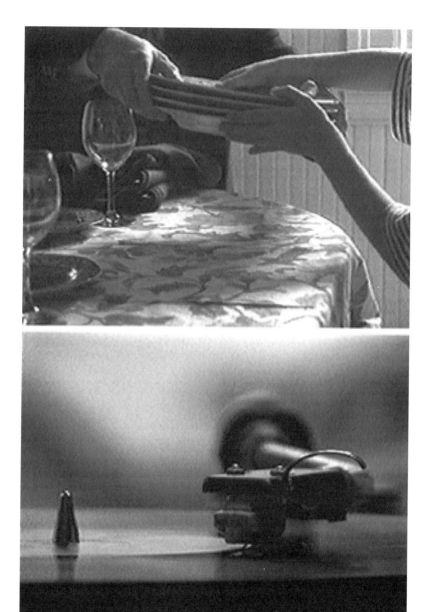

Figure 5.5
Passing plates and record player, from *Time Bomb,* 1998

predictable moment it would go off by making a loud buzzing noise. If you were caught with the bomb in your hands when it went off, you had to go up on stage. After five or six losers, as they were called, had been gathered, each and every one of them in turn would be forced to sit in the electric chair.

The electric chair was a straight-backed wooden chair rigged with wires that led to an electrical socket and to a control pad held by the man who had spoken of the pain and anguish of hell. One by one the losers would be led to the chair, sat down, and administered their shock. A few resisted vocally and physically up to a point, but they were led firmly to the chair by the leaders of the group to the hilarity of most of those sitting in the audience.

Following game time there was another prayer that concluded with the reminder that anyone who hadn't yet taken God into their heart could do so now. During an expectant silence, some would pray to God, asking to become a part of his kingdom. Those who made the agreement with Him would stand to show they had accepted the Lord Jesus into their lives. As we each stood, singing, blessings and congratulations rang out from all sides.

———

The "Notes for June 18, 1995" by Blomberg, Suchman, and Trigg reproduced in the left-hand column below were presented by Suchman to the SF Cinémathèque audience directly following *Time Bomb*. In the right-hand column are Muse and Finley's subsequent interventions, the "Notes on 'Notes for June 18, 1995,'" which take the form of questions, comments, irreverences, and irrelevancies. The center column offers a response in kind by Suchman, along with WPT members Blomberg, Trigg, and Newman to Muse and Finley's "Notes on 'Notes.'" With such a structure we hope to put our PAIR relationship itself into allegorical form, a palimpsest that holds the trace of our encounters, our difficulties, our pleasures.

Figure 5.6
Aya with hands clapping and Aya with hands cupped, from *Time Bomb,* 1998

Notes for June 18, 1995
SF Cinémathèque
Jeanette Blomberg, Lucy Suchman, and
Randy Trigg

Notes on "Notes for June 18, 1995"
Jeanne C. Finley and John Muse

Response to "Notes on 'Notes'."
Lucy Suchman, Jeanette Blomberg, Randy Trigg,
and Susan Newman

Like Jeanne and John's screening, ours is a work in
progress.

The first word, "like," errs on the side of our affinities
without implying identical pursuits—i.e., like but not
the same. This word prepares the ground for future dis-
tinctions and irreconcilables. The pronoun "ours" in
"ours is a work in progress" stands in for the phrase
"our screening." Is not the word "screening" from our
territory?

Certainly this is an ambiguity, perhaps even an ap-
propriation. We meant *ours* to carry the reader for-
ward, toward "work in progress," invoking the
open horizon of our ongoing work as well as the
evening's presentation. We didn't actually think of
the latter as a screening, given that the word
screening is from your territory. But on this partic-
ular evening we were in your territory, attempting
to fit in but not to pass; to be recognizably compe-
tent and interesting while at the same time being
different. We aimed both at making sense within
the setting of the Cinémathèque and at manifesting
our distinctive relation to your work and to *Time*
Bomb.

Moreover, it's assembled,

The "like," your first word, and the "moreover" from
this last sentence don't yet account for the (b)ordering op-
erations of our disciplines. Our practices, the uses to
which our artifacts are put, and the communities to

which we each must answer are proximal but still at a distance.

The experience of this distance calls for evidence and testimony. Some of us answer to artist, *some to* anthropologist, *some to* computer scientist, *some to* writer, *some to* scientist, *etc. Your screening and ours were contiguous, but neither of the same order nor even in a fully obvious relation to one another. Your presentation wouldn't be recognizable as art criticism nor as itself a work of art. Nonetheless, it could reconfigure the task for the critic: not "is it beautiful?," not "how and for whom is it beautiful?," not "what effects does it produce?," but "what disappears? what falls away into a kind of artifactual unconscious? what gets to count as the matter of art? how are the abandoned parcels, words, times still somehow at work in the work?" This last question seems the most pressing and as yet barely touched on. So neither evaluative, nor merely descriptive, your discourse salvages things, moments, movements, accidents, ephemera, and "errors" that seem to count for nothing in the artifacts themselves, and yet are the secret situation of things.*

Yes, at least that's our aspiration.

Is there in your work a connoisseurship of the marginal, a taste for the derelict occurrence? How does your taste compare with ours? Is it even a question of taste?

Not so much of the marginal as the circumstantial, taken-for-granted, unremarkable that, as you say, disappears in work's products. As for *taste,* that's a word from your territory, a term we've never used in relation to our own work. In using it you urge us to reflect on, to become more aware of and articulate about, our own aesthetics. It's in these "crossings" that we feel the value of our collaboration.

according to our usual practice, as a collection of video sequences designed to be talked around rather than shown from start to finish.

So we'll be setting up each sequence with some comments on why we're showing it to you, the issues that it raises for us.

In general, in our collaboration

We're less and less certain that this word "collaboration" is adequate to the relationships and situations that PAIR has facilitated. Not only could we ask how our collaboration has affected each of our works, we could also ask how our contacts and crossings have changed our concept of collaboration. Did our collaboration happen according to scripts previously known or unknown? To what extent did we fail to greet one another across the divide of our positions, practices, concerns, passions, stipends? To what extent did you overestimate our irreverence, our subversions, the richness and importance of our being artists, the weighty mystery of our decisions? To what extent did we fail specifically to address in our work the areas of your expertise and day-to-day commitments?

A moment of shared guilt/anxiety here, as we think of what we might have done with you, absent competing and more forcefully presented demands to prove our business value to Xerox. Some envy of the different zones in which your productions circulate and their different purposes. And some regret for what else we could learn from you, if we had made the time for it.

Unfortunately, we left you to account for collaboration effects, for the ways in which we crossed and double-crossed each other, for telling the story of our times, places, and contacts.

Our double-crossings at least were done respectfully, affectionately. Sustained collaboration requires more dedicated times and energies, perhaps more courage, than we were able to assemble.

with John and Jeanne we're interested in the relation between their practices as artists, particu-

larly their use of video in the creation of visual images, and our own practices as researchers.

In what ways are artists like researchers? In what ways are researchers like artists? Do the terms "artist" and "researcher" help or hinder? Were we proposing that researchers become artists? Was this ever a serious possibility? Was there not a narcissistic benefit to being taken by WPT to be exemplary image makers? Was there not a narcissistic benefit to proving that artists are so at home in the grammars and rhetorics of the image that we escape their effects or can master them?

These questions of likeness are the stuff that could have made up, been manifest in, a sustained collaboration. Some preliminary thoughts: that your art involves you in forms of research (drawing as you do on documentary and literary resources), that our research relies on forms of artfulness (in the framing of images, selection of settings and occasions, attempts to make compelling narratives out of fragments of mundane talk and activity). We tried not to turn you into icons, representatives of the class artist, while at the same time looking for what you could teach us about such practices. This is a recurring problem for our work—finding the general in the specific, generalizing without stereotyping.

This includes exploring a set of concerns that have been around in ethnography and ethnographic film since the 1970s, summarized by the notion of returning the gaze. This phrase refers to the sense in which the anthropologist increasingly is called to account not only for the other but for herself as part of the ethnographic encounter. This repositioning is resonant with developments in filmmaking during the same period, and it's part of the ground we share with John and Jeanne.

The 1970s: our arrival at and work for PAIR was both an occasion for recalling what was encountered but left behind, a shared ground perhaps, but also a cemetery of sorts: we share, we mourn. We remain curious about the stability of this shared ground, about the footing it provides for and against our respective domains. We have always tried to produce works that allegorized their conditions of production, works built with meta-narrative movements, highly reflexive structures, allegorical thicknesses, and unresolvable conflicts; all by now fairly conventional strategies. And although one tires of problematizing the maker's right to the word, image, voice, etc., do you find yourselves ready, willing, or able to live up to the imperatives of this repositioning while employed by Xerox Corporation?

A site of conflict for us, no question. How can we simultaneously develop the reflexivity of our practice, with all the experiments that requires, while still being seen as competent within the traditional frames of our own workplace, which demands that we "speak with authority," where science rules and where, as anthropologists, we're already of somewhat dubious scientific status?

In this particular collaboration, though, the phrase "returning the gaze" has opened up for us a new range of meanings having to do with questions of who's creating images, for what readings or uses, by whom.

Can we be specific about the genealogy of "returning the gaze"? Such a notion implicates many too many proper names and theorizations. To quickly lay out some alternatives: "returning the gaze" could imply a posttheft work of restitution, or a duel, or even a discarding of the scopic itself: a turning, or returning, away from visuality as the privileged domain of occurrence, sense, evidence, etc. So either someone or something had the gaze on their side and has returned it, possibly to its rightful

owner or proper place. Or someone looks back, with or without permission, at the one who had previously wielded the gaze as an instrument of domination and in doing so destabilizes permission itself. Or scopophilia itself is put into crisis, and ambivalence wanders onto the set. The latter was our concern during the production of Time Bomb. *Visually the piece proceeds through a sequence of tropes that figure the work of memory, the "light" of memory, as simultaneously revelatory and obscuring, constructive and destructive.*

For us the phrase "returning the gaze" raises central questions of audiences and purposes in our different uses of video: questions invoked but not yet taken up directly in our own productions. We conceive of ourselves still as speaking to engineers and scientists (or within the discursive regime of science) about how things really are. We are still engaged in providing evidence for foundational qualities of social life, working life, life with artifacts, etc. Science and reliable witnessing are linked, however we may perturb the relation. And these demonstrations are our primary warrant for demands for technological change, changes in design practice, within Xerox.

We think this has to do at least in part with the fact that we use the same technologies—video cameras—in our work

Can two technologies ever be the same, especially when the ensemble of technologies and practices within which these same technologies are located are disparate? The questions "who's creating images, for what readings or uses, by whom?" can't be external to the question of what something is. We each put a video camera to work—but what the camera is is constituted through the contingencies and particularities of use. A fine point, yes, but important because the phrase "same technology"

carries forward a claim of sameness and undermines the
likeness between our activities.

This fine point is the heart of our work: the irre-
ducible contextuality of technologies as prac-ticed.
Your point regarding likeness is one we have tried
hard to make with respect to, e.g., photocopiers,
documents, computer artifacts. The particulari-
ties in the case of our collaboration with you have
to do with what it means to study a work practice
and its technologies where the technologies in-
clude, centrally, a camera—a fact that makes our
own camera-in-use more visible to us, less a matter
of mere recording.

and that this has all sorts of interesting conse-
quences. What we're presenting tonight is aimed
at trying to give you a sense of that.

And thus any expectation that you would directly ad-
dress Time Bomb *or the larger project* O Night
Without Objects *was abandoned. And so your atten-*
tion, the turning and returning gaze, treated the spec-
tacles of design or the moves, procedures, and accidents
that destined the artwork, Time Bomb. *If we hun-*
gered for a word, it's only because we didn't take your
caution or your particular passions seriously.

We're reluctant to take up the stance of art critic,
feeling ourselves intimidated, unprepared, unqual-
ified. Our responses to the works themselves are
unarticulated ones for which, if we have words at
all, the words seem unprofessional and inappropri-
ate for public presentation.

At the same time, we think there is something
other than art criticism to be done that would
nonetheless focus carefully on the artifact, the rep-
resentations of events, settings, actors, that the
video accomplishes—specifically, an enlightening
confrontation between our strategies and yours.
Takes time, of course.

We're going to start with a bit from John and Jeanne's studio space at Xerox PARC. As is our usual practice, we've left a camera in their workspace and asked them to turn it on for us while they're working. What's happened, though, is that they've not only turned it on for us but appropriated it to make particular images for and of themselves, partly as an additional resource for their work, partly as a distraction.

We're interested in precisely how you understand the spectacles to be both a resource and a distraction. In particular: What is distraction? What is it good for? For whom were the spectacles primarily a distraction?

We thought we took the term "distraction" from you, believing you to mean it in the positive sense of a break, a play time.

Yet your reading here points as well to the problematic presence at PARC of what might at first be misrecognized as distraction—the haunting worry that the PAIR collaboration is a distraction, in the most alarming sense, from the urgent concerns of the company, a kind of fiddling while Rome burns.

In the process their workspace has become in part a performance space.

Within our performance space we imagined even more elaborate productions and more visible interventions at the worksite and beyond: an area to stage a return of the repressed within the confines of a corporate culture: as we could ever live up to such a project. As if it would have made any difference. But what kind of difference would we have wanted to make? Should we have decided on the latter prior to making trouble? Or does the need for decision function only as stall?

But mostly we were acting out in hopes of provoking a reading, a response. The framings we would impose— the monologues, complaints, the proscenia and transparencies placed before the camera—were to produce

Jeanne C. Finley and John Muse et al.

shock, laughter, and were to solicit further enframings from your side. We did and didn't want to be subjected to analysis. We did and didn't want to be called to account for what we were doing, asked questions. We work and work hoping that the work outstrips our accounts—to speak about one's work is always some kind of betrayal.

And we did respond, loving your provocations, taking them partly as ventriloqutions of our own malaise, partly as a form of engagement with us that we've missed in our work with other subjects, busy conspiring to ignore us in service of creating a naturalistic record of their work.

In this short sequence, Jeanne is reading John a passage from Rilke that you'll all recognize as a text that later found its way into *Time Bomb*.

I mentioned that in the 1970s there began to be some changes in the practice of anthropological filmmaking. This next image is nicely illustrative of that.

Figure 5.7
Jeanne Finley and John Muse, reading Rilke, WPT video, 1995

Figure 5.8
Future direction of innovation. Reproduced by permission of the American Anthropological Association, from *American Anthropologist* 97:2, June 1995. Not for further reproduction.

The caption of this image (taken by us from the *American Anthropologist* of June 1995) reads "Future direction of innovation. Hortensia Caballero, trained by Timothy Asch in video editing, now instructing Yanomamis in filmmaking themselves." Our practice of handing over a camera to our subjects with the request that they make their own films for us is reminiscent of this innovation. It's complicated in the case of John and Jeanne, however, by the fact that the equipment is already an integral, indigenous part of their working practice. Moreover, they're significantly more sophisticated with respect to filmmaking than we are: in part, our collaboration is about them teaching us new strategies of documentary video production.

In the days of our first encounters we chose to critique your ethnographic video, Workplace Project, *according to the way it unconsciously repeated errors it otherwise explicitly condemned.*

The term "error" isn't a term that we would use, at least insofar as it implies a correct practice: it's more a question of what's assumed in traditional representations of work, that we ourselves have unwittingly reproduced while trying to overthrow, for example, the assumption that operations proceed in an orderly way because they are designed to do so, rather than through the ongoing order-producing activities of organization members. But what we see as a result of your interventions is that, while asserting the contingent and local logics of situated work practices, our video failed to show them as such. Instead, we rendered the work as heavily analyzed sequences, easily recognizable even by an unfamiliar observer, thanks to our tidy narrations.

> *Subsequently, experimental films, documentaries, narrative features, and ethnographies were brought to PARC so as to share with WPT works that manifestly thematized their conditions of production, works that did what they said, that questioned the presumption that the spectator ever masters or is fully mastered by the spectacle.*

We found these viewings extremely provocative, challenging our own video production strategies, opening up new directions for experimentation. And then later we bemoaned our inability, unwillingness, to follow through on these new possibilities, knowing the expectations of our audiences.

So who, in this case, are the Yanomamo?

> *Who, indeed?*
>
> *Rewind: our proposed collaboration with you shuttled through a few options but settled rather quickly on the idea that we would position ourselves as the objects of WPT's usual observational practices and inscriptions. At the same time we would intervene in the modes by which we were called on to become objects, never underwriting the notion that a recording apparatus is*

ever unobtrusive or passive. We hoped in turn to produce works that explicitly revealed these conditions of production. Thus, several reflexive circuits were built into the relationship so as to perturb standard operating procedures. For example—and this very text is such an example as well—we kept a scrapbook journal during our residency and made it available to WPT via the internal PARCweb. You subsequently wrote short commentaries cataloging each of the pages. We, in turn, printed out your commentaries, cut them out, and incorporated them into the journal. The online version was then updated to account for the changes.

F & FV Video Log
95.04.01-02, C13
J & J at work,
logged by L. Suchman

Time code	Comments	Issues/Quality	Stills
	Opens with visit from John Winet and Margaret Crane. Brief discussion about how it's our camera that's running, after which laughs and glances are exchanged, and J and M announce that they have to go work. But talk continues, including about arguments for and against Freud and his charged cover up of the abuse of his hysterical patients.	Opening hugs are for the camera. JM: "You were even almost in frame!"	
00:08:48:19	J&J comment apologetically on the lack of technology-relevance of their project, and my comment that "work practice is a technology." JM: "We are a technology."		
00:13:53:21	J and M leave. JM: "Speeding through our heavy workload for the day."		
00:15:37:00	JM hangs conscience dog Blackie transparency in front of camera.		
00:16:50:12	JM sits down on floor and starts to cut. Brief discussion about whether they're "burning tape" or doing something interesting. Jeanne describes a story, then looks for it in book (?) that JM produces for her.		
00:19:26:25	JF finds story. Reads it aloud for JM. Dogs, needles. Here's the quote about needles from image 13 of J&J's journal.		
00:22:26:07	JM asks what time it is. JF: "Oh shit, 5:14? I'm not going to finish this tonight."		
00:23:55:01	JM back from spraying ? JM: Vicky says I throw everything around. Is that true? JF: She's right.		
00:25:10:12	JF: We don't know how to wrap this thing up, you know? JM: Mm hm. JF: It's like so fucking what towards the end. JM: The most compelling thing to me the last time I went through the transcripts, which was a couple of days ago, is all the ways the word "family" gets used. Um, with qualifiers, like sur– not surrogate, what's the word that Julie uses. Replacement family. Right. That kind of stuff was really interesting to me, just to track those moments. But that's not narrative, I don't know how to tell you, like ... JF: Well, it's getting kind of non-narrative. JM: That's good.	Given the frame, it's hard not to see the conscience dog and Blackie in relation to Jeanne on the left, John on the right, though the latter are looking away from each other, absorbed in their respective tasks...	

Figure 5.9
A page from the WPT video log, 1995

Jeanne C. Finley and John Muse et al.

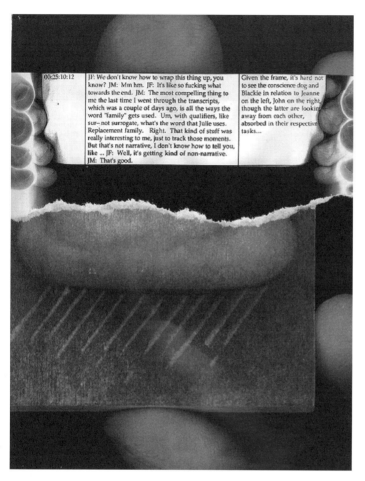

Inside the image:

00:25:10:12 | JF: We don't know how to wrap this thing up, you know? JM: Mm hm. JF: It's like so fucking what towards the end. JM: The most compelling thing to me the last time I went through the transcripts, which was a couple of days ago, is all the ways the word "family" gets used. Um, with qualifiers, like sur– not surrogate, what's the word that Julie uses. Replacement family. Right. That kind of stuff was really interesting to me, just to track those moments. But that's not narrative, I don't know how to tell you, like ... JF: Well, it's getting kind of non-narrative. JM: That's good.

Given the frame, it's hard not to see the conscience dog and Blackie in relation to Jeanne on the left, John on the right, though the latter are looking away from each other, absorbed in their respective tasks....

Figure 5.10
Log reused in John's journal, 1995

Having our descriptions read by those whose activity we were studying was already a stretch. More than that, we were concerned that casual descriptions of your journal pages in our logs were finding their way into subsequent layers of that very journal. It helped that you chose to put the descriptions on different pages than the ones we were describing. That made it seem as though our words were being taken up as materials in an artistic endeavor,

rather than calling into question the accuracy of our descriptions.

You also appropriated our video logs, which we were taken aback to see clipped and transported into new contexts. Yet isn't this a case of turnabout being fair play? Did you think that our clips took bits of your activity out of context? Is such ripping off of activity records, such moves of "bringing home the Other," common to both of our practices? Is this what you expected when deciding to work with us? Are you disappointed that we didn't do even more?

As objects we desperately wanted to be interesting, worth saving, worth preserving, worth collecting, worth teaching, worth reading. But we were exotic not only because of our apparent foreignness. We were exotic because unlike many of your colleagues we listened to you and shared with you traditions, suspicions, a particular criticality, and so on. Your position within the apparatus of PARC is as readily describable and strange as ours.

And we're further worried that the Yanomamo are working in this text at all, brought along for rhetorical purposes, even productive ones.

Point well taken. What does it mean to identify images of specific persons as tokens of a class? What does it mean to be the artists, or the anthropologists at PARC? And how do we reproduce these tokenizations when we use the Yanomamo as tokens of the Other, however ironically?

To give you a sense of how the subject as filmmaker has worked for us in the past, we'll play two short sequences taken from a collection made for us by a lawyer whose work we were studying. We were especially interested in just how he used a particular filing cabinet in his office.

Figure 5.11
Mark at the filing cabinet, WPT video, 1995

As Mark ironically but tellingly says, the
video in this case was for us another data point.
While in fact we approach such materials not as
data to be processed but as images to be inter-
preted, we are treating the camera as a kind of pas-
sive device aimed at unobtrusively recording
Mark's working practices.

*Please elaborate on the reading of the above sequence.
What does it deliver directly that we either deliver more
indirectly or refuse to deliver at all?*

*Also: could you more fully articulate the distinction
between data processing and image interpretation? Are
you saying that Mark's irony tells the truth of his rela-
tion, not only to his work but to the camera that he
wields against himself, to you, to his employers who you
do and don't stand in for?*

Mark's irony turns the camera back on us, simulta-
neously playing with but also acknowledging the
scientific premises of our engagement with him as

subject/object. His remark underscores the ambivalence of the camera in his office, operating both as recording device and as a communications medium. The camera's ambivalence mirrors our own, as we are caught between a position that takes images like those he creates for us as bits of story-telling, of moments to be heard using all of the cultural resources available to us, and as evidence that speaks for itself leaving us un-implicated. As you suggest, there are other equivocations here as well—of time and motion studies, surveillance. These seem less at play in Mark's case, given the power of his profession, but are always present when cameras are in the workplace. A challenge that we face in our research is to distinguish ourselves from the management consultants, the marketeers, the efficiency experts. Instead we position ourselves as researchers, a title that affiliates us with science rather than management or marketing and serves to legitimize a project of understanding rather than re-engineering or sales. Art does not seem to be an option.

And this stands in sharp contrast, as I said, to John and Jeanne's appropriations of our camera as a resource of their own.

In the next sequence as in the first we showed they've created a kind of proscenium, in this case to stage a scene expressing some aspects of their experience of working at PARC, specifically their feelings of anxiety about the technological imperative that pervades that setting.

There are at least two dimensions to this technological imperative: on the one hand, we presumed ourselves late-comers to digital media, feigning disinterest, critical distance, and ignorance, while moving among our more wired peers with acute cases of bad conscience. On the

other hand, we wanted to be taught, led to the sandbox, and shown how to make it all work.

And unlike other workers with whom you've occupied yourself, we could only mime certain anxieties: we don't necessarily fear being replaced by technologies and aren't fragilized by the automation fantasies driving most technology design. Well, sometimes: being replaced happens piecemeal, organ by organ, territory by territory, prosthesis by prosthesis. The cyborgs that we already are, that we always already were—these creatures distributed across languages, technical media, socialities—have never been at home, whole, in one body at a time. So we're anxious—but not for the sake of threatened homelands.

We often worry that our participation in technology development can only be read as a search for greater time savings, replacing human labor with ever more sophisticated machines, even enlisting workers themselves in the enterprise.

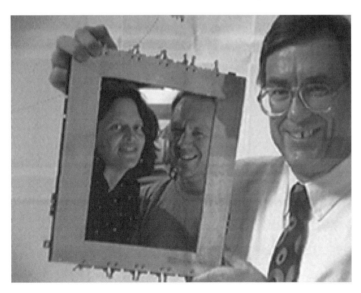

Figure 5.12
John and Jeanne seen through one of their proscenia, WPT video, 1995

Figure 5.13
John pauses after shooting to ask Lucy, "Any questions?," WPT video, 1995

> For us as researchers, fears of being replaced
> take the form of a forced transformation from re-
> searcher to entrepreneur, a transformation hap-
> pening, as you say, piecemeal.

To appreciate this sequence, you should know
that one of PARC's claims to fame is the invention
of an extremely high-resolution computer dis-
play, celebrated in a recent annual report as being
"as good as paper."

This last sequence was recorded with our cam-
era but seen by us only after the fact, as we re-
viewed the tape. Our usual practice, as I men-
tioned, is just to let our camera roll, as John and
Jeanne have said, "incessantly." And in general,
our camera is rolling wherever it is that the work
in which we're interested is happening. In the
next two sequences our camera is rolling as John
and Jeanne work on location in my office at PARC
shooting a sequence for *Time Bomb.* You'll see that
in this case I'm behind our camera, but still it's

Figure 5.14
"Okay guys, here's the shot," WPT video, 1995

positioned to operate as a kind of unobtrusive observation device. Again this stands in contrast with the painstaking camera work that John and Jeanne are engaged in.

The reason we let our camera roll is that we're interested in relations between John and Jeanne's ongoing work and the artifacts that result from it, including how much of their work "disappears" in the resulting artifact. But of course John's question to me—"Any questions?"—anticipates that the meanings of their work cannot be read off unproblematically from the images that our camera creates. Moreover, the accounts they might provide us at any given moment about what they're doing are as dynamic and equivocal as the activities they narrate. That's one of the paradoxes of our practice.

Can meanings ever be "read off unproblematically"?

No, never.

I assume "Any questions?" only anticipates a general dilemma, a general paradox, a general equivocality that attends all readings, all testimony.

As it does, but an equivocality still without acknowledgment within the scientific territories we inhabit.

The final three sequences, which we'll play without interruption, again are taken from an occasion of John and Jeanne at work shooting on location for *Time Bomb*. Again, the view you'll see is through our camera, positioned as usual so as to be as close to the action as possible without getting in the way. At the moment we enter the action here our camera has been swung around momentarily to record the scene that John and Jeanne are currently shooting. Walking by our camera, which has a small monitor on top of it, Jeanne notices and admires our view and calls John and Jim Meek, their cameraperson, over to see it.

In the second sequence, John and Jeanne ask us to move our camera out of the way, so that they can recreate the same shot with their camera. Finally in the third sequence, having been unable to find the shot they're looking for, Jeanne comes and asks again to find the scene through our camera.

When you "swung around momentarily to record the scene," something strange happened: the recording of our ongoing activity, of our preparations, our work on and with the camera was for you insufficient. You swung around to approximate our view because the latter was the artifact we were establishing, the thing-to-be-looked-at. You did so as if you were performing in our place, taking our place, constructing an image "like" ours, with a camera "like" ours. Whereas in other situations you move to take in workers' views of the action, never have you turned to take in such a view that was it-

self being established precisely for framing by a camera. Our respective positions became substitutable—and the "actual" substitution, our appropriation of your camera, made this explicit.

Our camera is often turned not on workers but on the objects of their work—documents, whiteboards, drawings. We're always struggling for some approximation of what the world looks like from their points of view, their experiences, their concerns, their time frames. We bring the camera in when talk requires its objects in order to be intelligible, at the same time that objects require being talked about in order to be understood. This instance is unique for us insofar as not only did our camera record what you were doing with your work's object, but our own camera work mimicked how you were doing it.

As I mentioned, we believe that the fact that our work and John and Jeanne's share technologies has led to some interesting mutual appropriations of equipment and images—appropriations that don't occur for us in settings where the technologies in use by others are different, and the camera is clearly ours.

The lesson may be even more fundamental: the camera was never and is never clearly yours. It is always taken up and appropriated even if the mode of appropriation appears to be mere passivity. The camera always stages some spec-tacle, some image, some relation of the framer and the framed.

These boundary crossings have challenged even further our relations as researchers and subjects. So, for example, we've asked ourselves what might be the outcome of our work with John and Jeanne. Are we likely to produce some kind of analysis of their practice, as we have in previous work studies that we've done?

We think not.

*Admittedly, we do carry some slight sense of disappoint-
ment. We would like to have been delivered over to rigorous
analysis, not because we want an upgrade or because we be-
lieve in a manifest truth of creative labor—as if the latter
were clearly distinguishable from any other activity.*

At the outset we imagined doing this more naively
than we would now, something closer to a variation
on our previous practices, attempting to do some
kind of justice to the character of your work. Were
we to do it now, our analysis would be meant more
as a shared provocative object, a site for further
collaboration. But now our reluctance is due more
to your status (or lack of it) as prospective cus-
tomers, turning on questions such as: How could we
position artists as a market in which Xerox might
have an interest, or how could we generalize your
work to make it recognizably relevant? Which
product division would sponsor such work? How
can we possibly justify it otherwise or manage to fit
it in along with the projects that we have promised
to deliver?

More likely, we'll assemble our own set of images,
partly created by us, partly by John and Jeanne,
sometimes with our camera sometimes with theirs.
Having given up the notion that what distin-
guishes us are the different roles of authors and sub-
jects, scientists and artists, we're left with the much
more interesting problem of how to elaborate in
other terms the samenesses and differences among
us. That for us has become the collaborative project.

*We hope that this text, by enacting our hybridity, will
be the occasion for further coelaborations.*

Part 2: Based on a Story

Below are two texts—a script for a documentary videotape entitled *Based on a Story* and a reading of a few of its production artifacts by WPT. The former is the second installment of *O Night Without Objects*. The events related in *Based on a Story* occurred over the course of a year and involve Grand Dragon of the Ku Klux Klan Larry Trapp, Cantor Michael Weisser, his wife Julie, their children David Weisser and Rebecca Nelms, hospice

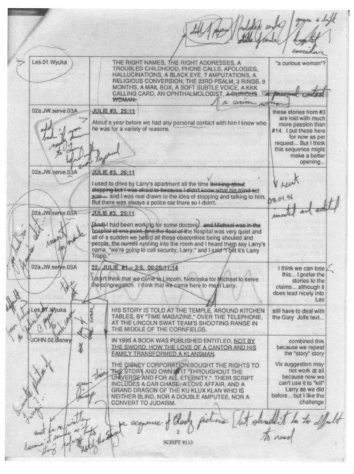

Figure 5.15
Page 2 of Script #113 for *Based on a Story*, 1996

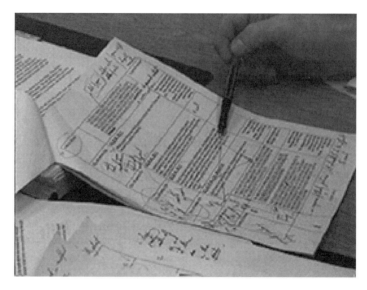

Figure 5.16
John explaining Script #113, WPT video, 1996

nurse Jan Branting, and temple congregation member Eva Sartori. The middle column is the voice-over script.

So here and there on my coverlet lie lost things out of my childhood and are as new. All forgotten fears are there again.

The fear that a small, woolen thread that sticks out of the hem of my blanket may be hard, hard and sharp like a steel needle; the fear that this crumb of bread now falling from my bed may arrive glassy and shattered on the floor; the fear that some number may begin to grow in my brain until there is no more room for it inside me; the fear that I may betray myself and tell all that I dread.

I asked for my childhood and it has come back, and I feel that it is just as difficult as it was before, and that it has been useless to grow older.

—RAINER MARIA RILKE, *The Notebooks of Malte Laurids Brigge*

Based on a Story

Julie Weisser: I mean, I hate to use the word *phony*, but it almost is the word that strikes me because you know Larry was the Grand Dragon of the state, yet it was a very small group of people who were actively involved in his group. You know, he had a bodyguard, and he had a few members. But who Larry was when he was the Grand Dragon was more or less in his head.

On September 6, 1992, a man dies. Several days later he is buried on Mt. Lebanon, the Jewish section of the Wyuka cemetery in Lincoln, Nebraska.

There's evidence. The right names, the right addresses, a troubled childhood, phone calls, apologies, hallucinations, a black eye, seven amputations, a religious conversion, the Twenty-third Psalm, three rings, nine months, a mail box, a soft subtle voice, a KKK calling card, an ophthalmologist, a curious woman.

Julie: I was really drawn to Larry before anything ever happened because about a year before we had any personal contact with him, I knew who he was for a variety of reasons. I used to drive by Larry's apartment all the time, and I was real drawn to the idea of stopping and talking to him. But there was always a police car there, so I didn't. And I had been working for some doctors, and Michael was in the hospital at one point, and the floor of the hospital was very quiet. And all of a sudden we heard all these obscenities being shouted and people, the nurses, running into the room, and I heard them say Larry's name: "we're going to call security, Larry." And I said, "I bet it's Larry Trapp."

His story is told at the temple, around kitchen tables, by *Time* magazine, over the telephone, at the

Lincoln swat team's shooting range in the middle of the cornfields.

In 1995 a book was published entitled, *Not by the Sword: How the Love of a Cantor and his Family Transformed a Klansman*. The Disney Corporation bought the rights to their story and own it "throughout the universe and for all eternity." Their script includes a car chase, a love affair, and a grand dragon of the Ku Klux Klan who is neither blind, nor a double amputee, nor a convert to Judaism.

Lawrence Roger Trapp was born on May 30, 1948, in Omaha, Nebraska. On a sunny Sunday in June of 1991, Larry Trapp placed a call. This is where the story begins.

Larry Trapp: Well, the first thing I did was I made a call to his home. I believe it was a Sun-day afternoon, and I simply stated—I didn't say who I was, I just simply stated—"You're going to be sorry you ever moved into" his address, and then I said, "Jew boy."

Michael Weisser: And the phone rang, and I picked it up, and a voice on the other end of the line said, "You'll be sorry you ever moved into 5810 Randolph Street, Jew boy."

Julie: And the phone rang, and Michael answered the phone, and this voice on the other end said, "You'll be sorry you ever moved into 5810 Randolph Street, Jew boy."

There's a history. By the age of six Trapp had developed the diabetes from which he would later die at the Randolph Street home of Michael and Julie Weisser. For two years in the early 1970s Trapp served as chief of police for Pierce, Nebraska. In 1988, at the age of thirty-nine, Trapp joined the White Knights of the Ku Klux Klan. By this time he

had undergone seven separate amputation proce-
dures on both legs.

The call Trapp made to Cantor Weisser often be-
gins the story. A few days later someone at 5810
Randolph Street picked up the mail.

Michael: I came home from the Temple about five
o'clock or five-thirty and picked the mail up out
of the mailbox at the curb and bought it into the
house. And there was a big fat envelope.

Julie: It was mostly anti-Jewish kinds of mate-
rial, and on the top of all this anti-Jewish mater-
ial was a little calling card that said, "The KKK is
watching you, scum." And that is when I really
felt fearful.

Larry: You'd be surprised what fear can do, es-
pecially to a person with a family, either a man or
a woman. You can say that you know where their
kids go to school. You don't have to actually say
what you're going to do to them you. You just say
that you know where their kids go to school. Be-
ing an ex-police officer I knew what I could and
could not say.

Despite several surgical interventions, by the late
1980s Trapp's cataracts and diabetic retinopathy
had worsened considerably, and he was unable to
read anything but heavily magnified text.

Trapp conducted substantial business from his effi-
ciency apartment at 817 C Street—by mail, by
phone, and through regular meetings with Klan
members and skinheads. Trapp organized the
March 1991 ransacking of Omaha's Vietnamese
Resettlement Association. He brought Tom Metz-
ker's show *Race and Reason* to Lincoln Nebraska's
cable access channel and said during an interview,
"We sponsored this show just to let the general

public know more about the white movement—to let them know that we're not the killers society seems to say we are. We just have a goal in mind."

He used a tape recorder to make lists and record his thoughts. He would edit these recordings for "Vigilante's Voice," his racist hotline. After his message callers were invited to leave one of their own.

Michael: I know that when I first called Larry it was in anger, and I wanted to somehow get even for what he had done. And I know that's true because when I called at first I didn't identify myself. I just called. And so Julie said, and it was sort of prophetic—"If you ever reach Larry on the phone say something nice to him; it will blow him away; he won't know how to deal with that." And that's exactly what happened. And so I began to call Larry.

Julie: And he would leave messages like "Why do you love the Nazis so much? You're a disabled person. You would have been one of the first to be killed."

Michael: And another time Larry knew about what time I was going to call, and Larry left a thirty-second fart noise on the tape, and when it was over, I was inspired by it, and I said, "It sounds like the voice of the master race to me." Finally, one day Larry answered the phone and yelled in the phone, "Why do you keep calling me? Why do you keep calling me? You're harassing me. I'll have your ass in jail." I remember that real clearly. He sounded angry and bitter and awful. And I remember what Julie had suggested, and I said, "Well, Larry I know you're a disabled person. I thought you might need a ride to the grocery store."

And Larry's voice got quiet and he said, "No, I have that taken care of. Thanks, anyway. But don't call this number anymore. It's my business phone."

Larry: And I had one of my nurses listening, and I asked her, "Well, what do you think this is all about? Would you trust this person?" She said no. She wasn't a racist. She was just putting herself in my position: would I trust that person? She couldn't understand it either. I suppose in a way it did instill fear in me now that I think about it. Not knowing something you will fear it, and not knowing what his intentions were, a soft subtle voice, it worried me.

On the "Vigilante's Voice" hotline he left the street address of an African American activist and encouraged callers to "Pay her a visit and let her know what you think." One night his cat wouldn't stop crying, so he shot it. To his favorite nurse he said, "Leave your fucking hands off my fucking television." She walked out and never returned. Someone left a poem on his hotline about a fish laid against a wall with its eyes popping out. One day at his ophthamologist's office Trapp had difficulty finding his way into the elevator. A woman offered to help him. He declined, saying, "No thanks, I'll do it myself." "Where are you from?" He asked. "I am from Vietnam," she said.

On November 12, 1991, Trapp pulled *Race and Reason* off the air.

Michael: And I said, "Larry I see you've taken your program off the air," and he said, "Yeah, I'm rethinking some things." And I said, "Well, do you want some help with that? Do you want to talk about it?" And he said, "No, no, no. I can handle it myself."

A few days later, on November 16, 1991, another call was made. The phone rang at 5810 Randolph and Michael Weisser heard someone say, "I want to get out, but I don't know how." They conferred, and the Weissers offered to bring a bucket of fried chicken over to Trapp's C Street apartment to talk things over. Trapp equivocated and then consented.

Julie: And so Michael asked if he could come over, and at first he really balked and didn't really want to do that, and Michael persisted, and said, "Larry, come on. We need to talk."

Michael: And so I told him that I'd talk to him, and did he want to talk right then that night, Saturday night, and he said yes. So I said, "I'll bring over a little bite to eat, and we'll talk about it." So I hung up, and I told Julie what had happened. And Julie said, "Hey, we ought to bring this guy a gift or something. You know he is probably just as leery of us as we are of him."

Julie: And I thought, "God, what am I going to take this guy? I can't take him candy; he's diabetic. I can't take him a book; he's blind." So I started rummaging through this jewelry box, and I found this ring that I had given Michael that was this silver braided ring that I thought was kind of pretty that he never wore. And so I decided to take him this ring.

Michael: So we drove to his house, knocked on the door, opened the door, and Larry let us in. And I reached out and shook his hand, and he started to cry.

Julie: Larry started tugging on these rings he had on his fingers that were swastika rings, and he pulled them off his fingers, and he put them in Michael's hands. And he said, "I want you to get rid of these and get them out of my life."

Larry: I had these two swastika rings on. They were Maltese crosses—iron crosses, some people call them—and they had a swastika in the middle. And the minute I shook Michael's hand I couldn't wear them any more. And I took them off and gave them to him and said, "I can't wear these." And it was just a good feeling that I had. It was just a feeling that I was doing something right.

Julie: I put this ring on his hand, or Michael did, I don't really recall who put it on his finger, but one of us did. We kneeled down beside his wheelchair, and we were all crying, and after that it was all history.

Trapp renounced the Klan. The next morning he wrote a letter to the office of the White Knights: "Please accept this as my resignation from the Ku Klux Klan, effective immediately. This resignation is due to personal reasons."

In the months that followed he apologized to everyone he remembered harassing. He made phone calls, lectured to school groups, spoke at the temple's Martin Luther King Jr. birthday celebration, and made other public appearances.

Michael and Larry were interviewed frequently by local and national media.

Michael: Most of the people from the media, I think unconsciously so, acted as if they were doing us a favor, when really what they were doing was disrupting our lives. But on the other hand, the word that got out through the media—even though sometimes it was a bit distorted, and sometimes it was angled in this way or that way—the word got out that there is this possibility that every human being can change. An or-

thodox Jewish Lubavich woman called me one day from New York and told me about the problem her community was having in relating to the black community. These orthodox Jewish women and these black women from the same neighborhood would get together in each other's homes to have a cup of tea, and whenever they came to an impasse about some community problem that they couldn't solve, one of them would say, "If that Jewish guy in Lincoln, Nebraska, could be friends with a Ku Klux klansman, then we shouldn't think our problems are so great."

Julie: I think the story with Larry, I think it was pumped. And it was pumped because there are people out there who want to show other people, "Look what can happen. Look at this story of hope and redemption and love." And so as real as that is, it still has—it still can be played upon. Everybody wants to latch onto something to promote their own story.

Julie began attending Larry's personal needs. Julie: I went on this cleaning spree and started throwing out all this stuff that was gross and clothes that were ruined with food stains. We bonded. All of us bonded, and it felt so right that I guess I started—I don't know. The maternal dimension kicked in. I just felt that it was OK to straighten things out.

One day she rearranged some of Larry's belongings. Later, when he couldn't find them, he flew into a rage, screaming, "I've been looking for my god damn toothbrush, and you've moved it, and I'm a blind person, and you can't move a blind person's belongings." Surprising even herself, Julie struck him hard on the back as she walked toward the door. But Trapp called her back.

Julie: "If you're going to leave and not ever going to come back," he said, "I at least want to see what you look like." So I walked over to this desk, and Larry turned the lamp on. And he put on these glasses that had the magnifying glass attached, and he was adjusting it, and he asked me to lean down so that he could look. And all of a sudden I looked through this magnifying glass, and all I could see were these big blue eyes just filled with tears. And it was kind of a pivotal moment where everything kind of changed.

Larry: I'm used to whatever I said before—no matter how hateful it was, no matter how damaging it was to a person—I was always backed up by other people with the same ideas. Now I'm on my own, and I'm learning how to love people again. That's a whole different way of life. It's not easy. Sometimes I think to myself, "Well, these guys were my friends." But really, if I stop to think, they weren't my friends. They were using me because I had a way to get in. I had my handicap. Well, I don't call it a handicap, I call it a disability. I had my lack of legs, and my blindness to get me in the door. I could get in places they couldn't because people would feel sorry for me because of the way I was. Then I could really nail them to the wall once I got in the door.

In January of 1992, somewhere in the middle of the story, Larry moved into the Weissers' home, displacing Julie's daughter, Rebecca, to the basement with her stepbrother and sister.

Michael: We knew that Larry couldn't go on living by himself, and we also knew that whatever support system he used to have was gone because he was now the enemy for his former colleagues. And we knew that it would be wrong for us to not to continue to grow our relationship with Larry.

And so we decided to invite him to come live with us.

David Weisser: Julie had the harder job. She invited him to move in. Dad would have never made that step, I don't think. He would definitely have called. He would definitely have traveled to his apartment and talked to him and helped him find a place and helped him with his medical difficulties and all that. But he would never have brought him into the house and paid for his medication. And I think that's where Julie comes in. . . .

Julie: When this all started, it was really initially between Michael and Larry—the initial contact, the initial breakthrough. But once that happened, I think that Larry had this rapport with me because for a variety of reasons Larry had been wanting a woman to be a part of his life.

> Larry's room began to fill with a growing collection of model trains and Martin Luther King Jr. memorabilia. He studied Jewish faith and traditions with Michael and expressed his desire to convert to Judaism. He acquired a cat, a bird, and a hamster.

> Julie shampooed and cut his hair, shaved his face, trimmed his nails, changed his bedding, and prepared his meals.

Rebecca Nelms: When Larry came to live with us, he needed a full-time nurse because he was so sick, and Mom became that nurse. And she was running around after him, and she didn't really have time for us kids. And so I kind of felt like I really didn't have a mom because she'd be running around the house, but she'd be doing things for Larry because it was like having a little baby around all the time: you know, you need to constantly take care of him.

Larry: I told Julie I haven't been confused until I moved in here, and that's the truth. I never had a family life. So the things that go on: I like what I see. I love the kids, you know. They tear my nerves up once in a while, but I think I did the same thing when I was little. Of course, if I got out of line, I'd get a fist upside my head.

Julie: He said he wasn't confused until he lived with our family. Which isn't true, I don't think, but there is this sense of confusion because he doesn't know how families are. He doesn't know that in relationships, that there's all this conflict in relationships. It doesn't matter if you love someone or if you hate someone: there is conflict in families.

Michael: Is the story to give hope? Is the story to give a lift to someone who feels down trodden? Is the story to show that even the most recalcitrant individual in the world can change? Or is the story made better by telling the dark side along with it? The dark side of the doubts and the hassles and the yelling and the screaming that went on: How necessary is that?

> Toward the end of his life Larry worked diligently on his model train collection and often played audio tapes of engines, whistles, and signals.

Jan Branting: I believe there had been numerous phone calls back and forth between the Weissers and Larry's father. I'm not sure if Larry actually made the phone calls, but I know that it was important for those two to get together. And it was also a really difficult situation because Larry's father was very angry at the Weissers and very suspicious of them, and he would not come into their home if they were there, so they were both gone for the day.

Julie: I think that Larry's parents were so incredibly—his father, in particular—were so abusive and so neglectful of Larry's needs physically and emotionally. And I think that Larry replicated those things because, you know, it's interesting: he had this hate for his father and this love and admiration for his father. So I think that the way that he neglected his body and his relationships were the exact way he had seen his parents do that.

Larry: So everything I did—or nothing, I should say—nothing I did impressed my dad. Whether I was on the right side of the law or the wrong side. In fact, I became the chief of police in Pierce, Nebraska, a small town. That was wrong. He said, "I can't imagine you carrying a gun." Well, my sister took a different view of the whole thing. She became very antiracist. Myself, I took Dad's way. I thought, "Well, I'm trying to impress Dad." Everything I did I was trying to impress Dad. So basically he instilled—He said he wasn't a racist, but when he found out I was living with the Weissers, he called Michael Weisser up and said, "Why don't you keep your Jew—your big Jew nose out of family business?"

Jan: Larry was so scared of his father, and he refused to be alone with him that day. He really was a scared little boy. He knew how close it was to the end, and it was important to tell his father he was sorry. When his father came, he was very dapper, and they immediately started to talk in Larry's bedroom. I was in tears listening to them apologize to each other. I was touched by how hard it must have been for Larry's dad to be able to apologize after all these years and for what all Larry had done in his life. That would be real hard for a

father. Even though I think his father's behavior when Larry was young precipitated this behavior.

Eva Sartori: One troubling aspect of the story is that people came to the conclusion that Larry's immoral acts were the consequence of an unhappy, troubled childhood. And I think that's a great simplification of how a person is prompted to perform evil deeds and leaves to the side larger social questions. Those issues were never analyzed in the Larry Trapp story. The focus was entirely on the relationship of Larry and Michael. I think a lot of people felt that Michael's stance exemplified the highest morality. I guess I don't. I don't see his motives as being as much moral as emotional. Emotional in terms of his own needs for the kind of recognition that the publicity awarded them.

> That evening Larry asked Michael to step into his office. He said, "I'm ready to convert to Judaism and join the congregation." Michael asked him, "Why? Why on this day?" Larry replied, "my father and I have forgiven one another. We've had a Yom Kippur."

Julie: It was part of the story about Larry that made it so newsworthy, but I didn't really care. Larry was the same person to me that he was before the day of the conversion or the day after. That didn't change who Larry was, not even a little bit.

> Late one night Trapp confessed to Julie a number of lies: he had never been a mercenary soldier; he had never been in the Hell's Angels; he had never fully divulged the extent of his hate crimes.

Julie: And I guess the most difficult thing he had to say was that these black kids in reform school never raped him. I mean that was the hardest thing for him to say. And he went on to say that he

had done things that he had never talked to us about and that he had never told me about. He was really, really, remorseful when he told me that this had not happened—that these four boys in reform school had not raped him, that he had no reason to be a racist. That he had created his own racism through this mythology, this lie that he had created in his head about this rape.

Michael: Larry did have a fantasy that he was going to be this great powerful leader of a racist organization. Larry designed his persona for a long time and added to it and added to it. When he would get feedback from various racist organizations around the country it helped him to believe more and more that he really was this Grand Dragon of the state of Nebraska. But the truth is it never became who he was. Only he didn't know that. Because if it really was Larry, then Larry could never have responded to a telephone call, or a few telephone calls from a person like me and to a hand of friendship from a person like Julie. He would have said, "Get the hell out of here. Are you crazy? I hate you. You're the enemy."

> One day in August after handling his trains, Trapp suffered a mild heart attack. He recovered, but his condition became even more precarious. He began to move seamlessly between dream and conscious states. He dreamed he was stuck in a circular saw and was being chopped to pieces. When his kidneys began to malfunction, the accumulating toxins in his blood stream amplified his hallucinations.

Julie: Larry, at some point on the way out to the car, just stopped his wheelchair, put his hands on the wheels and stopped it. And he looked at me and said, "Am I dying?" and I said, "Yes, you are." And he started to cry, and then he told me— he said, "You know, the car is filled with soda

bottles." And I said, "No, it's not." And he said, "Yeah, I know." There was also a day that he thought his whole room was filled with electrical cords dangling from the ceiling, and if he moved he would be electrocuted.

Michael: The night that Larry died Julie went downstairs and woke up the kids. It was kind of interesting what they did. They all came upstairs—maybe one by one, if I remember right—to Larry's room, and they said good-bye even though Larry was already gone. And they left the room, and we called the hospice people, and Larry's body was taken away. Julie made sure it was covered with a quilt rather than the plastic bag they usually use. That's how he died. It was really not a horrible way to die. Was pretty sweet, actually. We knew that an episode in our life that had its moments of spirituality and rage and humor was over, and we would be going forward to other things pretty soon.

This is where the story ends.
Michael: The story of Larry Trapp and my family is very important to us. All of its details are very important to us. But I wouldn't tell you all the details because in a way the most personal of the details are really nobody else's business. The essence of the story I think belongs to everybody.

David: What people thought about the situation—from their perspective—was that it was this huge, timeless biblical event that was, I don't know, like my dad was some messenger of God, and we were angels of mercy, and we brought this lost soul into our home and endured this situation with him, and they spoke to us as if we were martyrs, really. But inside the house we ate together, played together. Larry listened to tapes. He had train sets.

Julie: I don't really care to denigrate Larry's memory. And yet there is this whole issue of the truth, and I think there will always be dishonesty that's connected with this story. And really it's been one of the things that has just not been OK, but I don't have any choice. I feel like there is this part of it that's very personal that's there that I'm not willing to deal with—I mean publicly deal with. So there is this whole part of it that's dishonest, and it sort of fits actually, given all the things that went on. It fits.

Jan: I think many people in the community felt that Michael and Julie did this for the publicity—that it was not real, that Larry was using them, or that they were using him. When you were in the home, it was very obvious that this was not the case. It was very genuine the love they had for each other. After he died, and they ran all the tapes on the news, and I saw him after having not really remembered seeing him in his Klan garb, it was—it gave me a chill to think of the contrast in this person.

Eva: There were people who were and I think still are very angry at the episode. They felt that Michael was spending an awful lot of time with Larry on Larry's needs, and he was neglecting people in the congregation who were perhaps equally as needy. It wasn't an easy issue, and I thought it was resolved and I had come to terms with it. This was an incident that was in the past. But I think the more distance I have from it, paradoxically, the more bitter I feel.

Rebecca: Larry, I miss him. I mean, I do. I loved him. He was—we had some really good times. I mean there were some awful times, but we had some really good times.

Larry: They're going to be people out there who will say, "Oh, Larry Trapp is no longer the Grand Dragon of the state of Nebraska, but at least now we know that the Klan is an active entity in the state. So let's look around and see who we can get to join the outfit." Then there are some who will think, "This is good. Here is a Klansman who changed his mind." And this person saying this, if he's got racist ideas, maybe he'll say, "Let me, let me kind of look things over." This is what I'm hoping, he'll say, "Let me, let me have another—let me think about this another time."

We have four, mutually referential artifacts—a rough-edit tape (Based on a Story: Test Print for WPT Only), a script, a page from a working document in John and Jeanne's notebooks (figure 5.15, plate 1 in the color pages), and a videotaped interview in which John discusses the notebooks with members of WPT. For John and Jeanne, these artifacts are elements in the production of O Night Without Objects, *a work that when completed will supersede the rest. For us, these ar-tifacts are documentary evidences for the work of writing and reading as part of the ongoing activities and interactions, the working practices, of video production.*

Our project is to recover the work from these documentary evidences, which we read as residual moments, as traces of J&J's activity. But as we read them they remind us, or teach us again, that such artifacts are irremediably incomplete as records of the activities of their production and use. The artifact opens out onto a temporal course of past and future activities, of experiences and referents, that aren't themselves in evidence. This partiality of artifacts in relation to the activities that produce and make use of them is a basic premise of our work and of its central problem. Our problem is to read these traces, to assemble them into recountings of each document's meaningful embedding in ongoing working practices, while knowing that they were written to be read not as a text but in situ, practically, in relation to activities beyond the page.

Script 113 is a canvas with multiple layers, indexed to multiple activities. It documents J&J's work of production—the evolving script and its changes, including work completed and work to be done. It also documents J&J's interaction, their collaboration. It is a hypermedia document, crossing in and out of paper and electronic forms, referencing conversations as well as video segments, databases, paper and digital texts. The spatial geography of the page represents the temporal sequence of the script, the layers of annotation its reworking over time.

This script itself, *113*, *stands for one version, one moment or series of moments in the course of the work. The oldest layer is a template, borrowed from WPT's video logging practices and reused/adapted for J&J's production work. The template is a table: in column 1 are references to tape segment names as stored for use by the editing system. In column 2 are references to videotapes, as tape i.d.'s and time codes, as well as references to the audio track,* USING UPPERCASE FOR NARRATION, *lowercase for protagonists' own voices. And in column 3 are references to ongoing work and conversation and "J&J's notes," comments to themselves and each other.*

Onto this template are layered handwritten annotations. Different colors of pen trace different moments of annotation, though their order is only partly recoverable. The order that is recoverable requires us to make use of our own members' knowledge of practices of writing and reading. So, for example, we read the relations of red, black, and green in the annotation in the page's top margin ("still of papers, rolodex cards" etc.) as first red, then black, then green—not because the order is in any way readable directly from the marks but because we recognize the black box as a kind of highlighting operation on the red text, the green squiggling line as a kind of deletion. In the interview John explains to us that these notes for him evoke images of images on the tapes.

In an effort to reanimate the page we ask John to narrate it for us, videotaping him as he does. He explains the annotations "a curious woman" and "a personal contact" as last items in the list read by the narrator. In the course of his explanation for us John underlines the words personal contact, *under* JULIE #3, 25:11, *in black pen. We know then just how that mark got onto the page, its occasion within the course of his explanation, its working at just that moment as an act of highlighting, directing our attention to that particular phrase. We assume the other marks were as occasioned as this one within the work, though in ways no longer recoverable.*

Crossing-out operations, for example, represent edits or deletions to the script, but we can't always tell whether the work is still to be done or has been already. In some cases this question is anticipated and addressed in further layers of annotation, like JM's green 08.04.96 inverted and edited, which we can read, from its placement and its sense, as a reference to work done on the script to the left of the note, as indicated by the lighter green S around these two sequences, the black penned instruction to invert, *and the cross-outs, in the same dark green pen, of parts of the text. And in looking to the tape we can see that this inversion has been done, while the note to rewrite* the *to their* in *the* Disney Corporation bought the rights to the story, *indexes work still to come.*

Part 3: Blacky

> Afterward I never again saw that remarkable house, which at my
> grandfather's death passed into strange hands. As I recover it in re-
> calling my child-wrought memories, it is no complete building: It is
> all broken up inside me; here a room, there a room, and here a piece of
> hallway that does not connect these two rooms, but is preserved, as a
> fragment, by itself. In this way it is all dispersed within me. . . . It is
> as though the picture of this house had fallen into me from an infinite
> height and had shattered against my very ground.
>
> —RAINER MARIA RILKE, *The Notebooks of Malte Laurids Brigge*

The following presents relevant fragments of an email correspondence John
and Jeanne conducted with the editor of this book, Craig Harris. In March
1997 Harris wrote to them:

In our past discussions I had the impression that Part 3 may not end up in the chap-
ter. I could use some explanation of your views on what was sent to me in the recent
draft. Is it your intention to publish only the Rilke quotation followed by the pho-
tograph of Blacky with no caption for Part 3? If so, please let me know what it is that
you have in mind here.

We replied:

We expect to complete *O Night Without Objects* in July of 1997 and are just now begin-
ning work on *The Adventures of Blacky,* so it has been difficult for us to say with preci-
sion how Part 3 of the chapter will work. Now we know more. In the piece a woman's
voice will be heard reading a series of questions from the *Blacky* pictures, a projective
psychological test much like Rorschach's. Our script begins as the test does:

Here are some cartoons. I'd like you to make up a little story about each one. At
the end of the story I'll ask you a couple of questions to make sure I got every-
thing you had in mind. There are no right or wrong answers. I'm just interested
in what you imagine the answers to be. The comic is about a family of dogs: Papa,
Mama, Tippy, and the main character, Blacky.

Figure 5.17
Jeanne Finley and John Muse, Blacky, from *O Night Without Objects,* 1997. Here Blacky is very upset.
What might have happened between the last picture and this one?

A young man and a girl sit across from one another. Ostensibly, she is the test sub-
ject and he the administrator of the test. The girl will be played by the same actress
who claps at the end of *Time Bomb,* and Pamela Z, who narrated *Time Bomb* and *Based
on a Story,* will also narrate *Blacky.* This voice and this girl are intended to unify the
sections of the trilogy and raise questions concerning the position of the narrator rel-
ative to the events.

As a caption for the image—we've always called this one "Conscience Dog"—
please use the following question: "Here Blacky is very upset. What might have hap-
pened between the last picture and this one?" The image presents—at least this is
how we imagine it—the paradox of conscience. Look closely at the image: Blacky
turns tail, turns against himself and in such a way that the one, Blacky, turns out to
be two: Blacky, and his conscience. For there to be one there must be two: i.e., to be
oneself one must have been called and caught up in a circuit that puts a double in
place as voice-that-knows-better. Yes, pace Gertrude Stein: I am I because my little
dog knows me.

The cartoon foregrounds this doubling insofar as the rendering of con-
science mimics that of Blacky and vice versa. The squiggled marks to the
right and left of Blacky frame him, put him into—i.e., inside—the fear and
persecutory shudder that these marks on the page are conventionally under-
stood to signify. This scalloped edging, Blacky's fear, molds him, forces him
into a space, a container, one *like* the billowy cloud in which the other dog
floats. And Blacky's spine, too, doubles the shudder, doubles his conscience's
cloud, doubles even the halo and its sparkle. So which comes first—the shud-
der or the splitting headache? And thus, who comes first—Blacky or con-
science?

O Night Without Objects: the conversations, our collaboration with WPT.
We hope to put our practices to the test of too much scrutiny, too much con-
science, this book. We want to include these very paragraphs in Part 3; as
much as our work at Xerox PARC, our email correspondence has been con-
stitutive of the chapter, of our written pieces, of our relationships to WPT
even. Would these writings exist at all, their responsive rhythms, if we had-
n't been persuaded that textual and graphic artifacts of our collaboration
could be *representative* of our work—or at least representative of its unrepre-
sentability. The demand that we narrate and thus allegorize our relations
produced effects that weren't limited to a representation of work we were al-
ready doing. The chapter itself is a work that attempts to dramatize the
fragility and fecundity of the relations that made it possible.

Best,
John and Jeanne

6

Public Literature: Narratives and Narrative Structures in *LambdaMOO*

Judy Malloy

Introduction

Beginning in 1993, as part of my residency at Xerox Palo Alto Research Center, I worked with words in *LambdaMOO*, a text-based social virtual reality site, created at Xerox PARC by Pavel Curtis, that runs *LambdaMOO* code and is publicly accessible on the Internet. Investigating the narrative variety inherent in MOOs (multi-user dungeons—object oriented), I created three different narratives—*The Ocatillo Files*, *Brown House Kitchen*, and *Deep Creek School*.

The Ocatillo Files was an ephemeral performative narrative that examined role playing and story telling in the heart of this virtual community—the *LambdaMOO* living room. *Brown House Kitchen* is an exploratory collaboratively experienced narrative in which text is disclosed by programmed objects. *Deep Creek School* is a collaboratively created model of an alternative art school.

MUD Communities

MUDs (multi-user dungeons) are extraordinary virtual communities. They are cohesive text-based universes existing parallel to life where, just as they do in real life, stories occur daily that usually are observed only by the participants. In these people-centered places a wide variety of public literature can be created.

It is no accident that the many World Wide Web books that currently line the shelves of the book stores are of the "how to" category—how to design, how to program, how to find; whereas the books and articles that are appearing on MOOs are more human-oriented—*Life on the Screen: Identity in the Age of the Internet*[1] and "MUDder? I Hardly Know 'Er! Adventures of a Feminist MUDder."[2] Despite elements of interaction, the Web is, at its core, an information delivery system—suited for solitary information access. MUDs, on the other hand, are recreational gathering spaces that connect many users to the same place at the same time. Users are visible to each other and share a database of rooms, exits, and other objects.[3]

LambdaMOO

Spawned by a multi-user adventuring program written in 1979 by students at the University of Essex in England,[4] MUDs have remained for the most part recreational. However, The Social Virtual Reality project at Xerox PARC, headed by Pavel Curtis, whose theatrical and computer science

backgrounds merge fortuitously in these environments, is exploring non-recreational uses of MUD technology[5] and, in particular, the notion of social virtual realities.

Beginning in 1993, as part of my residency (as a writer and designer of experimental computer-mediated narratives) at Xerox PARC, I worked in *LambdaMOO*, a MUD that uses an object-oriented programming language (a cross between C++ and LISP) developed by Curtis.[6] The term *LambdaMOO* refers both to this software and to the server that Curtis runs at Xerox PARC that uses this software and is open to the Internet public.

LambdaMOO (and similar sites based on LambdaCode) are malleable code-based structures where, as if participants lived in an intellectual equivalent of Home Depot, building materials are always within reach. Although general MUD usage has centered on creative social interaction, the flexible programming system that Curtis created also has the potential for complex information delivery and for an infinite variety of narrative structures.

Literary forms that are possible here include narrative environments that groups of readers can virtually enter and explore such as *Brown House Kitchen*,[7] performative narratives such as *The Ocatillo Files*, and collaboratively created narrative environments such as *Deep Creek School*.[8]

There is a difference between making a work in a preexisting virtual community like *LambdaMOO* and making a work in a MOO created to serve a specific community (such as *PostModern MOO*,[9] *Hypertext Hotel*,[10] *Astro-VR*,[11] and *WaxWeb*[12]). *LambdaMOO* is already a well-defined, richly embroidered virtual environment. A user who opens the door to the closet (the standard entry way to this environment) enters a well-defined room that is based on Pavel Curtis's real-life living room: "It is very bright, open, and airy here, with large plate-glass windows looking southward over the pool to the gardens beyond. On the north wall, there is a rough stonework fireplace. The east and west walls are almost completely covered with large, well-stocked bookcases."[13] Although it is challenging to create in this already shaped space, I believe that the feeling of actually being somewhere fosters visualization of three-dimensional, community-oriented narratives.

The Ocatillo Files

Before I physically went to PARC, in September 1993, I began to explore its environment in a way that was comfortable to me as an artist with a history

of street performance and of telling stories on the net.[14] Since 1986 when I set *Bad Information* in motion on the WELL,[15] I have told stories publicly and produced collaborative narratives in conferencing systems such as the WELL and Arts Wire. However, these are relatively intellectual communities where like-minded people, speaking as themselves, discuss issues of interest. There is an enormous difference between additive conferencing in these intellectual environments and virtually sharing a couch real-time in the *LambdaMOO* living room with characters of indeterminate gender and pseudonyms like Upstream_Salmon, Xander, and Hilde_Ragor.[16]

I initially entered *LambdaMOO* with, as is customary in this environment, a character—an alternate identity called *scibe* (a scribe who cannot spell). In September 1993, with a story on her mind, scibe entered *LambdaMOO* in the usual way—through the coat closet. Perhaps it was how out of place I felt the first time that I entered *LambdaMOO*, which prompted me to flesh out scibe as a homeless woman, returned from a dusty voyage to some desert locale. She was a somewhat inappropriate character for this seemingly male-dominated virtual space where self-descriptions run to hyperbole—*beautiful, tall, blond, strong, voluptuous,* and so on. Scibe had just had an abortion and was feeling cold, vulnerable, and withdrawn.

For this virtual performance narrative, I used the common commands in this environment—*say* to produce speech and *emote* to produce description, feelings and thoughts. When I typed

Emote wearing a plain pink dress that hangs below her thin knees.

the system informed the other inhabitants of the room that

scibe is wearing a plain pink dress that hangs below her thin knees.

Quietly resisting attempts to fondle her, I/she opened the door that led to the living room, sat down beside the fireplace, and began to tell her tale. She was uncomfortable speaking in this somewhat alien environment so (using emote) she thought the words that began her story. These thoughts were visible to other participants in the room:

scibe thinks that at River Side, the river rushed through the gorge—like white foam on the warm beer that Gary poured into plastic cups.

On successive evenings in September and October 1993, scibe visited the living room at *LambdaMOO*. She made her way through the crowd, occasionally smiling at familiar characters:

scibe walks as usual over to the fireplace and sits down. thinks that the warm fire feels good on her back.

With the audience in mind, she embroidered her story to hold their interest:

scibe thinks . . . After a while I realized that he only wanted to make love on the nights another woman came to dinner, and he sat beside her—touching her feet and legs under the table.

Around the second week of the story, scibe acquired a notebook, a device that worked better than visualizing her thoughts:

scibe pulls a black notebook out of the pocket of her pink dress. scibe writes slowly in the notebook. . . .

And scibe became more adept at following the disjointed conversations that took place around her and at linking her words to the threads of these conversations. For instance, when she overheard "Yes, the crime in Houston is bad too, but we haven't killed any Europeans lately," she responded with

The morning that he left for Miami, he showed me again where the loaded guns were kept.

As time passed, living room visitors became accustomed to scibe's visits and, for the most part, ceased to interact with her as a sexual object, allowing her space to tell her story, accepting (as in real life) the somewhat different behavior of artists:

Xanoz looks at scibe. Is she out of it, or wiser than most?

In return, scibe responded to audience questions and accepted interjections with good grace

scibe writes As I stood behind the heavy front door in my nightgown, I realized that there was no way to see who was out there. "Who is it?" I asked, but either the door was too heavy for whoever was there to hear, or whoever was there chose not to answer.

Marvin (to scibe): It was me, delivering a Bigfoot pizza.

scibe smiles.

scibe's performative narrative was a way of familiarizing myself with the environment and audience before I began a more complex work, but it was also a coherent work, told in ancient Greek fashion, in a marketplace setting. The story she related, called *The Ocatillo Files*, was set in Arizona at the walled estate of a creepy modernist sculptor. It was loosely hypertextual, using text fragments (*lexias*,[17] in hypertext terminology) and implicit (as opposed to explicit) links.[18]

Brown House Kitchen

I physically entered PARC in November 1993. I had an office and a SPARC workstation in the legendary Computer Science Lab (CSL) across from the office of Rich Gold, the director of the PARC Artist-in-Residence (PAIR) program. In this cubicle (which I decorated with horse chestnuts and horse shit from the neighboring fields), I labored over the programming of the wind-up duck in an informal *LambdaMOO* tutorial.[19] Soon I was spending my days glued to the terminal on familiar territory—the Internet.

In November on the CSL veranda at PARC, Pavel Curtis and I discussed what I would do in *LambdaMOO*. Also present was ethnographer Cynthia Duval, who recorded and transcribed the conversation. I had envisioned the narrative as a kind of hypertext, but Pavel pointed out the three-dimensional qualities of the medium. He spoke about "creating a space that was itself literature in that by walking through the space and manipulating the objects that I might see there, or by taking different paths through the space, one would encounter this work of literature."[20]

Pavel also suggested that objects in this space could disclose text. Additionally, we discussed the public art possibilities inherent in *LambdaMOO*. Both Pavel and I felt that the story should be one that would appeal to the citizens of this community.

In the course of a walk across the horse-strewn fields that border the PARC building, down Page Mill Road, past the *Wall Street Journal*

building, past Hewlett Packard, down to the Coronet Motel on El Camino Real (where I was staying with not much but a 286, a modem, a black cat, a few items of clothing, and some powdered soup), I conceived of *Brown House Kitchen.*

Influenced by the ubiquitous computing research (the creation of an environment where many invisible-to-the-user computers are available) being undertaken in CSL,[21] the kitchen was conceived as a future communal eating space where interrelated devices integral to its functioning would record events in various ways. In *Rashoman* fashion, these devices are capable of relating the details of things that occurred in a previous November in separate but related ways.

The participant who enters this environment now reads this:

An Early Ubicomp Era kitchen

The sun, coming through white lace curtains that frame a small irregularly watered yard, falls invitingly on a round oak table, surrounded by chairs. In the northeast corner, an old man sits in a bluegreen rocking chair, reading a newspaper. He looks like your grandfather. To your left, you see what appears to be a sculpture of a kitchen drawer mounted on a pedestal. Near the northwest wall, there is a kitchen sink, decorated with blue tiles. An orange cat stands on the edge of the sink, drinking water from a slow faucet drip.

Players who enter *Brown House Kitchen* can unfold the story in various (unpredictable) ways by examining the things they find there. Some of the devices (simulated video, simulated audio) disclose information that is seen (when activated) by everyone in the room. Other devices (electronic book, diary) disclose text visible only to the player who activates them. Players can sit at the table, order meals, and as is usual in *LambdaMOO*, talk with their companions.

The environment contains five integral text disclosing devices as well as a large amount of hypertextual "tiny scenery" (figure 6.1, descriptions activated by the word *look*).[22] The devices are a mobile, audio-equipped robot (figure 6.2, Ralph, a Will Clean Up After You unit), a database food dispensing table (figure 6.3, GoodFood), a prenarrative video device (figure 6.4, Barbie-Q),[23] and two electronic books (figure 6.5, Sarah's diary and the narranoter).

Two of the devices—Ralph, the Will Clean Up After You unit and Good-Food—are time-based. The information they disclose varies according to the

```
look cat
The cat has a white splotch across the top of his face. If you
say "Fireball, get down!," he will look at you with yellow eyes
and then go back to drinking from the slowly leaking faucet. When
Ralph approaches the sink, Fireball retreats to the small shelf
beneath the telephone.

look sink
Dirty dishes from the last meal are stacked in the stainless
steel sink. The wooden door below the sink is slightly ajar,
revealing an old fashioned garbage can.

look window
Through lace curtains, out the South window, you see unmowed
brown grass in a yard that looks like any yard in a Northern
California University town. Under a centrally located apple tree
sits a lifeless looking Sophie unit.

look Sophie
She - a Sophie Will Weed Your Garden Unit - sits like a life size
abandoned doll on a white metal lounge chair under the apple tree
in the yard. At her feet lie rotten apples and a metal spade.

look spade
A wood handled spade lies at Sophie's feet. Dried black dirt
clings to its rusted triangle-shaped metal blade.
```

```
look old man
Ralph appears to be human, but look! He has laid his newspaper on
the table beside his chair, next to the ship in a bottle. He
walks slowly to the sink and begins to wash dishes. Is he for
real?

look Ralph
Ralph is an aging Will Clean Up After You Unit, manufactured in
2003 by Orlando Kitchen Thingmans. His straight white hair is
combed back from his pink, wrinkled simulated skin. When you talk
to him, it becomes apparent that his gossip player is stuck in
some previous month.

talk ralph
Ralph turns his head, and speaks these words softly: "Becky and
Robbie were holding hands under the table. Jack scowled at the
runny poached eggs on his plate and pushed aside his stewed
prunes."
```

Figure 6.1
Judy Malloy, "tiny scenery" descriptions hpertextually activated by the user command "look," from
Brown House Kitchen, an exploratory narrative on *LambdaMOO,* 1993–1995

Figure 6.2
Judy Malloy, a user interaction with Ralph, a "Will Clean Up After Unit," from *Brown House Kitchen,*
an exploratory narrative on *LambdaMOO,* 1993–1995

```
look table
A food procural, storage and dispensing unit that is housed in
the center of a round oak table. GoodFood was introduced into
Brown House kitchen by Becky, a vegetarian. It is programmed to
procure, store, and dispense foods that it considers are good for
you. GoodFood serves 93 different meals that are determined by
the time and day.

sit down at table
The yellow brown straw that covers the floor is prickly looking,
but there is an empty eaters chair at the GoodFood Table. You sit
down there. Beside an empty yellow plate, nestled in a white
linen napkin is a small device.

look device
In the kitchen, unobtrusive devices hum quietly and musically.
Your eye is drawn to the small square devices with 3 buttons that
are nestled in white linen napkins on the top of the GoodFood
table.

look buttons
There are buttons in various places around the room. One of the
buttons on the table "tab" says "order food" you notice.

order food
You push a button on the table device that says "order food."
grilled cheese sandwich on whole wheat toast, green salad, kefir
slide slowly up the plastic tube. The beverage exits from a door
in the tube and slides to a stop beside the plate. Food spurts
from the top of the tube and shoots down a translucent tongue -
landing squarely on the plate.
```

```
look barbie
Your eye is drawn to a shiny black food preparation device that
burns, chars, and crisps red meat as well as smothering it with a
wide array of sauces. The word BARBIE-Q is written in pink
sequin-studded letters on its side . "Property of Jack" you read
underneath these letters in smaller pink print. A television
screen is set beneath the grill. The embossed metal doors under
the Barbie Unit's grill swing slowly open, revealing a video
display. View Barbie......View Barbie......, a female voice
utters enticingly.

view barbie
On Barbie's television screen you see Ralph. It is dark except
for the otherworldly light that emanates from the tips of his
fingers. A collection of keys fastened together with a silver
ring lie on the table beside him. He has picked up the ship on
the bottle that normally sits beside his chair and is turning it
around in his hands. You notice a small crack in the glass of
which the bottle is made.
```

Figure 6.3
Judy Malloy, the ordering of a meal from "GoodFood," from *Brown House Kitchen,* an exploratory
narrative on *LambdaMOO,* 1993–1995

Figure 6.4
Judy Malloy, a user interaction with "Barbie-Q," from from *Brown House Kitchen,* an exploratory
narrative on *LambdaMOO,* 1993–1995

```
open drawer
Sandy's drawer slides noiselessly open. It has been lined with
pink felt. Inside, there is a well used cutting board and a sharp
knife with a black ebony handle. A blue plastic stand with the
word narranoter written on it is dimly visible in the back of the
drawer. You see: a blue leather-bound book embossed with gold
writing a narranoter

take narranoter from drawer
When you place your hand on the narranoter, the screen above the
three buttons lights up and displays these words: My name is
Sandy. The notes I write after dinner in Brown House Kitchen are
scattered haphazardly in the memory of this device.

read noter
You put your finger on the word READ below the display screen of
a narranoter . These words appear on the screen:

Sarah's poisonous phrases hang in the air beside me. I have never
seen Becky so angry. Her eyes black. (like the scorpions under
the sink) Parsley and rough ground black pepper float on the
surface of our mushroom soup. The screen on the narranoter grows
dim.
```

```
Deep Creek School
An alternative art school in Telluride, Colorado, USA exploring
the connections between 'on-site' and 'on-line'. On your left,
you see a rock outcrop on which words and images have been
inscribed. It looks like a primitive map.

look map
What looks like a river and a road are etched on the rock. People
have written their names along the river and the road.

look names
Laurie, Andrew, Sheila, Lisa, Willie, Becky, Juanita, Judy, Jason
S., Jason R., Gene and Taylor, Victoria, Zelie, Matt, Bill,
Kirby, Dan and Ray.

look Bill
I'm a painter doing pottery, and I'm making a drum. I feel as off
centered as this blob of clay spinning in front of my face. I
don't really like computers, but I'm open to what they have to
offer.
```

Figure 6.5
Judy Malloy, a user interaction with the Narranoter, from from *Brown House Kitchen,* an exploratory
narrative on *LambdaMOO,* 1993–1995

Figure 6.6
Judy Malloy and students and faculty at Deep Creek School, a simulated educational environment on
LambdaMOO, from the entrance to *Deep Creek School*

day of the month and the time of the day in which you enter the story. Barbie Q discloses text sequentially. Sarah's diary and the narranoter produce hypertextual lexias at random.[24] In addition, there is a garden outside the kitchen where text is disclosed in a fugal way using fork, a feature of *LambdaMOO* code that allows time delays in the production of text.

Brown House Kitchen is structured with parallel intersecting data streams that are contained in and disclosed by this collection of objects. The idea of parallel data streams was one that I had worked with in *Wasting Time*, a narrative data structure where the words and thoughts of three characters are treated as parallel intertwining data streams.[25]

Brown House Kitchen, a work that exists in a time warp in virtual space, is a more complex narrative. It not only challenges readers to discover less obvious streams of text but also locates them within the story.

Because what Ralph says, what Barbie-Q recorded, and so on needed to be consistent, a chart where these details were plotted hung on my wall for months. To structure the work, I used food as an integrating device and started by writing the menus for the ninety-three meals that were to be served by GoodFood over the course of a month. The chart integrated what was eaten at the meals with what the video device has recorded, the gossip Ralph discloses, and the words that Sandy writes in the narranoter.

Although they are not to be blamed for any weird elements in my programming of *Brown House Kitchen*, the work would not have been possible without the presence of Pavel Curtis and other knowledgeable, helpful CSL researchers, including Rich Gold, Ron Frederick, Berry Kercheval, and David Nichols. Because of the large amount of detail that it required, *Brown House Kitchen* would have evolved more smoothly with a team of writers and programmers actually working on the project. Certainly, a more experienced programmer than I am would not have banged his or her head against the virtual walls of *LambdaMOO* as much as I did in the creation of this work.

Nevertheless, in ways that teams of writers, artists, computer scientists, and musicians may eventually do on a future shared-space, multimedia Internet, *Brown House Kitchen* integrates narrative disclosing devices that both relate to each other and respond interactively to investigation. As in this envisioned future Internet environment, *Brown House Kitchen* is communal in that it works best when several people are in the room.

In November 1994, I invited Tim Collin's and Reiko Goto's Carnegie Mellon Art Systems class into the work. Sitting at separate terminals in the

computer room, the students jointly explored *Brown House Kitchen*. Although the narrative is difficult to comprehend if only one person is exploring it in a solitary manner, as I had envisioned, the environment worked very well in this group situation. Its rich detail was apparent, there was no need for a didactic Help file, and the students were enthusiastic.

Some Public Art Problems

The making of an interesting model is not inappropriate for PARC, but as often does happen in real life with public sculpture, it was not easy to link *Brown House Kitchen* into the community for which it was destined. When I looked for an appropriate place to "attach" it—so that visitors to *LambdaMOO* would be able to stumble onto the work instead of having to teleport to it—I found that urban sprawl has placed limits on how things can be added to Lambda House and its environs. The residents of the places I suggested attaching it to felt that they already had a kitchen and that *Brown House Kitchen* was not consistent with the theme of *LambdaMOO*.

I felt like an out-of-town artist foisting a piece of sculpture on an understandably resistant community. It had not occurred to me that *LambdaMOO* already had a kitchen. Since it was designed as a time-warped future environment, I didn't think of *Brown House Kitchen* in quite that way.

A solution, since it is really a narrative, was to put the work inside the virtual covers of a book called *Murder After Dinner*. *Brown House Kitchen*, the narrative I began in *LambdaMOO* in November 1993, is now contained between the covers of a virtual book luridly titled *Murder After Dinner*:

You see a red leather bound book.

The words *Murder After Dinner* glow mysteriously on its spine.

open book

You open *Murder After Dinner*. The story is so compelling that you feel you have been transported to the site of the murder. The book slips from your hand

Now all I have to do (as soon as I find the book; it has disappeared) is to convince the present owner of the library in *LambdaMOO* to accept this book as part of the collection.

Deep Creek School

A model of *Deep Creek School* was created in *LambdaMOO* in June 1994 while I was artist in residence at Deep Creek—an art school associated with Arizona State University.[26]

Deep Creek roared by the ice house where the school's computers were located. Art students worked outside, in the shadow of snow-capped mountains, building site-specific installations or preparing performance works related to or inspired by the environment. For the most part, the students were not computer literate.

I conceived this model as a nonthreatening way to introduce art students to computer environments and as a way for students to begin to write about their work. In addition, it was a way to create a collaboratively written document about the experience.

I avoided the creation of programmed objects (things with responsive behavior), focusing instead on words and hypertextual linking. This tiny-scenery approach didn't take advantage of the full range of the medium, but I wanted each student to be able to work in this virtual environment easily. And like most writers, I believe that words alone are capable of creating rich virtual environments.

This was the second year I had worked with Deep Creek students. The year before (working with email and conferencing systems) I found that because of the amount of learning required and the competition with mountain, forest, creek environment, few students actually sat down at the computer. Those who did were unlikely to return. (As an artist-in-residence, I was a resource and not a teacher of a scheduled class.)

In contrast, this year many students immediately immersed themselves in *LambdaMOO* and were interested in locating themselves and their work within the model *Deep Creek School*. Working with details, students represented themselves and their work in any way that they wanted and linked themselves within the virtual model (Figure 6.6).

I had originally hoped that students would acquire their own characters and meet in the virtual *Deep Creek School* to discuss art and community issues, but most of the students did not have computer accounts from which to create characters.

During one session, to heighten awareness of the interactive performance and public art aspects of this medium, I took the students to the *LambdaMOO* living room. The experience raised issues about the public art audi-

ence, the MOO as a place to create public art, and *Deep Creek School* as a sheltered community. "Do we want those people in *Deep Creek?*" one student asked after spending about ten minutes in the *LambdaMOO* living room.

Although it could benefit by more depth writing and better spatial organization, *Deep Creek School* on *LambdaMOO* provided an effective way to introduce art students to online environments, coax students to start writing about their work, and provide a record of the summer of 1994 at Deep Creek School. Ideally, it will be reshaped and repopulated by future Deep Creek students.

Conclusions

In retrospect, from a public literature point of view, I could have worked more closely with the *LambdaMOO* community. The record of my tenure in this virtual space is like the record of an out-of-town artist who places a work in a community that the community feels is alien—either because the artist has not adequately studied the community or because the artist understands but does not share the values of the community involved. Nevertheless, the three narratives that I created are useful models for future Internet literature. *Brown House Kitchen*, in particular, is representative of the kind of narrative that will be possible in a future shared Internet space that incorporates audio, video, and graphics.

As the Jupiter Project Team expresses it, "In the real world, people who do things together do so in the same place; the very act of sharing location enables joint activity. We would like to see the richness of 'place' conceptually embedded in the network."[27]

Notes

1. Sherry Turkle, Life on the Screen: Identity in the Age of the Internet (New York: Simon & Schuster, 1995).

2. Lori Kendall, "MUDder? I Hardly Know 'Er! Adventures of a Feminist MUDder," in Lynn Cherny and Elizabeth Reba Weise, eds., Wired Women: Gender and New Realities in Cyberspace (Seattle: Seal Press, 1996), pp. 207–223.

3. Pavel Curtis, "Mudding: Social Phenomena in Text-Based Virtual Realities," Xerox PARC CSL-92-4 (April 1992).

4. Richard Bartle, "Interactive Multi-User Computer Games," MUSE Ltd. Research Report (December 1990). file://parcftp.xerox.com/pub/MOO/papers/.

5. Pavel Curtis and David A. Nichols, "MUDs Grow Up: Social Virtual Reality in the Real World," Xerox PARC (May 5, 1993). file://parcftp.xerox.com/pub/

MOO/papers/. Curtis is currently principal architect at Placeware. http://www.placeware.com.

6. Pavel Curtis, "The LambdaMOO Programmer's Manual." file://parcftp.xerox.com/pub/MOO/ProgrammersManual.

7. To get to Brown House Kitchen point a web browser to telnet://lambda.moo.mud.org 8888 connect guest (or your character if you have one on LambdaMOO) type @go #24969. Alternatively, you can type @go #11714 which will take you to the front steps of the kitchen.

8. According to the wishes of students at Deep Creek School, the URL for Deep Creek on LambdaMOO is not publicly available.

9. PostModernMOO provides access to texts generated by Postmodern Culture as well as an opportunity for real-time discussion. Point a Web browser to telnet://dewey.lib.ncsu.edu.

10. Hypertext Hotel uses a filter that Tom Meyer created that takes Storyspace-based hypertext documents and converts them to LambdaMOO. Point a Web browser to http://duke.cs.brown.edu:8888.

11. Astro-VR is a social virtual reality intended for use by the international astronomy community, created by Xerox PARC in collaboration with Dave Van Buren, an astronomer at the NASA/JPL Infrared Processing and Analysis Center.

12. David Blair's WaxWeb site integrates collaboratively created hypertext writing, moving image, and sound. Point a Web browser to http://bug.village.virginia.edu.

13. To reach the LambdaMOO living room, point a Web browser to telnet://lambda.parc.xerox.com:8888, connect guest, and open door.

14. Judy Malloy, "Uncle Roger: An Online Narrabase," Leonardo 24, no. 2 (1991): 195–202 ("Uncle Roger," the first electronic hyperfiction (1986) is available on ACEN on the WELL; a version is also available adapted for the World Wide Web at http://www.well.com/user/jmalloy/party.html); Judy Malloy, "Artist on the Net," Paper presented at the Third Conference on Computers, Freedom, and Privacy, March 1993; Judy Malloy, "Electronic Fiction in the Twenty-first Century," in Cliff Pickover, ed., Visions of the Future (Northwood, Eng.: Science Reviews, 1992), pp. 137–144.

15. Judy Malloy, "OK Research/OK Genetic Engineering/Bad Information, Information Art Defines Technology," Leonardo 21, no. 4 (1988): 371–375.

16. As is customary in writing about MUDs, I have changed the names of the characters I encountered to protect their identities.

17. G. P. Landow, Hypertext: The Convergence of Contemporary Critical Theory and Technology (Baltimore: Johns Hopkins University Press, 1992).

18. S. J. DeRose, "Expanding the Notion of Links," Proceedings of Hypertext '89 (New York: ACM, 1989), pp. 249–257.

19. Judy Anderson, "LambdaMOO tutorial," http://www.cs.reading.ac.uk/people/ mkh/virtual_worlds/MOO/tutorials/ducktutorial.html.

20. Cynthia Duval, "The Use of Artifacts as Tools for Thinking: A Sociocultural Study of Creative Work," manuscript, 1996.

21. Mark Weiser, "Some Computer Science Issues in Ubiquitous Computing," Communications of the ACM 36, no. 7 (July 1993): 75–84.

22. Someone in CSL suggested that it might be beneficial to change these commands into more natural English. At the time I agreed, but as I got deeper into LambdaMOO I realized that this would be akin to visiting Paris and altering the French language to suit me.

23. Rich Gold told me that there was some research at PARC on selective videotaping that they called prenarrative. The video recorder that is housed in Barbie-Q is programmed to begin recording when human heartbeats accelerate and to stop when they revert to normal.

24. The lexias are actually pseudo-randomly generated using the UNIX date function in much the same way that "Terminals," the third file of "Uncle Roger," works. See note 14.

25. Judy Malloy, "Wasting Time: A Narrative Data Structure," After the Book (Perforations 3, Summer 1992).

26. Deep Creek School is an alternative art school in the Rocky Mountains of Colorado that is sponsored by the School of Art at Arizona State University. It is directed by Dan Collins and Laurie Lundquist. Point a web browser to http:// www.asu.edu/cfa/art/events/deepcreek/DCSflyer96.html.

27. The Jupiter Project Team, Xerox Palo Alto Research Center, "Not a Highway, but a Place: Joint Activity on the Net," CPSR [Computer Professionals for Social Responsibility] Newsletter (Fall 1994). The Jupiter Project is extending the MUD form to include audio and video.

7

Forward Anywhere:
Notes on an Exchange Between
Intersecting Lives[1]

Judy Malloy
Cathy Marshall

Forward Anywhere is an interactive hypernarrative, a densely interwoven collection of vignettes. It is neither literal truth nor fiction but rather a single transcendent vision formed from two pasts. We wrote *Forward Anywhere* over a period of almost two and a half years, using email as our medium. During this time, through our writings, we came to know each other, much like two people who meet from time to time over a beer in a local bar or who share a late coffee break in an empty lunchroom. In our collaboration, we relied on the evocative force of memory and the mystery generated by the interplay of our separate stories.

Cathy: Long-term Collaborations

Long-term collaborations are based not only on subject matter or the work to be done but also on the relationships that form among the collaborators. These relationships emerge over time through conversations, through stories and anecdotes,[2] through half-remembered bits of hallucinatory past. The fabrics of communities are made up of these densely interwoven strands of their members' mutually constructed pasts until the past becomes shared.

The mission of Xerox Palo Alto Research Center's Artist-In-Residence program—and our work as collaborators—has been to build bridges between artists and research scientists. To do this, we embarked on a multiyear experiment to exchange the remembered and day-to-day substance of our lives.

The process itself was hypertextual, with new content arising through association.[3] Each lexia (or node) consisted of a screen-length image, story, or reported conversation. We responded to each other's previous lexia or our own without making the hypertextual structure explicit.[4] We called these lexia *screens*, since they usually consisted of about a screenful of text.[5]

We could have met in a MOO or used digital video to tell each other our stories; these technologies would have had some cachet, especially in the technologically charged environment at Xerox PARC. But instead, we chose to work in email, a medium so familiar and by now so ordinary that it was almost invisible—a part of our everyday lives.

For the duration of our project, we avoided face-to-face meetings, fearing that the stuff we wanted to capture would leak into our conversations. Judy had an office in the Xerox PARC building for more than a month during our two-plus-year collaboration; we had lunch together only once in this span, in addition to two brief meetings at the project's outset. In retrospect, email

was a perfect medium for working this way: during our collaboration, we each moved several times and worked from home, hotel rooms, guest offices, and airplanes using a variety of computer equipment. We often worked asynchronously, at different hours of the day and night.

In the original collection of screens, the only structure came from the associations we held in our minds. Themes emerged organically, both from peripheral elements within a particular screen (for example, a screen that mentioned old beer cans evoked several stories involving old beer cans) and from main threads of our conversation (living and working in basements is a theme we selected during a very early discussion of the project in September 1993). Later, we decided to make other means of navigating through our process available to a reader, although the published work, *Forward Anywhere*,[6] avoids the use of standard hyperlinks and instead uses navigational strategies that more faithfully reconstruct our own process.

Judy: Eventually We Called Our Work Forward Anywhere

Eventually, we called our work Forward Anywhere *because of the "buttons" on the interface that allow the reader to either navigate sequentially forward in our collected, exchanged screens, or to enter anywhere at a randomly selected screen. The words* forward anywhere *also connote our sequential additive process and its unexpected anywhere turns.*

In October 1993, for instance, Cathy described a Valentine's Day pink frosted French cruller preserved for many years in its box on her hearth:

Cathy: Heart in a Box

The doughnut looks none the worse for wear after all these years, although I am afraid to turn it over.[7]

On the day that I received that screen, her words evoked a vivid train of doughnut shop memories that I turned over in my mind while I walked down Shattuck Avenue in Berkeley. I remembered the plain doughnut

that lay on a paper napkin beside my computer every morning during the years that I worked at the University.

Subsequently, I remembered a usual lunch during the same period of my life: wonton soup at the nameless corner deli across from Radston's Stationary. Although I had not been there for over three years, in a few minutes, led by a virtual exchange of word-expressed memories, I was sitting in that deli, eating hot won ton soup, explaining to the proprietor where I had been. I pulled out my notebook and wrote a response that began like this:

Judy: Routines

When I worked at the University, every morning a plain doughnut lay for half an hour or so on a paper napkin beside my computer.

There was something of the expectant anticipatory pleasures of reading fiction in our process—where we were each both reader and writer. Once I had emailed my response, I could anticipate that unfolding of small details that cumulatively builds a work of literature. In her response to my doughnut/wonton soup screen, for instance, Cathy related a conversation at an Asian market with a man about whom I knew very little. The incidental details in her response aroused my curiosity, but I had no idea when or where he would surface again.

Typically in artist-originated collaborations on the Internet, an artist comes up with an idea and a framework or structure and sets it out where it is responded to or shaped.[8] Forward Anywhere seems more related to group installations that I have been involved in with other artists where we all worked (on an equal basis) on a piece of an installation, meeting occasionally to exchange ideas and shape coherency of content, visual ap-

pearance, and space overlap but essentially each making our own separate but integrally related part of a loosely linked whole.

During the writing of Forward Anywhere, *I continually experienced the same sense of pleased surprise that I experienced during the final installation of* Monumental Women,[9] *when I watched a painted swimming pool on the floor, a spiral tower of yellow bricks, a thousand white origami cranes emerge beside me as I worked.*

Judy: By Electronic Mail We Would Look for the Links

We met to plan our project in October 1993 in a backyard on the Albany-Berkeley border. It was a Sunday afternoon. We sat on white plastic chairs. I remember Cathy's reassuring blue jeans and the coffee and beer on the white table with the faded oilcloth cover.

Like those conversations that occur in coffee houses or bars between people meeting for the first time, the work would be an exchange of details about our lives. By electronic mail we would look for the links in our artist-researcher existences—basements, brothers or sons studying history, the assuming of persona, the playing of multiple roles.

Cathy: A Postcard Suggesting Fiction

What I visualize from our first two meetings—besides basements and gardens and beer and coffee—is a postcard, a duplicate of the one I had pinned up to the bulletin board on my office wall when I first received it, earlier that year.

The postcard is from Eastgate Systems and promises "WOMEN, HYPERTEXT, AND ART: important new hypertext fiction from Eastgate." It is an announcement of two works of hyperfiction, including Judy's *its name was Penelope*.[10]

The postcard I remember so vividly is annotated with Judy's email address on the WELL and directions to her Berkeley basement (in a subsequent penciled scrawl). Its twin has faded, for the bulletin board hung beside a sunny window that looked out onto the live oaks and horse pasture next to Xerox PARC.

The postcard made me think of our possible work together as hypertext fiction before our first meeting. But during our second meeting, we decided on a course that avoided unnecessary invention—to exchange the real remembered substance of our lives. The links would arise naturally within this constraint, shaping the work in an organic way.

We agreed, at our meeting in Berkeley, to define structure later in the project, after we had amassed content by email. The links were to be left more or less implicit in our exchange (although, in practice associations often found their way into the Subject line).

In retrospect, email seems like a naturally hypertextual form, with its splitting and merging threads of conversation, its subjects that recur and reemerge, and its tendency to discourage linearity and closure.

Judy: A Series of Flashers

Our work began by electronic mail between well.com and parc.xerox.com in late September 1993, although Cathy's enviable Southern California childhood

Cathy: No Basements

When our teachers would ask us why we hadn't been in class, we'd shrug and say, "Went to the beach," as if full disclosure would suffice.

seemed worlds away from my more rigidly structured New England past:

Judy: School Was Inevitable

In New England, school was as inevitable as the commuter train that my father took into Boston every weekday morning.

There were unifying themes. Basements and a series of fires began in the opening screens. Controlled substances, white food, the gathering of horse chestnuts, cockroach death chemicals occurred, reoccurred. Men appeared in pairs. Men appeared in motels or on motorcycles. Flashers exposed themselves intermittently (figures 7.1 and 7.2).

Since we had both been using it for over ten years, electronic mail was more than just a method of delivery. Because both of us have sent and received thousands of email messages and are comfortable, experienced, and fluent in this medium, it was also a shared medium. Additionally, we both used old email archives as a source of narrative material:

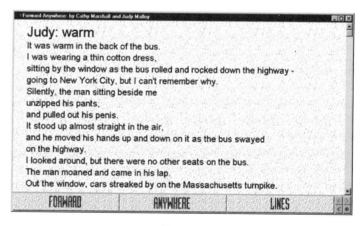

Figure 7.1
Judy Malloy and Cathy Marshall, Judy: warm, from *Forward Anywhere,* 1996

Figure 7.2
Judy Malloy and Cathy Marshall, Cathy: beached pervert, from *Forward Anywhere,* 1996

Judy: Old Email

Fred and I are working on the FineArt Forum archives. In a message with the Subject "hi, ho silver," Fred gives the programs Lone Ranger Names "silver," "tonto." Did I tell him about my childhood fantasies about the Lone Ranger before or after he named these programs?

Cathy: Email Romance

At first, we flirted shamelessly by email, as if I still lived there in the basement with him. I'd be ready to click on the scroll bar if there were footsteps in the hall.

> *"The image of you/me—our physical selves always there in the writing," Martha Petry wrote in "Notes for Izme Pass Exposed,"[11] the paper that she and Carolyn*

Guyer created about their collaborative hyperfiction Izme Pass. But they knew each other, and we did not.

Because we did not know each other, the creation of the work resembled, to a certain extent, a two-way therapy process. For instance, in response to triggering passages in Cathy's screens, I freely related previously unexposed details of my life. Subsequently, a certain amount of editing, name changing, and fictionalizing was necessary.

Cathy: Fluidity and Congruences

Time became very fluid, malleable, during our exchanges. We'd flit back and forth between childhood, earlier today, and indeterminate points in between. Chronology of the events in our exchange is elusive and reclaimed only by the construction process that each of us play as readers. These three excerpts are from screens that use the ocean as a backdrop span childhood, the late 1970s, and the writer's immediate setting:

Cathy: Tidepools

chitons clinging to rocks, darting sculpins, ocean-green anemones, their tentacles swaying with the mild swells. . . .

Perfect worlds, miniature, bright and moving.

Cathy: Narrow Bridge

The ocean grew louder.

A million chirping frog voices merged with crashing waves. . . .

"I think I'm stepping on frogs, man."

Corky's voice floated back toward us.

Judy: Oasis

Here there is no cold, deep blue green ocean water, no jelly fish drying in the sun, no tide pools in the beach sheltering rocks.

The screens grew to be a collage of (sometimes overlapping) memories. Odd moments of congruence emerged. Our voices sometimes seemed very similar, and at other times quite distinct.

Judy: At Xerox PARC

In November 1993, I was inside Xerox PARC working in the Computer Science Laboratory (CSL) with Pavel Curtis on a different project—a narrative in LambdaMOO *called* Brown House Kitchen.[12] *Soon after I arrived, Cathy and I had lunch in the cafeteria.*

Questions and answers flowed so quickly that it was apparent meeting face to face would dilute our exchanges. As a result, reluctantly for me at least because conversation with Cathy was a welcome oasis from the

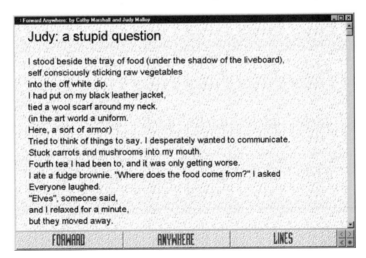

Figure 7.3
Judy Malloy and Cathy Marshall, Judy: a stupid question, from *Forward Anywhere,* 1996

Figure 7.4
Judy Malloy and Cathy Marshall, Cathy: celestial small talk, from *Forward Anywhere,* 1996

fascinating, but code-focused, mostly male CSL, we agreed not to have face-to-face meetings until the following August, when we were scheduled to spend a month together structuring and programming our work.

However, during the month that I spent inside PARC, I recorded some of the more awkward aspects of this environment in a series of screens that I emailed to Cathy (figure 7.3). I was surprised by the echoes of my inept socializing with researchers in her responses (figure 7.4).

And sometimes I waved when I passed her window on my way to PARC in the morning.

Cathy: Metaconversation

I kept my steadily growing record of our exchange in a mail folder. When I look back through the folder, I find little conversation outside of "project content" (the screens that became part of what eventually became the published work). There are only intermittent messages about our own status. Most of those concern garbled transmissions, travel (that is, periods when we would be out of email contact), or the schedule for the period when we planned to work together at PARC in August 1994. They are, for the most part, brief messages.

In early July 1994, I sent out a message:

Wanted: Rental or Housesitting for August

Judy Malloy is a PAIR artist who will be in residence at
PARC during August. She would like to find either an
inexpensive sublet or (better yet) a housesitting situa-
tion for that month. Near PARC is best. She has a quiet
female cat.

Ironically, this was the day before Judy's acci-
dent in Phoenix.

Judy: Another Accident in Phoenix

*I am lying on a couch in Berkeley, looking out the
window, down the driveway at several resonant-of-
Arizona palm trees. Some of my words in our collabora-
tion were written in Berkeley, some in Palo Alto, some
in Arizona where I was doing some work for* Arts Wire
*(an online communications system for the arts) in the
first half of 1994. Now I am back in Berkeley where it
began. Cathy's surroundings have also fluctuated dur-
ing the years that we have been working together. For a
while, she was writing me from College Station, Texas.
Now she is back at PARC.*

*It is a foggy summer morning and in the damp air,
the metal rods in my leg that did not exist when this
work began, persistently ache as I review the trail of ac-
cidents and scars in our work that (so fittingly from a
literary sense) ended with "another accident in Phoe-
nix." Like the fires, these accidents and catalogues of
scars began early.*

Cathy: A Catalog of Scars

Mark has scars too, one on the bridge of his nose where a
cop hit him hard, with a closed fist when he was wearing

glasses. He had been riding his motorcycle: it was a motorcycle accident of sorts.

Judy: Internal Scars

I remember seeing the wheels of the ongoing cars as my head skidded on Grove Street after the kid in the station-wagon ran into my motorbike. I remember that a man on the sidewalk told me that they thought I was dead and that while I lay there unconscious for several minutes, no-body had stopped the rush hour traffic.

Cathy: Another Accident

Yesterday's accident in Phoenix reminds me of Corky. Af-ter the crash, he could only move the muscles above his shoulders. His neck was knotted with tension as he watched *The Black Stallion* on the VCR in his room at the nursing home.

Cathy: Midconversation

Midconversation today, my mother asked me,

"How's that boy doing?"

"Corky? Mom, he died more than a year ago, in the sum-mer. I remember telling you."

I was standing in front of the kitchen sink when I said this to her because it seemed just a little warmer there. I had abandoned the crossword puzzle at the kitchen table.

"That's right," she said, "I remember.

Drug overdose?"

"It was a car accident." I didn't want to talk about it a second time. Nor did I say anything about the accident outside of Phoenix almost a week ago, even though she'd known both boys.

In July 1994, about half a year after Cathy sent me the series of screens about the accident near Phoenix, I was crossing Mill Avenue near Phoenix, in Tempe, Arizona when a pregnant seventeen-year-old girl with no driver's license was looking at the shopping center instead of the road:

Judy: Another Accident in Phoenix

I don't remember what happened.

The witnesses tell different stories:

"She was walking a bike on the crosswalk."

"She was riding a bicycle across Mill Avenue."

"All of a sudden a car appeared and struck her."

"I heard a scream."

"The victim was an older woman on a bicycle."

"The victim was a girl."

"The accident victim flew through the air along with her bike."

"Saw her fly through the air and fall."

I remember what looked like a disconnected rubber foot bleeding profusely with bones protruding, lying beside me on the unbearably hot pavement.

I spent the rest of July at Maricopa County Hospital in Phoenix Arizona where a series of surgeons bypassed my severed artery with pieces of vein harvested from my ankle, inserted rods and screws from my hip to my ankle, and finally covered the exposed bones with pieces of muscle and skin from donor sites on other parts of my body. Despite the reconstruction, there was an 85 percent chance of losing my leg.

In August I emerged from the hospital with a fresh patchwork of scars. I still had a semifunctional left leg, but there was no way that I could go to Palo Alto as originally planned and work with Cathy. We talked on the telephone. Since we are both interested in virtual communities and virtual collaboration, we decided that a virtual way of continuing and finishing our work was not inappropriate and might even be interesting.

Sometimes working while visiting nurses changed the dressings on slowly healing extensive graft sites, I began the process of organizing our accumulated words on a Toshiba laptop borrowed from PARC.

Cathy: Lexia and Dyslexia

Judy's screens about her accident in Phoenix marked the end of the first phase of our collaboration. We then turned our attention to structure— the details of how to present the individual lexia, how to connect them, and how to give a reader some sense of the process that shaped them. We also began to edit the screens, creating composite characters and fictionalizing the events and places described in the work.

Structuring the work was more difficult than I expected. My first impulse was to draw a map of the structure—a graph that showed (with labels and arrows) how the lexia were linked. This map covered five sheets of paper and grew so inexorably complex that I could not bear to continue creating the diagram. Was Judy's thirty-second screen really linked to my thirty-sixth? Arrows snaked around the margins of the page. Lines became dotted lines, as I found screens that were part of multiple sequences. Ambiguities were noted. Labels were crossed out and moved to another page. Small notations—"drinks & lam-

preys," "handgun," and "accident"—appeared as I worked.

After days of struggling with what seemed to be an impossible task, I realized that the reason it was so hard to render this structure was that these tangible associations did not reflect what we had done together. The fluidity of the process obscured the complexity of the structure. The piece is both densely interconnected and loosely woven. The question then became, How do we express the process and make it accessible to a reader? Should we expect a reader to experience the screens in the same order in which we wrote them? Should we put the reader in front of a CRT in a darkened motel room?

Judy: Black Vinyl Headboard

I have the lights turned out. Yellow words emerging from the black monitor.

Should we choose multiple beginnings and multiple endings? Should there be coherent threads through our lives? Chronologies? The work is neither fiction nor biography, neither literal truth nor carefully wrought storytelling. It is a hypernarrative, a form with no prescribed structure.

Fall 1994 was a period of blossoming activity on the World Wide Web. We decided to realize the original collection of screens as a Web site[13] and set about experimenting with ways to give a reader the appropriate means of navigating the piece. We kept the markup simple so that the work could be read with a minimal hardware configuration using any of the then-popular Web browsers and would not be frustratingly slow if

accessed via modem. Figure 7.5 shows a sample Web page—text-based with three text buttons at the bottom of each page.

We designed three functions that fit with the way in which the work was created. The first, *Forward*, traverses the screens in the order each of us saw them (either as we read them or as we wrote them). Events and episodes unfold as they were revealed to each of us as a reader. This type of navigation simulates the process and captures the mystery we each experienced.

Anywhere brings a reader to a screen selected at random from our entire collection. Anywhere addresses the high interconnectivity of the lexia just as surely as using a large number of explicit links, since the effect is in some ways quite similar: a reader can get to any screen from any screen. Through new juxtapositions, the Anywhere function reveals unintended connections and the merging of our voices.

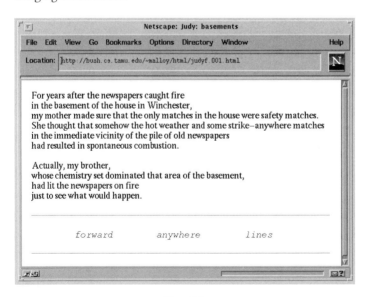

Figure 7.5
Judy Malloy and Cathy Marshall, Judy: basements, from the initial Web version of *Forward Anywhere*, 1996

Because so many of the associations between our screens grew out of particular words, we decided to include a generative function called *Lines* in the first Web version of the work. Lines gave the reader an interactive way of collecting screens about similar topics. The function organizes traversal thematically; it shows how the work coalesced into threads about the people, places, and events that have shaped our imagined conversation.

The idea for Lines came from a talk Judy gave at Stanford in which she used a technique of this sort to gather excerpts from our collected screens. She had used a Search command to accrete all the lines from both our screens that referred to beer and create a composite screen, which she then edited for presentation.

This, we reasoned, was something any reader might want to do—request a screen to be gener-

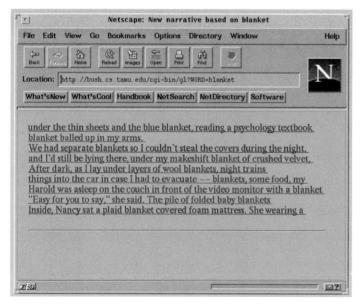

Figure 7.6
Judy Malloy and Cathy Marshall, automatically generated lines containing the word "blanket," from *Forward Anywhere*, 1996

ated from the work based on a thematic word. In the Web version of the work, the Lines button first requests a word from the reader and then gathers the lines containing that word. Prior to display, each line is automatically marked up so that it is linked to the screen from which it originated. In this way, the reader might request the work to generate the following screen about, say, blankets. Figure 7.6 shows the results using the word *blanket*. Note that one of the links is to figure 7.5 above.

This technique adds a third voice to the work—that of the reader, since it is the reader's choice of words that drives the gathering process. I have been surprised in my tests to find that even arbitrary (nonthematic) word choices like colors lead to interesting, automatically generated screens.

Judy: Two Installations

When computer-based works are presented in an art context, it is helpful to the user-viewer to situate the work in an installation context that highlights elements of the work and draws the reader to the screen.

In two separate installations—in the lobby of Xerox PARC during PARC's twenty-fifth anniversary celebration[14] and in Artemisia Gallery in Chicago as part of the show ADA: Women in Technology[15]—we placed Forward Anywhere *in situations that invited viewers to experience our process as well as our work.*

In October 1995, two white plastic chairs and a white plastic table were placed in PARC's corporate lobby. Covered with a blue and white checkered oilcloth, the table contrasted with the formal green couches, massive reception desk, and conventionally framed art work in the PARC lobby. Not only did it suggest the more in-

formal backyard environment where our conversation began, but it also echoed the idea of a cafe conversation between two strangers that had been the impetus for our work. In the center of the table, the Web version of Forward Anywhere *was running on a PARC MPad, a mobile wireless X Window platform.*[16]

At the ADA show in March 1996, Forward Anywhere *was installed on a round revolving wooden table with two chairs. On the table were a keyboard, a coffee cup, and a beer can. ADA curator Andrea Polli both installed the work and provided the details of the installation.*

The monitor was mounted on a pedestal that dominated the table and was visible throughout the gallery. When viewers sat at the table and navigated the work using the keyboard, our screens—implemented for this installation with a black background and yellow and green text (figure 7.7, plate 2 in the color pages) that

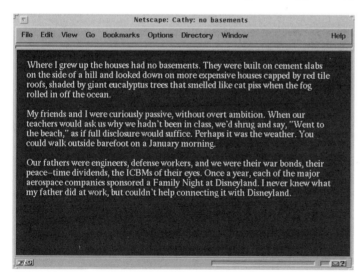

Figure 7.7
Judy Malloy and Cathy Marshall, Cathy: no basements, from the version of *Forward Anywhere* installed at the ADA show, 1996

Cathy: Beginnings, Endings, and
All That Lies Between

It has been almost three years since Judy and I met over beer and coffee outside her basement in Berkeley. Sometime after we created the Web version of our exchange and before the installations, we came up with the title *Forward Anywhere.* The title is ironically apt considering the work was produced in email (a source for *Forward*'s double meaning) and written over a series of relocations and dislocations including Berkeley, Palo Alto, Tempe, and College Station (*Anywhere* is appropriate). The title came into being when we shipped the initial set of edited screens to our future publisher, Eastgate's Mark Bernstein.

We continued to exchange screens as we structured the results of our initial correspondence. The new set of screens both followed on from our

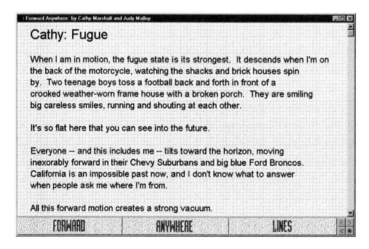

Figure 7.8
Judy Malloy and Cathy Marshall, Cathy: fugue, from *Forward Anywhere,* 1996

Figure 7.9
Judy Malloy and Cathy Marshall, Judy: horizon, from *Forward Anywhere,* 1996

older conversation and situated us in new places and circumstances as Judy began the long recovery process following her accident, and as I tried to adapt to life in a small town in Texas (figures 7.8 and 7.9).

In early 1996, after a series of eerily connected incidents in which our lives seemed to be following in a pattern dictated by *Forward Anywhere* (rather than the reverse), Judy and I made the difficult decision to call the piece complete. Mark Bernstein quickly reimplemented the work's three functions in a customized reader, and released a "Hypertext '96 Collectors Edition" of *Forward Anywhere* in March 1996 (figure 7.10). Its vermillion and blue packaging (designed by Eric Cohen) surprised us, but we agreed that the hallucinatory quality of two contrasting colors fit the spirit of the work. Likewise, Mark Bernstein's redesign of the Lines function followed the intention of the original. In the published work, a reader may navigate by clicking on words in the lexia. The anchors are invisible in the text; the destination is determined by the anchoring word

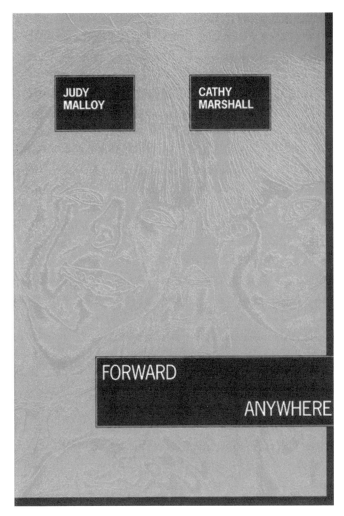

Figure 7.10
Judy Malloy and Cathy Marshall, front cover from the Eastgate version of *Forward Anywhere,* 1996

in combination with past choices. For example, clicking on *motorcycle* in figure 7.8 will bring a reader to figure 7.11, a lexia written early in our collaboration.

It has been six months since Judy and I stopped exchanging screens. There are many days

Figure 7.11
Judy Malloy and Cathy Marshall, Judy: scars, from *Forward Anywhere*, 1996

that I feel a twinge of regret: something has happened that would be perfect for *Forward Anywhere*.

Closure was never a goal of this piece.

Notes

1. This chapter includes some modified excerpts from Elizabeth Weise and Lynn Cherny, eds., "Closure Was Never a Goal of This Piece," *Wired Women: Gender and New Realities in Cyberspace* (Seattle: Seal Press, 1996).

2. Even the work itself may take place through the telling of stories. Xerox PARC anthropologist Julian Orr has found that the knowledge of the technicians who repair Xerox copiers is embedded in the informal stories they tell each other about fixing machines. See Julian Orr, *Talking About Machines: An Ethnography of a Modern Job* (Ithaca, NY: ILR Press, an imprint of Cornell University Press, 1996).

3. Most hypertext research and literature rests on the product—a published (and possibly collaboratively written) interlinked set of what Landow has termed *lexia*. See G. P. Landow, *Hypertext: The Convergence of Contemporary Critical Theory and* Technology (Baltimore: Johns Hopkins University Press, 1992). My research over the last five years has involved the more fluid process of putting together hypertexts, including the creation of implicit links. See C. C. Marshall and F. M. Shipman, "Spatial Hypertext: Designing for Change," *Communications of the ACM,* 38, no. 8 (August 1995).

4. In a few instances, one or the other of us would respond to something in a recent verbal communication—a *dangling link* in hypertextual terms.

5. Of course, hardware differences imposed different constraints on screen size.

6. Judy Malloy and Cathy Marshall, *Forward Anywhere* (Cambridge, MA: Eastgate Systems, 1996).

7. Ibid. The quoted texts in this chapter appearing in the center column are from *Forward Anywhere*.

8. For example, I produced *Thirty Minutes in the Late Afternoon* on Art Com Electronic Network on the WELL by setting out the beginnings of a story and a structure in (three parallel data streams) in which to shape it. The thoughts of three characters were then written interactively by eleven writers. See Judy Malloy, "Thirty Minutes in the Late Afternoon," *Art Com Magazine* 42, no. 10 (1990). Ubiquitous, easy-to-produce forms on the World Wide Web have trivialized this strategy, and the power relationship between producer and contributor inherent in this construct is currently much discussed among interactive artists.

9. *Monumental Women,* SOMAR Gallery Space, San Francisco (September 18–October 31, 1987).

10. Judy Malloy, *its name was Penelope* (Cambridge, MA: Eastgate Systems, 1993).

11. Carolyn Guyer and Martha Petry, "Notes for Izme Pass Exposé," *Writing on the Edge* 2, no. 2 (Spring 1991): 82–89.

12. Created in collaboration with Pavel Curtis, as part of my 1994 residency at Xerox PARC, the narrative *Brown House Kitchen* is disclosed by the objects in a room of that name in *LambdaMOO.*

13. The Web version of *Forward Anywhere* is located at http://csdl.tamu.edu/~malloy/html/start.html.

14. The Xerox PARC twenty-fifth anniversary show was installed (with the help of Marshall Bern) in various places through PARC in October 1995 as part of the celebration of PARC's twenty-fifth anniversary.

15. *ADA: Women in Technology,* Artemisia Gallery, Chicago, February 30–March 29, 1996.

16. Christopher Kent Kantarjiev, Alan Demers, Ron Frederick, Robert Krivacic, and Mark Weiser, "Experience with X in a Wireless Environment," Xerox PARC CSL-93-9 (September 1993). The MPad was installed with the help of PARC researcher's Lawrence Butcher and Bob Krivacic.

8

Endless Beginnings: Tales from the Road to "Now Where?"

Margaret Crane
Dale MacDonald
Scott Minneman
Jon Winet

It was 4 a.m. on April 19. Deep in the middle of the darkest, emptiest part of the night, we were all pretty punchy. The tatty fixtures in our trailer, at #7 Pine, were the only lights on at the University Mobile Home Park in Goleta, California. It was thirty-six hours before the gala opening of *Homeshow 2*, an exhibition of commissioned installations for the Santa Barbara Contemporary Arts Forum.

Jon, Margaret, Dale and Scott. Three years ago we had just been selected as a pairing for the artists-in-residence program. Now, we were all working to finish a combined physical and on-line installation in a 1959 single-wide, 7' x 38' mobile home. That night we were revising HTML and wrestling with Python code that would soon turn music CD players on and off. At the same time we were attempting to complete the networking of three Sun workstations that would allow us to run a local Web site. Next door, the safety light on the carport emitted an unremitting high pitched whine. After a while, we got used to it. It just became part of our landscape.

The third mind appears when two or more minds collaborate. Something emerges that is bigger than the sum of the parts. In that trailer, in the middle of the night, we were miles away from our early exploratory conversations as artists (Jon and Margaret) and researchers (Dale and Scott). In the three years since we had met, we had covered the distance between trying to unite our individual projects, developing a collective interest that had something to do with public art and interactive communities, tweaking technology until it does what you want, and making narratives between the virtual and physical worlds. But really, it wasn't about any of those things any more. It was about making this piece called *Accommodations*. As it began to grow light outside, the third mind looked kind of like a beat-up yellow trailer, and we weren't talking very much, and everything that we were doing was funneling toward this place that flickered across the monitors and linked up in a mobile home park on a quiet side street in Goleta.

The Snake Pit: SIGGRAPH 95

About a year after we began our pairing, we came up with the concept for our first collaborative public project. We called it *The Snake Pit* and planned to launch it at the SIGGRAPH 95 conference. *The Snake Pit* was a participatory installation designed to explore issues of mental health care and human consciousness. The piece spun off from Jon and Margaret's text/image work and exploration of social pathologies. It combined Dale's interest in the development of a high-resolution flat panel display and Scott's ongoing exploration of electronic communities. Despite our careful plans, this was not a successful project. In fact, it never left the drawing board.

In hindsight, this failed project was pivotal to our creating a viable pairing that genuinely fit who we were. It was the beginning of a shared working practice combining art and technology. And *The Snake Pit* brought Jon and Margaret deeper into the culture of PARC and smack up against Error 33. Dale says we followed the recipe, but the recipe didn't work. Within the original PAIR model,

We planned for *Snake Pit* visitors to use a tou screen interface to engage with a near-photograph 6.3 million pixel (3072x2048), greyscale, liquid crys display, driven by an extended hypertext mark language and a customized World Wide Web brows

artists and researchers were to create an intensive, finite project. We discovered that this first project only got us started. While developing *The Snake Pit* on paper, a typical conversation would go something like this: Jon or Margaret would say to Dale or Scott, "I have an idea that would look really great. What can we do with technology to make it happen?" We were still in our distinct and separate capacities as artists and researchers. Our individual interests were clearly identified, but collective enthusiasms were still to come. Then it all became academic. Marketing would no longer allow less than perfect displays out of the building. Perfect displays were still eighteen months away. By that time we would undoubtedly be on to something else. Error 33. We cancelled the project.

Things we build during the day fall

Search for Tomorrow: some notes from the PARC residency...
Vocabulary Lessons—In the first four years of our two-month residency, we grappled with questions of language. In our very first meetings in October 1993, we discovered that particularities of specific language systems—UNIX, Xemacs, perl, HTML and of course, our individual idiosyncratic usage of

The evolution of affinity groups, collaborations, and online communities opens the way for new methods of thinking and making things that cut across the lines of traditional disciplines. The cultures of art and scientific research clash and blend. The compatibility lies in the friction. That's where you

The third mind—that incarnation of the collaborative imagination—doesn't just happen automatically when people work together: it is an achievement, it takes time, and it requires effort. At the outset of our pairing, we had little of the scaffolding typically present in groups that are being encouraged to collaborate—no corporate culture, no dedication to a material or financial

"Hello...Hi Jon...Lunch at 12:30, sure! See you then." Click. Food has been our friend. Noon was the time and the PARC cafeteria was the place where much of our expectation management took place. With oddly overlapping schedules and diverse commitments, lunch became the forum for the four of us to talk. Much

Er♦ror 33 (er' ər thurt' ē thrē) n. a failure mode resulting from allowing a research project to be predicated on results not yet obtained by another, separate research project.

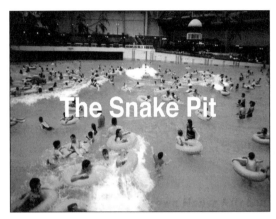
The Snake Pit

The Snake Pit was designed to be a multimedia narrative forum that allowed viewers to contribute their own stories to the site via textual, audio and video authoring facilities.

The melodramatic mushroom cloud of the millennium looms on the horizon. Cardboard scenery flies away in the monsoon wind. Lightning illuminates everything. In the cobalt sky these words are written: *All that is solid melts into air. All we want is what we've lost.*

apart at night. Down the street, a

English—both provided bridges to our respective cultures of art and technology research and kept us at bay.
The Document Company—On the up side, in much the same way that when you're holding a hammer, everything looks like a nail, life and work at Xerox puts one in a frame of mind where everything looks like a (potential) document. Our

get the spark. Technology offers a space where disciplines can merge.
Over time, we developed a shared culture—a place to work together in. It's part research, part art. This culture exists on the Net, in gallery installations, and in public locations. Over the years, we've created

goal, no common opponents. It's somewhat ironic, but the bureaucracy of contemporary work life came to the rescue here. Margaret once quipped in an interview, "We spent the first six months trying to figure out where to sit." Cemented by the experience of getting security badges, computer passwords, telephones, voicemail, and chairs, the next steps looked easy.

of our communication started over lunch and by afternoon drifted off to a series of one-to-one conversations. After lunch, we lapsed into a workable mix of sending email and bumping into each other in the halls. Occasionally, we'd call a meeting to resynchronize our thoughts, but once a production

General Hospital

General Hospital was an investigation of mental health in American society. In the world view of *General Hospital*, personal and institutionalized issues surrounding mental health created the context for looking at late twentieth century America. The piece was done as part of San Francisco-based Capp Street Project's *Art in the Urban Landscape*. We created a framework that allowed us to explore various strategies for working in physical and digital venues for public and gallery based art. The resulting series of interconnected pieces used high- and low-tech media ranging from the Internet and the World Wide Web to live focus groups and wired gallery installations.

We like to think of our version of *General Hospital* as a kind of do-it-yourself soap opera looping though the infinite void of electronic space. Our soap opera juxtaposes narrative text/image pieces with practical information and the voices of online participants. The

stories, comments, and late-breaking information posted to the linked text-based newsgroup `alt.society.mental-health` and to the interactive comment areas, revitalize the site in soap operatic fashion.

Our intentions with *General Hospital* were to extend notions of public space to

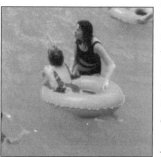

encompass electronic space, and within elec-

Some people think it's all an excuse. Others wish that the Detox Center was still open. Prevention works. And so does the self-help movement. It's about power. It's all in your head. If you lived on the street you might seem crazy too. Most everybody needs someone to talk to. The social safety net unravels. A few people are weaving it back together.

tronic space to adapt strategies of public art to digital technology. Our first sizable Web site was the pivotal element of *General Hospital*. It evolved over time with the ever-changing, quasi-public environment of the Web.

The layered nature of the digital landscape gets interesting when diverse tones and intents rub up against each other. It's a

car starts up. The clock ticks. A

linking of document and artifact, artifact and artwork provides the conceptual basis for our projects. We all use our preferred tool—computer science, photography, text, and design engineering—to attempt the creation of work that matters. At the core, and from different vantage points, we share a fierce passion for language in its broadest definitions.

this culture of our pairing. It's made out of all the things we brought to it. Like one of those science fiction movies, the survivors of a disaster create a new world out of the remains of the old. As time passes, original uses are forgotten. Artifacts take on new meanings and functions. That's kind of how

During the first year of our pairing, we inched toward actually doing something together. We were making headway on one of the pivotal accomplishments in collaboration—the development of shared understanding. As Jon and Margaret came to grips with synchronous and asynchronous collaboration in multimedia environments, shared sketching tools, ultra-high-

deadline drew near our communication became mediated by the work itself. We discovered that collaboration is a tightrope between power sharing and each individual's tendency to not relinquish any power. This forces a system of communication. "No" was seldom the answer, but it

place packed with an increasingly commercial clutter of home shopping sites, pornography, gossip columns, and upscale magazines. We designed *General Hospital* to offer its own variety of atmospheres—spaces for public interaction, practical information, resources, and poetic text/image work.

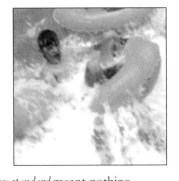

While working on the *General Hospital* Web site, we quickly learned much about the unstable state of HTML and its authoring and delivery systems in late 1993. Jon and Margaret adapted their visual ideas to the limits of the technology. Scott and Dale struggled with the various stunts required to give a modicum of layout control in a world where *standard* meant nothing.

Somewhere there is a perfect house. It is serene and neat as a pin. Exquisitely selected furniture represents the pageantry of history. Memory is evoked by wafting odors of lilac, urine and camphor. In this perfect house, well-intentioned technicians adjust our bandages. In the foyer, these words are gouged into an antique table: I cannot bear to live in this world.

As a location for public art, the Web offers unique possibilities for change and adaptation. Besides linking to the `alt.society.mental-health` newsgroup, our site offered interactive areas where users could respond to a changing array of topics. To accomplish this, we pioneered using CGI scripts and simple database technologies to allow readers to contribute to the site.

Diminishing public funding for mental health programs is part of the continuing disappearance of our public sector. This loss finds a corollary in the disappearance of public space. The context for making any kind of public art today, whether on the street or the Net, is this loss of public space. Its symptoms: creeping anxiety, fear of difference, and loss of compassion. These repercussions of the changing urban landscape create the background for the imaginary universe of *General Hospital.*

wheel spins. We tumble into its

The Collaborative Third Mind at Work—The art practice of the collaboration within "Margaret Crane/Jon Winet" from the get-go has operated at a host of intersection points. Within the PARC residency, we've found ourselves with a variety of new and continuing intersecting, overlapping, at times contradicting challenges. Task One: finding a place to work and a viable work practice as we

we've adapted elements from the cultures of art and technology. The process of working from a hunch or hypothesis is a way of thinking that links the two cultures. We all knew what it was like to imagine a result—whether technical, conceptual, or visual—and then

resolution display technologies, the Internet, and the budding World Wide Web, Scott and Dale picked up on social issue trading cards, precise graphical layout concerns, the Tonya Harding Fan Club, and new ways of thinking about reaching a public with a message. We became sensitized to how we each saw the world and what drove us to be doing what we were. We figured out that we

sometimes took lengthy conversations to understand when "yes" was. Often those conversations spanned months and projects. PARC is notorious for long-running conversations and arguments that take place solely over email between people whose offices are next door to one another. Amazingly, this behavior

alt.society.mental-health

We launched `alt.society.mental-health` in late 1994 as part of the exhibition *Collaborations: Inside the Armory/Out on the Street at the Pasadena Armory Center for the Arts in Pasadena, California.* The computer linked the physical gallery installation to electronic space. Visitors to the Armory were invited to post their comments to the electronic discussion on mental health.

The Internet newsgroup `alt.society.mental-health`, an interactive, text-driven component of *General Hospital*, depended solely on audience interaction and responses. One of our goals was to reach audiences beyond our built-in constituencies in the art and technology worlds. And for `alt.society.mental-health`, we targeted mental health care providers, clients, and their families. From these groups came active and articulate participants for a newsgroup that continues to this day.

The Internet's illusion of confidentiality makes it an inviting venue for discussing intimate and even secret concerns. Beginning with the launch of the newsgroup in November 1994, an online cast of characters—their interests as varied as their psychological states—have checked in to *General Hospital*. As these unscripted, unedited responses pile up, they create their own narrative environment—a virtual version of that popular soap opera setting, the hospital waiting room. As in the soaps, this sometimes chatty, often confessional, location serves as a device to bring disparate characters together. The results have been electronic posts covering everything from a patient's experiences in mental hospitals and a professional's barbed comments about psychiatric conferences, to tips and warnings about antipsychotic medications and eloquent pleas against forced commitment.

whirling vortex. The farther we fall,

move from art in the age of mechanical reproduction to art in the digital age. The Margaret Crane/Jon Winet collaboration's conceptual studio, traditionally sited in our heads, now also resides at PARC, with virtual racks housing our PAIR production over the last few years. Our second task is working toward and through collaborative practice. As our numbers swelled to four, with the

work through a series of steps to reach it. Scientific method and artistic practice are not the same, but we found the shared tools of intuition, improvisation, observation and awareness of process. And, through these tools, we figured out how to use our combined ideas to make something concrete.

were compatibly wacked and that we each needed to take turns policing topics in meetings or we would endlessly diverge.
Ideas crop up: "So I've figured out how to get the pesky file upload feature in Netscape 2.mumble working, and I've got a primitive public scrapbook working with it," or "Say, I stumbled across a site where somebody is monitoring the body

seldom crept into our collaboration. Several years into our pairing, we created conwis—an email address and alias for the four of us. The alias was first intended to facilitate conversations with the contributors to *Conventional Wisdom*. Now we use it as a "Hey, look at this!" vehicle for sharing information.

Postings pointed `alt.society.mental-health` participants to other emerging news-groups. Online affinity groups emerged. Some related newsgroups dealt with specific concerns such as bipolar conditions. Other postings conveyed established psychiatric viewpoints, while groups with alternative perspectives offered dissenting voices. We had discovered, and become part of, a text-based universe that was alternately contentious and supportive, despairing and hopeful. And it was the voices that rose out of that universe that guided the newsgroup along its tangential and ever-forking paths.

```
Active threads from alt.society.mental-health...
Involuntary psychiatric treatment      (+ 5 replies) Jan 14 1995
Discharge planning                      (+ 8 replies) Jan 14 1995
Windhorse Course Announcement                         Jan 16 1995
Truth about electroshock                (+ 9 replies) Jan 18 1995
Who is a consumer?                      (+ 5 replies) Jan 18 1995
```

```
Charter Post for alt.society.mental-health

We invite and encourage mental health and public policy professionals, consumers,
social workers, theorists working in and outside of academia, students, artists,
researchers, scientists, and the interested general public to contribute to a wide
range of related topics including (but not limited to) legal and legislative issues,
advancements in neuro-chemistry, the DSM-IV (the Diagnostic and Statistical Manual of
Mental Distrorders-Fourth Edition), violence and mental health, economic issues, the
role of family in mental health and mental illness, feminist theory and practice
within the culture of mental health, current research on the 'mapping' of the brain,
psychopharmacology and issues raised by the use of SSRIs (Selective Serotonin Re-
uptake Inhibitors)-Prozac, Zoloft, etc., public policy and practice in mental health
care, and issues of advocacy.

alt.society.mental-health compliments existing related groups such as
alt.psychology.personality and alt.psychology.support which have a more specific
psychological and therapeutic approach to the topics.

We hope alt.society.mental-health will make a positive contribution to the discussion
of these topics. We welcome your comments and participation.

---------------------------------
Margaret Crane/Jon Winet
crane@igc.apc.org, jawinet@ucdavis.edu

More? <sp>  Read? <ret>  Next thread? <t>  New thread? <n>
```

the smaller we get. The room twirls.

literal insertion of two scientists/researchers to form a new working group (c-m-m-w). Both the difficulties and rewards of channeling the third mind have increased exponentially.

General Grant on His Horse—It has been daunting to contend with the impact of the Internet on our collective sense of space and place. In terms of public art production, what replaces the statue in

Notions from public art about reaching audiences outside of galleries fueled our collaboration. We found that online technology created a place that could reach all different kinds of viewers. Electronic space possesses a combination of characteristics that make it a public art venue of unusual potential.

temperature of their pet gerbil," or "Hey, some of those passing cars have radio transmitters...garage door openers...can't we leverage that to control the interactive fiction on our video billboard?" The

ensuing conversation (and often accompanying demonstration) served many purposes. We'd all want, from our own perspectives, to know what was causing sparks of interest, what was different,

Outside of the closed system of conwis, the Internet has been the broadcast medium by which we inform the public about our projects and plans. It links us to our target audiences in art, technology, and multimedia. The Internet has also connected us with more specific viewer/users like the constituency of

Accommodations

For *Accommodations*, we envisioned this derelict trailer in Goleta, California as a bridge between two worlds—a physical place with an evocative online analog, and a rich online representation where movement and activity on the Web site produced effects in the physical installation. The piece was part of a series of site-specific installations that explored contemporary notions of home. *Accommodations* evoked home as an illusive site of the imagination—part memory, part history, part wish. Cyberspace mirrored the mobile home park. And the technology became another kind of bridge between two changeable, fluid locations.

Our goal was to immerse visitors in this charged narrative environment. But when we arrived at the trailer, gear in hand, ready to plug things in and run, we were faced with the difficulties of firetrap wiring and rickety everything. We had seventy-two hours to create a turnkey installation that would run problem-free for the next two months. Many trips to Radio Shack, Orchard Supply Hardware, and 7-11 later, the trailer was rewired and enough repairs were made that we could begin installing the piece.

The installation held a small, stand-alone network of three computers to run and display a local Web site. Visitors interacted with standard Web browsers on two Sparc Voyagers. From a nearby utility closet, a workstation served Web pages and controlled various MIDI devices that changed

In the center of the world is the place we all remember. Somewhere there is a place floating in the ether. It is your shelter in the night. It is your worst nightmare. Drive down Hollister and turn right at the Santa Cruz Market. Turn down the last road and look for number 7. Beneath the weight of tropical foliage the University Trailer Park sinks ever so slowly into the coastal plateau. Potted palms, lawn chairs, awnings and food smells. You can hear what everyone is saying and they know what you are doing too.

The limbic system ensures that emotions

the town square? And what replaces the town square? Much of the pairing's work has been to experiment with new forms of creative and social expression in public space. Irreversibly, our sense of self and others is dramatically evolving, with new notions of private and public experience and new forums for our cultural, social and personal lives.

Online technology can reach a vast, far-flung audience beyond the art world. It offers tremendous possibilities for audience interactivity and participation. The Web's nonlinear, layered structure calls for new ways of arranging information and narratives, while its capabilities for linking related sites provides

what it meant, how it might be used in another context, what were the limits, did it make sense, was it clever (and why), where it was headed, how soon, and myriad other things. Sometimes those conversations resolved themselves (fizzle or flare) then and there; other times they carried on for months, and taking them the next step was another open-ended proposition.

mental heath care providers and clients who participated in alt.society.mental-health. Our *Accom-modations* site also provided areas for our viewers to contribute their own perspectives. As PAIR gained notoriety outside of PARC, we were often called on for interviews. We turned these

the sound and lighting in the trailer. It all seemed pretty simple until, for instance, we tried to get a PARC-native workstation to boot when it wasn't connected to the network in Palo Alto.

Try as we might, providing graceful recovery from all possible error conditions was impossible. Many user actions could result in the docents having no choice but to restart the entire system from scratch. To reduce the odds of this, we hid interface features off-screen, mapped middle- and right-mouse clicks into benign commands, and everything else we could think of that would keep the browsers afloat in the face of naïve users.

On the day of the opening, we came face to face with the challenges of making a hands-on, Web-based installation truly user-accessible. Our first visitors, mostly elderly trailer park residents, drove

...the skeleton opens the closet door. He unfurls a perfectly painted historical backdrop. "On one hand, there is the wilderness," he says, "and on the other the garden." Behind him, flickering torch light illuminates the writhing bodies. "Time is promiscuous," he adds, "and that is why the past is so confusing."

home just how necessary our efforts had been. Over half of our visitors were sitting down in front of a computer for the first time in their lives. The photographs of their neighborhood were a hit, but we found ourselves explaining how the pointer on the screen was linked to their moving

the mouse. More technically savvy users brought their own challenges—mildly sluggish loading times provoked additional mouse clicks...with chaotic results. But as Scott points out, chaos was not a problem because "we're not interested in tried-and-true methods. We're interested in finding new methods that work for people. There's always an element of risk involved in what we do—because we're interested in expanding the possibilities of technologies." That agenda is one that Scott and Dale bring to the collaboration: "we have to invent and prototype new genres."

and memories travel almost together.

Browsing at 28.8 Kbps—The development of the World Wide Web was concurrent with our residency. Initial utopian hopes for a renaissance-like explosion of creative production on the Web has led to a more sober appraisal of the Web in its present "dot-com" state, which Michael Crichton refers to as "the world's most boring shopping mall."

the possibility for creating electronic affinity groups. Much of the work we've done revolves around making links—between art and technology, between the physical space of galleries and the virtual environment of cyberspace. For the *General Hospital* project,

Over time, this shared understanding has come to revolve around projects—the last one (what it meant, where it worked and didn't, how it might've been better, who saw it, what they'd come away with), the current one (what's getting done, what's turning out to be hard, who's doing what bits, how to talk it up), plausible next ones (what it might be, where are candidate venues, where it's going to

sessions into either self-evaluation conversations or actual design sessions with the interviewer as observer. Communications within PARC evolved as the collaboration progressed. Until 1996, Scott and Dale felt significant doubts about the legitimacy of their PAIR work within the PARC community. This led to very

Sometimes we get awfully moody.

We remember so much.

Circuits crackle.

Margaret Crane, Dale MacDonald, Scott Minneman, and Jon Winet

It's not the tool: it's what you

Conventional Wisdom

Real time and close to real time, the recent past and the media present collided to create *Conventional Wisdom*. A photograph of fireworks dissolved to a starry-eyed crowd of cheering delegates. You'd read an installment of a play where all the characters, stripped to nothing but their raw egos, stepped out of last night's prime-time coverage. In the other column, the writer described his mishaps at the demonstrations on the streets of Chicago. A tryptich of network frame grabs created an evolving series of small, enigmatic images. A stream of television closed-captioning scrolled across the bottom of the page.

Conventional Wisdom looked like the front page of a newspaper. We called it a dynamic document because a continuous stream of information shifted and changed across its surface. The connecting thread was the 1996 Republican and Democratic National Conventions.

Thirteen writers from around the country contributed to the site. Some were computer adept; others were not. As the conventions progressed, they discovered effective ways to make the electronic medium work for them. Rapid reaction, via the Web or email, became an instrument of dissent as the writers countered the media spin. As the conventions continued, a style of response began to characterize the universe of *Conventional Wisdom*—call it political analysis meets memoir. Exercising the opposite of journalistic objectivity, the contributors relied strongly on an individual voice, narrative, and a strong sense of place evoking their real-time environments. Personalities emerged through repeated contributions. The effect was that of an often angry salon illuminated by bursts of wit.

make with it. We pay the price for

Being There—A bit like the classic realtors' mantra—"Location, Location, Location"—issues of access appear at the center of our discussions. Who gets to see the work, participate in the dialog, and join in on its production? As artists and researchers, what do we lose or gain in visibility, effective communications, and sense of community as our work becomes more and more Internet-

we explored the possibilities of connecting the mental health community to the art world. Using online communications, we found points of entry between a community that requires confidentiality and one that traffics in self-expression.

break new ground, how it builds on our existing body of material and practices). Part of the collaboration issue was simply learning what to ask. The answer to the question "Can this thingy be done?" is seldom no, but equally seldom, for interesting values of thingy, is it "Sure, in five minutes." Time is an issue we deal with explicitly: four busy schedules don't naturally coordinate, but

little discussion of what they were doing and thinking with their peers. The advent that year of a new organization with a charter to develop and explore new document genres provided a perfect new home for Scott and Dale—and, consequently, Jon and Margaret. This new platform led Scott and Dale to begin to

Working in real time and nearly real time created a situation that was closer to performance than publishing. The Web site was the stage. Lights. Bandwidth. Action. The dull throb of the media churning out coverage created the rhythm beneath the site. We were all performers—tailoring our improvisations to the moment before it faded away.

On the surface, it all came down to the evocative power of words and pictures. But behind the scenes, what counted was the mix that comes out of the moment—balancing the elements of chance and intention to make an alternative environment that floated parallel to the unrelenting hype and false novelty of the media spectacle.

Everything was fragmented until it hit the site—then it was show-time. The parts combined into something that was purely itself. The nature of *Conventional Wisdom* was constructed from the reconciliation of distance. It played out as the juncture of disparate elements within a single electronic space.

based and electronics-dependent? Given a fundamental, quasi-pervasive, and often heartfelt mistrust and distaste for technological culture in large segments of the art world, we also face an isolation from a logically natural community and one familiar to Jon and Margaret. In dialectical fashion, there's also now a stampede mentality in the arts to race onto the information superhighway.

Stories can cement communities, just as stories can shatter them. Narratives affirm shared world views. They pave the way for dialog and dissent. Throughout history, stories have formed webs linking far-flung places and communities. Now the Internet and the World Wide Web comprise a

we recognize and value the energy that came from our working together. We also got better and better at checking to see whether something was going to pan out, from all perspectives, before heading off and doing much development. Our prototyping loops are closely intertwined; content and context inextricable from the get go.
Somewhere along the line, our collaboration got

speak more widely of their work and to raise many of the issues they had uncovered as significant research issues for PARC. It also allowed them to really promote *Conventional Wisdom* at PARC. The work was beginning to present interesting problems and solutions to other groups at PARC.

The Inaugural Ball

Humming voices of a happy crowd escalate into the roar of a riot. In the distance, we hear a throbbing disco beat. A big limo pulls into a concrete bunker. Writing streams across the wall: *Existential ennui wafts through the air like a narcotic perfume.* The seductive fear of the millennium grows stale. Fireworks explode. The globe spins like crazy.

Inside *The Inaugural Ball*, things changed all the time. The multimedia installation opened in January 1997, just in time for the ball in Washington. The piece set the 1996 presidential election against the Darwinian global politics of the shrinking world. This installation, at San Francisco's Ansel Adams Center for Photography, extended our research and focus on new genres and technologies.

The elements of the piece—photography, text, time-based digital projection, sculptural objects, environmental lighting, and sound—were combined to create a charged and shifting narrative environment. The intent was to contrast the zeitgeist of the 1996 presidential election campaign with notions of collective memory and amnesia and the challenge of the *fin de siècle* civic life.

We will take the bullet for them.

> *Ever since the Challenger exploded, nothing has been the same. Our memories are shot. We look to the past. Once, we were a nation of doers with cigars, big steaks, and deep dark suntans.*

Images for *The Inaugural Ball* came from the collection of photographs Jon had taken at the Democratic and Republican national conventions. This time, they were pulled from their original context as subjective documentary images. The recognizable faces were gone. Crowds. Parking lots. Hotel lobbies. It could be San Diego. It could be Caracas. As wall-size projections, the images became part of a dynamic physical space.

This place is a cold war rerun played as a yuppie trash thriller. The flash point of the drama is sexual jealousy.
11 ● 14 ● 26 ● 27 ● 31 ● 43

atoms of our bodies were once

It's a trend fraught with the high risk of technology fetishization and the questions of the relationship of artist and art to audience persist. Undoubtedly, this pairing has changed our lives and production enormously.

Rich Gold has been known to say: "If all the PAIR artists and researchers do is get together and drink beer and talk, that will constitute a successful

map of the layered stories and shifting meanings that are so much more like how we live than traditional narratives.

closer still. Jon was still the master of the sound bite, but we'd gotten to where any of us could tell any of the stories that needed to be told about our work. The aesthetic ideas were now nearly as likely to spring from the technologists as from the artists, and vice versa. We trust each other's design judgment, yet we knew what bits were best left to whom (Scott is the fussy perfectionist who's very

When we took our work on the road, communication assumed new meaning. Cultures collided. Jon and Margaret, Dale and Scott needed to communicate their different perspectives without the buffer of the PARC environment. Communicating with diverse audiences was fundamental to our offsite projects.

The environment changed around the audience—careening between a manic party and a slow meditation.

In previous pieces we had explored options for viewer interaction and participation. We worked on reaching viewers outside of galleries. For *The Inaugural Ball*, it was different. We created a highly mediated and controlled environment for an art-world audience. That was part of what the piece was about anyway—how sometimes the world seems to be spinning out of control. And in creating the illusion of an out-of-control-world, we were approaching theater and the creation of illusion.

It also solidified our collaboration into a more complex relationship than a pairing of artists and researchers. A shared world view emerged in the piece. The four of us dreamed up the melancholy party atmosphere with its flashing disco floor and the twinkling of mirror ball lights. Divisions between art and technology were blurring.

You think that you're safe because you're far away. You think that you're safe because distance turns facts into stories. One day you'll wake up and you'll be here. You won't remember it was ever any different. Look for the flash of refracted light in the mist. Listen for the ambulance.

stardust—ejected when stars exploded.

pairing." Our experience has been much more of a Jolt Cola, Java-driven, brinkmanship-crazed collaboration where we're all working way past bedtime to accomplish self-imposed, ambitious goals. From our increasingly shared base camps pitched at the edges of the art and technology worlds, we continue to work out defining issues in our search for tomorrow.

We've thrown our own stories into the mix. Like a contemporary version of *A Thousand and One Nights*, the stories online never end. They just snake back onto one another. The things you know transform with use. There is no beginning, middle, or end.

good with his hands, Dale writes shell scripts that'll work incredible magic, Jon can tweak an image with Photoshop to remove the machine to machine variations that our color printers exhibit, Margaret can massage even the most heinous text into something delightful). The collective mind has definitely emerged.

Building physical and virtual conduits for dialog, interactivity, and experience was essential. It all boiled down to communication in the end: "What are the right tools to make it happen?" Stay up late, and pass the junk food: "Hostess products anyone?"

Sunset: The Latest Frontier
(Do you know what I did with my keys?)

Sunset is a series of soap-operatic tableaux featuring a dozen glittering faux stars. By clicking their garage door openers or keyfobs, drivers on Hollywood's Sunset Strip can alter the narrative on two outdoor monitors. Their drive-by intervention changes the course of the narrative displayed on the screens outside the Billboard Live nightclub. Motorists can also tune in to an audio track from a micro-power FM transmission originating inside the club. As we stand at the corner of Sunset Boulevard and Doheny in West Hollywood, braced for the exotic sociologies of SIGGRAPH 97, a corporate computer graphics megagathering, and Billboard Live, a state-of-the-art high-technology nightclub, definite patterns for the collaboration have emerged:

• We appear to have an insatiable attraction for strange experiences in environments foreign to our natural milieus;

• We relish anthropological thrill-seeking in clashing cultures from the hallways of the mental health clinic to the spectacle of presidential politics to the heart of rock 'n' roll via a contradiction-fraught mobile home park project;

• While taking on the challenge of integrating new technologies into contemporary art practice, we continue to struggle to ensure that the meaning of the work isn't swamped by the seduction of those technologies.

At the deadline for this chapter, we found ourselves involved in research on various aspects of this project—the possibilities for intelligence and interaction in a 45 MPH zone, the potential of public venues, the possibilities of new narrative forms, and the translation of our work to the big display screen. And while the title is clearly site-specific and rich with evocative associations—the *fin de siècle*, the mysterious Desmond mansion just off the road, the blinding light to the west of a long hot day—we suspect we've just begun to work out the dynamics of our collaboration and the areas of exploration to which it might lead.

The WWW sites referred to in this chapter can be found under

`http://www.pair.xerox.com/cw`

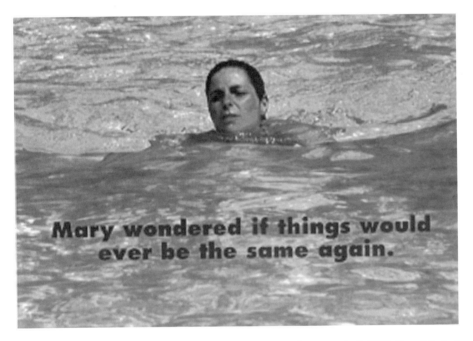

Crane, MacDonald, Minneman, and Winet; work image from *Sunset* project, 1997. See plate 3 of the color section.

An Archeology of Sound: An Anthropology of Communication

Paul De Marinis

For the insider . . . language is merely functional; only the machine is sublime.
—DAVID E. NYE, AMERICAN TECHNOLOGICAL SUBLIME[1]

I regard technology as the meeting ground of the physically possible with the humanly desirable—a sort of moving shoreline where our murky sea of dreams erodes and regales with beachcomb, the continent of matter. According to science, all phenomena are based in physical properties that began within microseconds of creation and are constant throughout the universe. While sharing common denominators, human desires appear to be of indeterminable origin, widely varied and mutable.

To further conflate metaphors, the site of the confluence of phenomena and desire may be thought of as a nuptial bed—lots of fumbling in the dark, some revelations, and a potential for offspring. In our corporate commodity culture, desire is regulated within strict channels. Out of this need to regulate, the sanctity (intellectual property) and secrecy (high priesthood) of the nuptial bed are born. Thus the research center's role as midwife of new technologies appears to the outsider as having some highly religious aspects.

Corporate culture varies among corporations, as do dreams among dreamers. The Xerox Palo Alto Research Center can trace its ancestry to the most ancient electronic image in existence—a block of pine rosin that contains the image of an electrical spark discharged on its surface in the eighteenth century. That such a singular and irreproducible fossilization should be the forerunner of a corporation whose name is emblematic of so much loose and easy reproduction is indicative of the many intersecting paths that technology follows between dream and product.

The medium of my work is sound and my subject, broadly, is technology. To this end I create machines that are at once declarative and interroga-

tive of the relation of technology to our senses, our memory, and our interminglings. For me it is axiomatic that discourse about technology requires new machines to be built—and that these machines, while retaining some of the discursive qualities of bachelor machines, also be functional in some tangential but congruent way.

My first visit to Xerox PARC was in 1976. I went to meet with the already legendary Alan Kay (later my boss at Atari), who was then involved, among other things, in a musical project with computers. I remember balking at having to sign a legalese nondisclosure form and wear a badge and feeling politely watched. We still had illusions of individual rights in the mid-1970s. But once inside the feeling changed. It was laid back. As I was escorted down the hallway, I noticed that the researchers seemed to congregate informally there. A researcher with an English accent was talking endlessly to another man who only nodded. The subject was rare vintage wines. I remember a cavernous lab where I met Alan Kay. There were schoolchildren using a device called a turtle—a kind of mouse in reverse—and trying to draw pictures with it. I recall being given a demonstration of a computer music application based on digitally recorded notes from a baroque organ, an approach now called sampling. *The demo seemed musically uninteresting—indeed, pathetic—to me at the time: I was involved in live performance with real-time electronic noises made with homebrewed analog and digital circuits. What did impress me, though, was Alan's demo of an animation program tied to a music program. There were little black and white rectangles on a cathode ray tube. In one was a little stick figure. In another were some lines of computer language—a music program. The music program would make the stick figure dance when the rectangles were connected with a line by means of a plastic box with a ball and wheels. We*

now call this type of display a graphic user interface (GUI): the rectangles were windows, the plastic box was a mouse, and none of our operating systems yet appear able to accomplish what SmallTalk promised two decades ago. In the ensuing discussion Kay seemed bent on dissuading me from my own technological-musical interests. He seemed to say that artists should not try to create technology. "Be content with what we make for you." Perhaps it was an ego game; perhaps he spoke from true conviction. He would have not understood that I had left behind the baroque organ as a musical organizing structure a decade earlier and for good reasons, and that electronic and informational paradigms seemed infinitely more promising to me then as an aesthetic. The conversation didn't go well, and it was time to go. As I walked down the corridor, I passed the same two researchers, the one still decanting, the other nodding endlessly. They get paid to do this! I left PARC that day basically disappointed. It seemed to exclude me and to pooh-pooh my interests in creating technology on my own. It seemed to declare that brilliant engineers knew what was best for everybody, including artists. They were now the experts in wine, women, and song. If the proliferation of MIDI-driven samplers playing baroque organ sounds were the only indication, they were right. But boring is still boring, even in abundance. I did not return to Xerox PARC and heard little of it during the seventeen years that followed.

My next visit to PARC was in the summer of 1993. I had been invited to interview for a possible artist residency at PARC on the tail of a successful presentation of my show The Edison Effect at the San Francisco Art Institute. On the way down to Palo Alto for the interview, my old Toyota's radiator blew up—cars are the ultimate enforcers of social class boundaries—and I had to cancel and reschedule the meeting. When I finally got there, I made a presentation about my work to a

small but attentive group of researchers. I played some musical examples from a recent CD, showed slides of my installations, and demonstrated my piece Fragments from Jericho—

an authentic recreation of what is probably the world's most ancient audio recording. A clay cylinder inscribed (by intention or accident?) with voices from the past. By gently turning a large black knob, you can direct the laser beam across the surface of the turning clay vessel to eavesdrop on vibrations from another age.

After lunch I did a tour of labs, talking with numerous researchers, trying to find a good fit. What seemed to surprise me then, but doesn't now, was that the researchers doing work in fields most related to my work (speech analysis, electronic design) appeared profoundly uninterested in my ideas and projects. I felt a connection, an affinity and interest for their work, but apparently they didn't reciprocate that interest: unrequited love is more piquant the second time around. On the other hand, the people I related to best were involved in things only remotely connected to my own immediate interests. As I spent time at PARC, I have tried to understand or at least accept this pattern. A few researchers are honestly enthusiastic about the PAIR program and artists. The majority are either benignly or actively uninterested in it, leaving a few who are probably hostile toward it. Gaussian demographics always satisfy.

I finally became PAIRed with Mark Weiser's Ubiquitous Computing project. The team was just finishing up the PARC Tab, a palmtop networked computer that communicates with workstations via an infrared cellular link. I went to meetings, met with researchers and unsuccessfully tried to find a place for myself in the project. Finally Roy Want, the Tab project leader, asked if I could compose a piece of music for the release party. Compose a piece of music for a device with a tiny piezoelectric

beeper that sounded like a tone-deaf mosquito and whose latency time ranged anywhere from 1 to 45 seconds? Indeed an opportunity to show these guys what art is all about. I created a series of insect and cricket like sounds that the piezo was quite good at making. I issued command scripts simultaneously to all the Tabs on the system to repeatedly play one or another of these sounds and let the ensuing network delays determine the temporal and spatial distribution—in effect the ecology—of the sounds. As it turned out, at the release party my software caused the whole system to crash—it took a quarter of an hour to restart it—so it actually became a useful part of the research effort, and I felt participatory.

Living with Electricity (1997) is an installation work I prepared as an homage to ubiquitous computing. It was site specific to the Mills College Art Gallery where it was exhibited, a huge and elegant space in 1920s Spanish style covered by a brilliant skylight and, unfortunately, dissected into visually divided segments by the presence of temporary walls that couldn't be moved. This gave it the not uncommon property of being one big space acoustically and many small spaces visually. A job for Ubi-Comp. I devised three small domestic settings, each consisting of a throw rug, a lamp, a rocking chair, and one of my sound sculptures. The rocking chairs were fitted with potentiometers that fed to single-board microprocessors that digitized their positions of recline. Each of my sound sculptures was fitted with a hobby servo motor that played it under microprocessor control. The microprocessors were connected in a little network so that rocking in chair A would animate the sculpture in area B and so on, our actions producing sounds and movements in somebody else's domestic space. The sculptures I made each had a dimension of domestic utility and depended

on electricity to produce this utility. The first—
"The Red Phone"—was a telephone rocking in its
cradle (figures 9.1 and 9.2). The voice of Joseph
Stalin delivering a 1936 address on the proposed
Soviet constitution emanated from its mouth-
piece, and from the earpiece a computer-intoned

Figure 9.1
Paul De Marinis, "The Red Phone" (above), from *Living with Electricity,* installation, Mills
College Art Gallery, 1997 (photo: Paul De Marinis)
Figure 9.2
Paul De Marinis, "The Red Phone" (below), from *Living with Electricity,* installation, Mills
College Art Gallery, 1997 (photo: Paul De Marinis)

Figure 9.3
Paul De Marinis, "Marionette Pathetique" (above), from *Living with Electricity,* installation, Mills College Art Gallery, 1997 (photo: Paul De Marinis)

Figure 9.4
Paul De Marinis, "Marionette Pathetique" (below), from *Living with Electricity,* installation, Mills College Art Gallery, 1997 (photo: Paul De Marinis)

English translation of that same speech. The rocking movement (caused by a remote rocking chair) panned the signal from right to left speakers by alternately moving the two ends of the handet near two little microphones. The microphones pick up

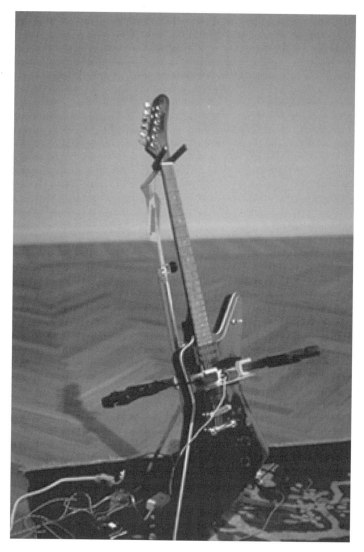

Figure 9.5
Paul De Marinis, "Slow Rock" (above), from *Living with Electricity*, installation, Mills
College Art Gallery, 1997 (photo: Paul De Marinis)

the sound and send it to two speakers so that they
hear the sounds change from human to machine as
someone rocks in another part of the space, always
incomprehensible. The second piece—"Maron-
ette Pathetique"—plays an old vertical-cut Pathé

Figure 9.6
Paul De Marinis, "Slow Rock" (below), from *Living with Electricity,* installation, Mills
College Art Gallery, 1997 (photo: Paul De Marinis)

disc recording of "That Naughty Waltz" with a
laser and photodetector at the end of a tonearm
that is moved by long strings attached to a servo
motor, somewhat like a marionette (figures 9.3
and 9.4). The final piece—"Slow Rock"—in-
spired by the online appearances of Mark Weiser's
band, "Severe Tire Damage," completes the do-
mestic dys-topia by twanging an out-of-tune elec-
tric guitar under remote control (figures 9.5 and
9.6).

*One of the most enthusiastic researchers is Dave Bie-
gelsen, a physicist working on a variety of projects, in-
cluding the scanning tunneling microscope (STM) ex-
amination of advanced semiconductor lattices. At lunch
one day we were talking about the possibility of feeling
the atoms in a surface by some kind of tactile mecha-
nisms inserted into the feedback path of the STM. I
didn't have any particular need for the STM in my
work, but the ideas of tactile perception intrigued me. I
fooled around with predictable approaches for a few*

weeks, using hobby remote-control servo motors and microprocessors, when I remembered a phenomenon I had noticed in 1976 while working on a totally different project. When the finger is drawn along an electrified surface modulated by an audio frequency, a sound at that frequency is produced by the minute sticking and slipping of skin over the surface. This phenomenon is commonplace, occurring with ungrounded appliances like refrigerators and toasters, but I had never seen a description or thorough explanation of it. About the same time I was reading Bruce's biography of A. G. Bell, in which Elisha Gray's musical bathtub is mentioned briefly but not explained. In the description I immediately recognized that this was the very same phenomenon I had run across years earlier. As I worked more with the phenomenon, my preoccupation with sound and tech history overtook my interest in tactile output for the STM, and I produced the four sculptures that comprise Gray Matter, *exhibited first at the Yerba Buena Center for the Arts in San Francisco in the summer of 1995 and again in shows in New York, Quebec, Berlin and Tokyo (figure 9.7, plate 4 in the color pages).*

Figure 9.7
Paul De Marinis, *Gray Matter,* installation of four sculptures, Yerba Buena Center for the Arts, San Francisco, 1997 (photo: Ira Schrank)

On Gray Matter

Our electronic media may be regarded, in large part, as the outgrowths of nineteenth-century laboratory apparatuses designed to isolate and investigate the functioning of human sensory organs. Viewed thus, they fracture the wholeness of sensation in an effort to preserve, replay, or transmit over distance the specters of our sensory experiences. But Victorian science, obsessed as it was with isolation, analysis, and reduction, had a goofy side too—a far-reaching interest in the discovery and creation of chimeras, both natural and artificial. In particular, the age of the inventor was also the age of the tinkerer, the combiner, the patenter of hybrid forms. No natural zoology could have engendered derby-hat cameras, bicycle-hammocks, and swearing tops. Perhaps every attempt to recombine the sensory wholeness lost by recording and transmitting media may be regarded as a chimera, the foremost survivor of which has been the sound cinema, with its uneasy pact between sight and sound, serving to perpetuate a myth of sensory integration. But a host of other teratogeny were, and are, being spawned, tried, rejected, and occasionally marketed in a ceaseless attempt to achieve multimedia.

There is a popularly promoted belief that technology drives culture forward and that our changing relationships, material and informational, are the result of advances made by science and manifested in the development of new materials, processes, and tools. Gilles Deleuze points out the flaw in this thinking: "technology makes the mistake of considering tools in isolation: tools exist only in relation to the interminglings they make possible or that make them possible."[2] A glance at the incred-

ible variety of possible technologies that have fallen along the wayside serves to support this view.

The present work lurches forward to examine one such failed technology—one that failed to acknowledge the rupture between hearing and feeling (touching). Most certainly indistinguishable in the womb, these are the two sensations with which we have the longest continuous experience. The invention of sound recording, initially incapable of reproducing low and palpable frequencies, exacerbated a rupture between touching and hearing that had been building through several centuries of notated music. By the last decades of the nineteenth century, audible and feelable vibration had become so dissociated that inventors were having a difficult time understanding the relations between waves, vibrations, and electrical undulations. A great many chimeric inventions resulted, among which is the telephone, commonly regarded as the work of one man.

Alexander Graham Bell had won his renown as a teacher of the deaf—patients who conveniently manifested the aforementioned rupture by being able to feel but not hear. Bell's teaching methods relied on lip reading only in part. The greater part of his expertise lay in conveying missed auditory information to his pupils by touching their hands in a defined grammar of strokes. This special knowledge gave him a distinct advantage over the many other inventors racing to formulate and patent what was to be the invention of the century. When the great race was won, Bell was the victor, filing his caveat on February 14, 1875. Five hours later, Elisha Gray staggered breathless into the patent office with his application for the telephone. Time and tide. . . .

Figure 9.8
Elisha Gray's musical bathtub, 1874 (photo: Robert V. Bruce)

There is no room here for an examination of the diverse trajectories Bell and Gray had taken to arrive at the similar apparatus in 1876. Suffice it to say they were different and in their diversity had given birth to many technological curiosities and chimeras, not least of which was Elisha Gray's "musical bathtub" of 1874 (figure 9.8). Siegfried Giedion has pointed out in Mechanization Takes Command, the Victorian era's preoccupation

with the mechanization of bodily functions, from weaving and skinning to cooking and bathing. Elisha Gray's fusion of bathing and playing music is one more chimera ornamenting the den of nineteenth-century monstrosities.

"In late January or early February of 1874 [Gray] heard the refrain of the rheotome issuing from his bathroom, where he found his young nephew 'taking shocks' to amuse the smaller children. With a vibrating rheotome in the circuit of a primary induction coil, the boy connected one end of the secondary coil to the zinc lining of the bathtub and held the other end in his hand. When the boy's free hand glided along the bathtub lining, it produced a whining sound in tune with the rheotome. Gray tried the effect and found that quick, hard rubbing made the noise even louder than that of the rheotome itself. When he varied the pitch of the rheotome, the noise followed suit."[3]

By some obscure and little-studied phenomenon, a vibrating electrical field seems to modulate the coefficient of friction of our skin, so that when we bow across an electrified surface with our fingers, we excite mechanical vibrations. These mechanical vibrations, suitably coupled, give rise to audible sounds. I discovered this phenomenon, as Gray did, quite accidentally in 1976, and I'm sure other people run across it every day. In a sense, Gray's discovery was likelier than ours, being as he was much closer to the era of Benjamin Franklin and Mary Shelley, when electricity, life force, and neural sensation were believed to consist of one in the same fluid.

As we stroke the wires, we both feel as texture and hear as sound the faint electrical stirrings within the wire: melodies, scales, creakings, and glissandi inhabit a world in which touch and hear-

ing are for a moment unified. This phenomenon may someday find a fit to the structure of our relations—perhaps as electrically definable surface textures, audio communication in a vacuum, or other applications. But for now it languishes in the backwater of the culturally inappropriate, insignificant, and obscure.

The fourth piece in this collection is based on Gray's later version of an electrical sound maker. Based on a more familiar electromagnetic design, it is a direct forerunner of the familiar loudspeaker and became part of Gray's telephonic apparatus of 1875 (figure 9.9). Of interest to me is that it retains the connection to bathing apparatus in the form of a washbasin. One might wonder, had Gray beat Bell to the patent office, if our telephones might not "ring," and if we might enter the wash-closet to speak afar, stroking small tin tubs as we listen.

Figure 9.9
Elisha Gray's washbasin receiver, 1875 (photo: Robert V. Bruce)

For the twenty-fifth anniversary of PARC we mounted a show of PAIR work in the reception area. I included one of the Gray Matter pieces—"Solo for Two"—in the exhibition (figure 9.10). Two violins are mounted on the wall about 15 feet apart. Four brass harpsichord wires pierce their wooden fronts and run the distance between them. The wires are electrified with a field on which a partita of J. S. Bach is modulated, so that when the back of the hand is drawn along the wires, the skin sets up the vibrations of the music in the wires that, when coupled to the air by the violins, sounds a recognizable version of the Bach. The electrical circuitry was put up

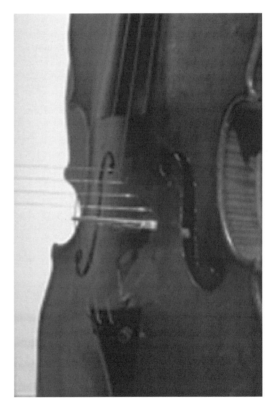

Figure 9.10
Paul De Marinis, "Solo for Two," from *Gray Matter,* sound sculpture, Xerox PARC, Palo Alto, 1996 (see Marshall Bern, fig. 13.12, for view of installation) (photo: Paul De Marinis)

in the ceiling not to conceal it but to get it out of the way in a busy hallway. There was just one thin bare brass wire dangling from the ceiling attached to the violin. People at PARC seemed mystified. No loudspeakers and, with only one wire, apparently not even a circuit. Heads were scratched.

Deceptions and illusions based in rotary motion
zoetrope
hypnodisc
phonograph
rotorelief
Ptolemaic planetary system
circumnavigation
rondo form
Copernican planetary system
eternal recurrence
Viconian history
acrobatics
juggling
whirling dervishes
merry-go-round
ferris wheel
karma
vertigo
clock time
calendar
floppy disc
Dinner at Ernie's

Hypnosis, psychosis, and gourmet sexual obsession—Hitchcock energy. Four spinning dinner plates decorated with spiraling movie soundtracks are played by scanning laser beams. Each carries one musical theme from Bernard Herrmann's score for *Vertigo*, the tale of obsessive

delusion. Jimmy Stewart and Kim Novak turn 'round and 'round the table at Ernie's restaurant.

"Dinner at Ernie's" is a small lacquered table set with four ceramic plates (figure 9.11). Each of the plates contains a pattern of a black spiral set against the white ceramic surface. A small switch near each plate starts it spinning in the manner of a hypnodisc, a 1960s-era patterned paper cutout meant to be spun on a record turntable to induce hypnotic or expanded mental states. Each of the spirals in "Dinner at Ernie's" is, however, modulated in width like a film soundtrack. As the plate spins, a tonearm assembly made of chopsticks scans a laser and photodetector across its surface. The reflected light is modulated by the pattern of the spiral and, via a loudspeaker, produces recognizable tones, in this case four clips from the soundtrack of Hitchcock's *Vertigo*. The voices of Kim Novak and Jimmy Stewart can be deciphered from the rumblings of the machine, and the strains of Bernard Herr-mann's musical paraphrase of "Tristan und Isolde."

Figure 9.11
Paul De Marinis, *Dinner at Ernie's,* sound installation, 1995 (photo: Don Carson)

I had in mind to make a playable dinner plate. But af-
ter a few weeks of experimenting with galvanometers
and black glaze formulas, then with LEDs and
paintable photoemulsion, I had exhausted my patience
with analog methods. The decision to go digital was a
comedown: virtuosity can exist only in the analog do-
main and when executed in real-time. So I borrowed
some books on PostScript, the language that runs inside
laser printers, with the idea that I could at least easily
prototype the piece on paper with laser printers. My first
small attempts at drawing a spiral line went quickly
enough, so I set about expanding my program to stuff an
audio file on the printer's stack, then pop each value off
one by one to create a line that varied in width as the air
varies in density when a sound is played. I went down to
the printer room to await my output. After fifteen min-
utes I decided to go do something else and return later.
When I did, other people were there waiting for their
jobs too. My first playable spiral popped out of the
printer after about two hours of churning. After a few
weeks like this it became clear that my project was
breaching lab etiquette. Russ Atkinson volunteered to
look at my code. "What a harebrained way to do it," he
commented. He graciously set about rewriting my code so
it would execute more efficiently and after three days or
so finally gave up, suggesting that I use ps2ip, a utility
that converts PostScript files to Xerox interpress format,
in an offline mode to compute the image, and then sent a
rasterized (interpress) image to a Docutech printer.
This worked wonderfully. I could leave a whole batch to
chug away overnight and test my experiments in the
morning. For me this was like a visit to the lost horizon
of early paper tape and punched cards that I never
knew—almost as good as analog.

A piece of my mind:

My first work with electronics and the imagination,
in 1956, was a scheme to read minds via television.

For an eight-year-old raised on Mr. Wizard, it appeared a simple task, and I couldn't understand why it hadn't been done years ago. I had read about brainwaves and knew about electrical signals and about television. All I had to do was to put them together, and I could watch the images inside people's heads on the cathode ray tube. I made electrodes from dimes (in those days made of real silver) that I beat with a hammer until they were the size of quarters, soldered wires to them and connected them to the antenna inputs of our TV, a ten-inch Dumont with a green screen. I placed the electrodes on the temples of my neighborhood playmate Dave—but all I could see were regular TV images. So I tuned the TV to a blank channel to avoid the stronger signal from broadcast stations. Just fuzz and static. I figured it needed more power, so I connected my 10,000-volt spark coil in series with Dave and the Dumont and turned everything on. Dave jumped three feet. The TV went dead. My mom was mad about the TV. Dave's mom said he couldn't play at my house anymore. I went back to the drawing board and spent a while there before I became a musician, an artist and then began to tinker with electricity again. Still, it took me years more to discover that what I had dreamed of had indeed been accomplished not long before. TV is the perfect medium for reading people's thoughts: you just have to tune to a broadcast channel and let them watch it.

Notes

1. David E. Nye, *American Technological Sublime* (Cambridge, MA: MIT Press, 1994).
2. Gilles Deleuze and Felix Guattari, *A Thousand Plateaus,* translated by Brian Massumi (Minneapolis: University of Minnesota Press, 1987), p. 90.
3. Robert V. Bruce, *Bell* (Ithaca, NY: Cornell University Press, 1973).

Reflections on PAIR

Stephen Wilson

During the period January 1994 to November 1996 I participated in the Xerox Palo Alto Research Center Artist-in-Residence (PARC PAIR) program. This chapter describes the collaboration that I developed with PARC researchers and explains what I believe are important issues in how artists and researchers collaborate. During sixteen years of working as an artist with emerging technologies, I have become convinced that artists must work at the heart of the research process and not just as consumers of technological gadgets.

Art as Research

Those in the arts are perplexed about how to respond to the growing importance of scientific and technological research in shaping culture. One response positions artists as consumers of the new tools who use them to create new images, sounds, and video. Another response sees artists emphasizing the critical functions of art to comment on technological developments from a distance. Yet another approach urges artists to enter into the heart of research as core participants. (See my paper "Dark and Light Visions" for a more detailed analysis.[1])

Conceiving of contemporary research as merely a technical enterprise is an error that has profound practical and philosophical implications for the culture. The shaping of research and development agendas could benefit from the involvement of a wider range of participants including artists.

One paradox of scientific and technological research is that it strives toward objectivity while at the same time it is shaped by larger political, economic, and social forces. Historians of science and technology have documented the winds that determine the research that ends up being supported, promoted, and accepted and the products that win in the marketplace. Thomas Kuhn shows how paradigms dominate thought and scientific practice until new paradigms develop in his book *The Structure of Scientific Revolutions.*[2]

As research grows in importance, it becomes more dangerous to accept this winnowing as inevitable. Valuable lines of inquiry die from lack of support because they are not favored by particular scientific disciplines. New technologies with fascinating potential are abandoned because they are judged not marketable. Our culture must develop methods that help us avoid prematurely surpressing valuable lines of inquiry and development. I believe the arts can fill a critical role as an independent zone of research.

For sixteen years I have been exploring this approach of artist as researcher. I have incorporated the monitoring of research developments into my artistic discipline. I monitor science and technology journals, participate in online forums, and attend technology trade shows and academic meetings. I engage the developers in discussion about their products. I have been appointed as beta tester and developer for several technology companies. I have functioned as an inventor and won a patent for a method I developed to integrate interactive electronics with print.

Emerging technologies are my medium. I seek them out before they become widely known. I focus on them to understand where they come from, where they might go, and what might be their cultural implications. I experiment with them to see whether they have unexplored potentials.

These years as a shadow researcher have been illuminating. I have read in the literature of intriguing developments that never saw the light of day. I have seen many inventions and emerging technologies killed because marketing departments judged that no money could be made from them. I have seen entire research and development departments and their years of research blown away by the winds of corporate politics. Government and corporate support for basic research has almost disappeared, and the concern with the bottom line has shortened the payback horizon to the point where few risks are taken. I have encountered debates in the scientific community that devalue approaches that do not fit the paradigms currently in favor.

I am worried that the invisible hand of the marketplace might not be as wise as many would like to believe. The judgments that make short-term sense for stockholders do not make sense for the culture. The peer review referees of scientific journals cannot always see beyond their disciplinary blinders. Many good ideas are orphaned, unheeded in the wilderness. Scientific and technological research are so critical that we cannot afford the premature elimination of these ideas and efforts that do not find favor through traditional channels.

The arts can function as an independent zone of research. They could become the place where abandoned, discredited, and unorthodox inquiries could be pursued. They might very well value research according to criteria quite different from those of the commercial and scientific worlds. The roles of artists could incorporate other roles such as researcher, inventor, hacker, and entrepreneur. Even within research labs artist participation in research teams could add a perspective that could help drive the research process. I

address this in an editorial written for *Leonardo* in 1984.[3] Several traditions of the arts uniquely equip them for this function:

- Artists typically pursue their idiosyncratic interests less constrained by utilitarian, commercial, or disciplinary imperatives than peers in other fields.
- Institutionalized iconoclasm means that artists are likely to take up lines of inquiry devalued by others.
- The valuing of social commentary means that artists are likely to integrate widely ranging cultural issues in their research.
- Artists are more likely than commercial enterprises to incorporate criteria such as celebration and wonder.
- The interest within the arts in communication means that artists could bring the scientific and technological possibilities to a wider public better than peers in other fields.
- Artistic valuing of creativity and innovation mean that new perspectives might be applied to inquiries.

The recent history of the personal computer illustrates the need for this independent research function and the role the arts might serve. Early developers such as Apple Computer founders Steve Wozniak and Steve Jobs found little support for their ideas about the personal computer from the companies they worked for. Supervisors signed waivers on the ideas because they could not imagine any market for a desktop computer used by individuals. Similarly, the discipline of computer science was mostly uninterested in software and hardware issues related to these computers. Advances came from individuals who worked outside traditional academic and business channels. Teenagers became world experts, and artists made significant contributions in the development of interface design and in image and sound processing.

If the culture had to rely only on traditional lines of research, we might have had to wait much longer for the developments that have profoundly shaped the last decades. This story potentially could be repeated many times in many other fields of inquiry if alternative venues for research are developed. The arts could well serve this function if artists are prepared to learn the knowledge, language, work styles, self-discipline, and information networks that are instrumental in their fields of interest.

PARC as Art Research Venue

There are some research environments that have worked hard to encourage open-ended research. For example, universities allow faculty to pursue whatever interests them. Although these faculty choices are constrained by funding, tenure, and promotion processes, there is some latitude. Some industrial research labs have achieved fame for even more effective support for basic research. For example, Bell Labs and Xerox PARC achieved world recognition for the visionary quality of their research agendas, the competencies and range of their researchers, the level of support offered researchers, and their freedom from short-term profit concerns.

I was especially interested in PARC. I regularly followed the work of its researchers in journals and at professional meetings such as the ACM Special Interest Groups on Computer Human Interface (SIGCHI) and on Computer Graphics (SIGGRAPH). I felt that PARC's early work on the graphic user interface and technologies such as Ethernet and PostScript had a major impact on computing. I wondered what working at PARC would be like.

I was quite happy to find that I had been nominated as a potential participant in PARC's new PAIR artist-in-residence program. Research labs such as PARC represented an interesting test case for my ideas about art research. How open-ended were these labs? Were the researchers really free to pursue any questions they wanted? How were research agendas determined? I assumed most of the researchers came from technical disciplines. How would the research questions they would ask differ from those that might be asked by technically sophisticated artists? How could artists help shape research processes? How could researchers help shape art processes?

The Selection

I was invited to give a presentation about my work. I decided to organize my presentation using categories of research issues that my installations have investigated. These categories included telecommunications, the mapping of conceptual and emotional space to physical space, artificial intelligence and characterization, and biological and environmental sensing. Talking to PARC researchers presented a challenge. I usually design my talks to art audiences to excite them about areas of research and emerging technologies that I find fascinating. Typically, I offer background information and position my art installations as investigations of these areas. At PARC I had to

adjust my talk to omit some of that background material that PARC researchers already were familiar with.

The PAIR core group had publicized the talks within PARC and encouraged researchers to attend who they felt might have some relationship to the artists' work. About forty PARC researchers attended my talk.

Later I had a series of short meetings with researchers who indicated interest in what I was doing. The researchers presented their work to me, and we discussed my work further. Eventually, researchers let the core group know who they would like to work with.

I felt there was an unfortunate asymmetry in this approach. Researchers could choose to meet with artists and ultimately pick which artists they wanted to work with, but artists did not have reciprocal opportunities. I was bothered that I would not have the opportunity to meet with research groups other than those who signed up to meet with me or who happened to become interested because they attended my presentation. I knew there was other research going on that might be relevant to my work and with which I might establish a working arrangement. Also I suspected there might be other research that I didn't know about that might result in productive collaboration.

I asked my PAIR contacts for a comprehensive description of the projects currently going on at PARC so that I could identify potentially interesting researchers to connect with. I discovered that even though PARC researchers regularly publish their work in journals and professional meeting proceedings, PARC had no centralized summary of these publications. In fact, PARC purposely did not create widely available summaries that might make it easy for competitor labs to determine PARC research directions. I had not thought much about competition in my notion of PARC as a research paradise.

The PAIRing

I was informed that two researchers, Jock Mackinlay and Polle Zellweger, had indicated an interest in working with me. I was pleased that I had been selected and eager to see the process unfold. I was a little concerned that we were a threesome because I thought the process of negotiating a collaborative focus might be easier with two people. On the other hand, I thought the project might end up being more interesting because it could span a wider set of research issues.

We met and discussed our work. Jock and Polle each separately gave me a review of projects they had worked on and their current interests. Jock worked with the User Interface Group (UIR) on creating three-dimensional graphic systems to visualize complex information spaces. Polle worked on hypermedia authoring systems and speech issues. Serendipitously, I was acquainted with their work through references I had seen in proceedings from SIGCHI and SIGGRAPH meetings. Jock knew my work from art installations I had presented in various SIGGRAPH art shows. I requested copies of papers they had written to get to know their work better.

The communality of interests and frames of reference seemed encouraging. Our mutual shared perspectives seemed like they would result in an interesting collaboration. I was curious about what our joint project might end up being and how we would arrive at it. We agreed that the summer would be the intense work time and we would meet periodically during the spring.

We had discussions about our research. I was eager to make contributions to their work and looked forward to their ideas about my work. I noticed, however, that it was very difficult to be helpful without much more background knowledge. For example, I studied Jock's papers and demos. I made several suggestions—for example, stressing the importance of text quality in his 3D worlds. The prototypes used a very simple font in order to speed rendering. He explained the technical difficulties that necessitated that choice. I felt I would have to learn a lot more to make my help valuable. Similarly, I discussed my "Memory Map" installation that I presented at CHI in Boston. Jock's suggestions were not as helpful as they might have been if he had more background understanding. I felt that we could have become more helpful if we had more time to enter into each other's worlds.

Lost Treasures

Jock and Polle's work was extremely evocative. It seemed to be ahead of its time and to have great utilitarian and commercial potential. Even more, I saw poetic, artistic, and cultural values in it beyond its practical usefulness.

For example, Jock showed me his citation visualization system (figure 10.1).[4] This system, designed to help scholars and researchers, visualized the network of references typical in academic publishing. You provided it a journal article, and it used the Dialogue citation database to create a visualization of all articles quoted by the target article and all articles that quoted the article. The articles could be arranged chronologically, and you could have

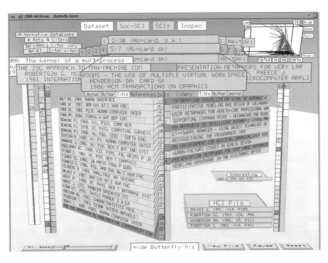
Figure 10.1
Jock Mackinlay, *Butterfly,* citation visualization system

the system also visualize the web of mutual quotations among other articles so that you could see the clustering of mutual interquotation. You could apply other filters, such as limiting by journal. Jock pointed out the usefulness for researchers trying to identify the best candidates for further scrutiny.

But for me, this was a window on the usually invisible intellectual structure of a culture. At a glance you could see the flow of influence and the history of ideas. I could imagine all kinds of interesting applications that visualized abstract intellectual structures. The visual webs of association were a kind of poetry in which cultural history became the language.

Polle's research similarly offered both utilitarian and cultural opportunities. Back in the 1980s Polle had been an early pioneer in thinking about the structure and process of hypermedia.[5] She had studied and developed hypermedia authoring systems that allowed authors great opportunities for designing the browser's experience. For example, an author could create a system of links that could be calibrated for the user's characteristics or the reader's previous traversals through the system. Multiple media components could be orchestrated so that links became available only after a reader had visited certain other nodes. Better-known hypermedia authoring systems such as Director, Authorware, or the World Wide Web demonstrated a much less complex model of the mental processes involved in hypermedia. Again,

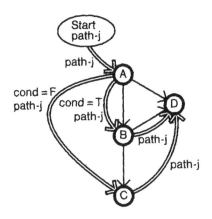

Figure 10.2
Polle Zellweger, paths-based hypermedia authoring system

here was a system that was much more powerful than what had come to currently dominate the market (figure 10.2). Besides its utilitarian value, the system also suggested broad new opportunities and focuses for interactive media artists.

Sadly, neither of the systems would be likely to ever see the light of day as discrete systems. Jock and Polle had each moved on to other projects. Jock's ideas continued to be worked on in contemporary UIR research, but only as an element in larger systems. PARC itself was no longer as supportive of this research as it once was. The internal politics of value had changed. When Polle had started her work, hypermedia was considered a cutting-edge research topic. Now that hypermedia had entered the mainstream, although in watered-down form, it was not crucial for PARC researchers to pursue it.

A full elaboration of the forces that drive valuation of research is impossible here. To me as an artist and analyst of the relationship of technology to culture, however, these were lost treasures. PARC's dynamics and the forces of the marketplace had devalued potentially rich resources. Although I was best acquainted with Jock and Polle's work, I learned of many similar fascinating lines of research in the UIR group and beyond that had been similarly deemphasized.

Here was a place where artists and researchers could perhaps collaborate. Artists and media workers could point out the potential value of research in-

quiries missed by researchers. If they could get appropriate access, artists could well build on the ideas and prototype work initiated by researchers. We might all benefit from these orphan lines of development being nurtured to full growth.

Deciding on a Focus: Getting Caught in the Web

In the summer the collaboration intensified. I moved temporarily to Palo Alto and arranged to come to PARC daily. I immersed myself in the life of PARC and Jock's UIR research group. Polle had taken a temporary leave to give birth to her son, and her research group was disappearing anyway because of reorganization. I attended all the Dealer, Whistle, and seminar meetings that I could to learn about the range of research going on. Dealer and Whistle were the internal seminars PARC researchers give every week to acquaint colleagues with current research. I obtained an email account and registered with several of the internal mailing lists. I regularly attended the UIR meetings and started to participate as I became familiar with the work. I believed that my work could benefit most, and that I could also possibly contribute to PARC's work, if I became knowledgeable about the research going on at PARC.

As we started the summer, it was not clear how our collaboration would develop. We had provocative discussions and a lot of mutual interest in each other's work. Still, everybody's plate was quite full. We were all working away on our own research agendas. It wasn't clear how Jock and Polle would be able to add a new project. I had a little more leeway because I was still on a sabbatical until the end of the summer. We had to decide what model to use. We could consult on each other's ongoing work, we could individually take on new work that the others would be interested in, or we could undertake new joint work.

Based on our discussions I decided to propose a brainstormed list of projects that interwove our interests. I planned that we would discuss those ideas and see what kind of collaboration might be feasible. Early in the summer I wrote some memos to stimulate the process. One listed my assessment of possible starting points:

- How does one visualize complex information?
- What complex information should people be dealing with?
- What special opportunities are created by multiple media?

- How does one create intriguing, engaging events that allow people to move through complex information spaces?
- How can the links themselves become a focus of art?
- How can computer networks be linked with other nets such as telephone?
- How can other senses and the body be engaged?

Another memo described particular projects that might be pursued:

- Web trawler
- Walking with Information Project
- Link poetry
- Real-time visualization of searches
- Demographic calibration of information
- Landscape as information interface
- Multiple video and sound information processing
- Biological processes server
- Pay telephone server
- San Francisco skyline server

Here is an example of some project descriptions.

- *World Wide Web telephone linkage* To create systems that allow Web navigators to connect with the telephone system, one option is ongoing real-time voice connection for people searching the Web. Another option is making telephone connections a resource available on the Web—for example, a variation on my pay telephone project in which calls to pay telephones would be available to people on the Web.
- *Walking with Information Project* Heads-up displays allow computer-generated material to be superimposed on transparent glasses so that the world can still be seen. There is an inexpensive version available for personal computers. I am interested in the superimposition of information-retrieval visual structures on everyday settings. Create a prototype event to test and demonstrate. For example, collect information about a particular stretch of an urban street (what and who is inside buildings, their credit ratings, history of the place, services, floor plans, and so on) and make it available via heads-up display as they walk that street. A full im-

plementation might involve a personal computer radio-linked to a comprehensive database.

- *Cultural differences in the Web* The World Wide Web allows instant contact with information spaces created by people in different countries and cultures. Are there differences in the ways that authors in different cultures structure and present their information spaces, or is a unified world cyberculture emerging in which these differences are minimal?

We mulled over these and other ideas in a series of discussions. We considered what we each found interesting about the ideas, reviewed what related research was going inside and outside of PARC, and brainstormed further extensions. But the World Wide Web seemed to capture most of our interest. It was just beginning to expand at this time, and only a few researchers at PARC had begun to focus on it. It seemed cutting edge, although none us could have predicted how quickly it would become mainstream. We were all fascinated by its potentials and intrigued by its shortcomings. Increasingly, the Web seemed a viable focus for our joint work.

On reflection now, this choice made good sense. The Web potentially encompassed all of our interests. Jock was interested in the ways collaborative and information work could be supported; Polle was interested in its hypermedia structure; and I was interested in its cultural impact as an emerging technology. Furthermore, it was a pioneering area that none of us had yet worked with, so it did not feel as though anyone was being asked to divert their work to focus on someone else's agenda.

During the summer we worked on two projects: *Searches as Portraits* and *the Road Not Taken/What's Ahead* project. I developed prototypes, and Jock and Polle collaborated in design and critique.

Portraits of World Wide Web Searches

In an information age, the way people engage information sources is an important part of their humanity. We were all interested in the search processes people used to navigate the Web. Jock and Polle's interest grew out of their previous work in using technology to facilitate productive work. I was interested in what you could tell about people by the way they used the Web. I hoped the records of searches would raise questions such as "Who is the

person making the search?," "What is important to them?," and "Would the viewer have made similar choices?"

I proposed to make "portraits" of people as made manifest through their Web activities. Using images, text, and sound from the URLs that a person visits, I intended to make digital movies to portray their navigation experience. We envisioned a server through which people could channel their Web activities. It would sit in the background, storing your movements and the pages you visited. Then when you were done, it would offer to play back animated "movies" of your search.

Jock and Polle thought these condensed records of searches might be useful tools for the original researcher or for other researchers pursuing similar projects. Other research they had done focused on processes for cumulating the fruits of previous work. I envisioned there might even be celebrity searches you could rent like people now rent videos—for example, how did Madonna search for recipes. Even more basically, though, I wanted to view each search as a window into the soul or mind of another person. It was a kind of portrait of the person who searched. It was also a portrait of the people who created the various URL resources that the search encountered.

Setting up the server was a technically complicated process for one summer. Luckily, there was a research group at PARC that had been collecting the records of Web searches for other reasons. The Voting Group was interested in cumulating the results of a community's action on the Web in order to find useful Web resources. For example, they wondered whether simple measures like the cumulative frequency with which certain sites are visited or the length of time people spent at sites could be useful information to other researchers.

As part of their research they had written a modified version of the Mosaic browser that automatically stored the record of sites visited by researchers throughout PARC each time they searched, provided they volunteered to participate. They agreed to make these anonymous records available to me. I built a set of prototype "movies" of people's Web navigations using various filmic techniques and transitions (figure 10.3, plate 5 in the color pages). These showed what an automatic server might be able to produce someday.

Jock, Polle, and I met to review the movies. They succeeded at demonstrating the concept of visually presenting searches, but something was missing. Polle asked, "Where is the art? What is the goal?" I was frustrated

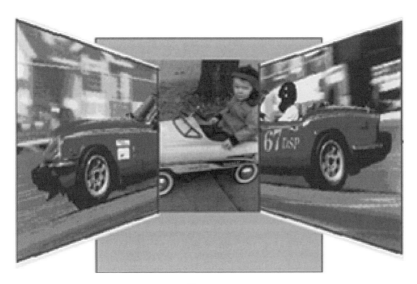

Figure 10.3
Stephen Wilson, *Portrait of a Web Search,* screen shot from an inspectable movie

with the coolness of these movies compared to other art forms. They didn't work very well as portraits; they told more about the nature of the search and nature of the resources the person found on the Web. We wondered whether the utilitarian nature of PARC researchers' Web work biased this particular body of Web searches in a way that made their visual records less interesting. I wondered whether a record of a Web search could really reveal much about a person.

We talked about ways of enhancing the portrait quality, such as using speech and musing about the choices in the background. We also thought about contextualizing the searches by combining them with movies of other Web surfers who happened to end up at the same page. We could link the searches using a commonly passed Web page as the unifier, like the movie *Grand Hotel*, which told the stories of all the people who happened to inhabit the same hotel room during a period of time.

I realized that I was especially interested in the options a person missed. Perhaps you could tell more about a person by what he or she does not choose. Jock and Polle were also interested because the record of what a researcher missed might be a useful resource. I proposed to mock up some more movies that embedded the record of searches in the context of what was

not chosen. I created movies with images and text from pages not chosen in the background. Also, I made these into "inspectable" movies—that is, they were live interfaces. At any point you could click on the images in the movie and a message would be sent to a Web browser running in a concurrent window to fetch the Web page the image came from. The missed option could thus be made live.

The Road Not Taken and What's Ahead?

I was unhappy with the canned nature of these movies made on already completed searches. I wanted to develop a more real-time system that would emphasize the options missed or potentially missed. I proposed to create a system that confronted users with information (such as text and images) not necessarily on the main path of their search. In *The Road Not Taken* project, this information consisted of choices other than the ones they were making at each point that they had choices (figure 10.4 in the color pages). These background images would be live, so that an interested user could click on the material to make it into a live Web page. I envisioned a Web server that would both allow users to search and also constantly throw up text and images of pages missed.

The Road Not Taken also was a metaphor. It used Internet choices to refer to life choices. It reflected on the fact that people often speculate about what life would have been like if they had made other choices—the "what if" question that is perennially part of human experience. It also hopefully would induce people to think about the human condition of having only one life to live.

Jock, Polle, and I agreed that this was an exciting project that we all found interesting. They saw it as a potentially useful tool for researchers, a kind of double check on search processes. Polle suggested that the idea could be expanded to include prospective as well as retrospective resources. She reflected that her hypermedia mapping research was often concerned with letting a user know what resources were potentially available in a system. Therefore, she suggested this shadow server could also provide glimpses of resources potentially available via links from the current page, in addition to presenting what was missed. I suggested that part be called the *What's Ahead?* project and that the whole system be called the Janus shadow server, named for the Roman god of portals with one head looking forward and one looking backward.

Figure 10.4
Stephen Wilson, *Portrait of Search,* context of choices

Unfortunately, the open hours of the summer were drawing to a close, and I had to resume teaching at San Francisco State University. We all agreed to continue working together on the Janus server project, although we didn't specify any details and there were significant technical and conceptual difficulties that we were confident could be solved. For example, a sophisticated script would need to be written to work with a server to service a Web navigator's requests at the same time as it was fetching missed and potential options. Also, realistically, how would you induce Web surfers to use this server?

A Detour: World Wide Web Design Guide

The work on the Janus server was put on hold for a year and a half while I published a book on the Web. Based on my work at PARC, I grew excited about the Web's potential to radically democratize publishing. I was concerned that few resources taught people how to design Web sites and, even more, that few resources connected potential Web authors with the kind of research that Jock, Polle, and other researchers at PARC had done that could enrich the Web. Inspired by my work at PARC, I envisioned a book that would combine hands-on instruction in Web authoring with the perspectives of experimental art and technology research. I hoped to convince Jock and Polle to write chapters in the book.

I wrote a book proposal and sent it to several publishers. A few immediately contacted me to express interest. I signed a contract with Hayden

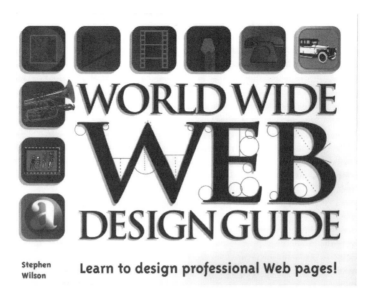

Figure 10.5
Stephen Wilson, cover, from *World Wide Web Design Guide*

Books because their acquisitions editor seemed excited by my vision of the book. Hayden indicated that there were many companies working on Web design books and that it was important to finish mine as soon as possible. I had to suspend all pending projects, including the Janus server, for the year and a half.

The book process turned out not to be the delight I had anticipated. Jock and Polle declined my offer to write chapters. Both noted that it would take more time than they could afford and that PARC would not value a chapter in this kind of popular book as much as work in more traditional research publications. Also, being a mass marketer of books, Hayden's vision of the book was different than mine. Their editors constantly resisted my attempts to include background material about experimental arts, technology research, or the cultural context of the Web. One editor (I went through three) wanted to strike out every use of the term *culture*. Another one, on seeing I had included a section on information visualization, protested that "readers didn't want to know about that." Ultimately, I was able to include some of the material that I felt was important but not as much as I had initially intended.

Figure 10.6
Stephen Wilson, screen shot, from prototype of *Road Not Taken*

Reviewers have indicated that the book is one of the strongest Web books available and that it is particularly interesting because its perspective is unlike any other (figure 10.5). In the twists and turns of life, this book must in part be looked at as a product of the PAIR process that helped inspire its birth.

Update

This chapter is being written two years after the end of the collaborative summer. PARC has extended my visitor privileges so that I can stay connected to my researchers and PARC. Jock, Polle, and I have started meeting again to reassess our collaboration. The future of our work together is still to be determined.

I have written a prototype of the *Road Not Taken* part of the Janus server (figure 10.6, plate 5 in the color pages). Rather than a server, it functions as

a browser "assistant" to Netscape by working in the background to bring up Web pages missed in navigation. Everything appears in Netscape windows, so the system seems to function as a browser with a mind of its own. It uses speech synthesis to speak text from missed pages as well as show them. Playing on the metaphoric meaning of Web choices, it periodically asks users to describe choice points in their life in which they wonder whether they made the right decision. It invisibly accumulates these from all users of the system anywhere in the world and occasionally uses speech synthesis to speak about life choices in addition to Web choices. It plays with a variety of synthesizer voices to differentiate its communication with the user.

Jock and Polle's situations have changed. Polle's research group has been reorganized away, and she now works with the work processes group focusing on activity capture and access (for example, investigating ways to capture the process of meetings for later access). Some of this work is targeted at using the Web as an interface. Jock's group has gone through major changes. Many of the researchers now focus on information access systems for the Web. Some researchers have left, and others may be spinning off from PARC to form a separate company.

Most of all, the Web has gone through major changes since we worked together. It has metamorphosed from an esoteric research system to a mainstream worldwide communication system that attracts widespread commercial and research interest. Some of the systems we fantasized in our initial work together are now easily accessible—for example, linkage to the telephone system, collaborative structures to allow Web navigators to consult in real time, and Web events linked to biological sensors. What looked like pioneering work two years ago does not appear the same now. We lost the momentum that we had established and will have to see whether we can find some common work that engages us all and fits with our current research activities.

What Was Learned? Mutual Influences

PAIR started with an interesting open-ended question: How could artists and researchers mutually benefit from collaboration in a setting like PARC? My work as an artist has certainly been influenced. I became involved with the World Wide Web much earlier and more deeply than I would have if I not been at PARC. I probably think more complexly about what the Web is and what it could be. Through my contact with Jock and Polle and other re-

searchers at PARC I became acquainted with a wide variety of fascinating research efforts that have both utilitarian and cultural potentials. Some day these ideas may find their way into my art work.

My book is the major concrete outcome of my PAIR residency. Readers indicate it is a useful resource that breaks some new ground in its integration of perspectives. Prototype art/interface systems—such as the inspectable movies and Janus server—are projects that may result in art events, but that is a story that still is being written.

I experienced firsthand contact with a world-class research center that helped me refine my ideas about the role of art in research. In the art world my circle of colleagues who are knowledgeable about emerging technologies and I attract audiences because of this knowledge. We pride ourselves on working at the cutting edge of our art. At PARC I discovered a whole community that worked at that edge. For example, in discussions with researchers I would often discover that what I thought was a unique and innovative idea was already a focus of some PARC researcher's work.

Also, I was amazed at the enterprise and productivity of PARC researchers. For example, the UIR research group was discussing agent technology and identified some places where researchers were doing new work on the topic. By the next meeting most of the researchers had read all the new publications available on the topic, and several had initiated conversations with contacts involved in the new research. This was the way up-to-date research needed to be conducted. It was humbling to realize that artists who hoped to work at the cutting edge would need to exercise similar self-discipline in their research activities.

The PAIR program also anticipated that the artists would impact on researchers. From my perspective I can only speculate on these influences and the reader should check other researchers' chapters in this book. Jock and Polle agree that there has been an impact on their research, although there are no specific projects or papers to point to. I suspect that our early involvement with the Web may have spurred their thinking about the Web and its opportunities and other ways of thinking about research. For example, Jock read a paper I had written about critical theory and postmodern analysis and the skepticism of these theorists about the utopian agenda of technological research. We had a stimulating discussion in which he explored how his perspectives differed from those of the theorists.

Jock and I made presentations of our work to the voting project and UIR research group. The voting project researchers were intrigued that their data could be used to generate movies of searches but were disappointed that I had not used a three-dimensional futuristic spacescape metaphor to visualize the searches. The UIR group was interested in the movies and future projects. The presentation stimulated a spirited discussion of page usage statistics. Probably the most lasting influence was my regular participation in UIR weekly meetings. During the summer when I was present daily, I began to understand enough about the ongoing work of the group that I could sometimes make contributions that members found useful. I suspect that part of that usefulness derived from the fact I was a visitor from art. I cannot assert that my engagement in PARC's research was an exemplar of the new kind of artist-researcher collaboration that I describe in my papers, but it did seem that it could have developed much further with more time.

The influence may have also spread beyond PARC's walls. Researchers at NTT's (Northern Telecom) research center heard about the PAIR program and talked to Rich Gold, PAIR director, about establishing a trial version for their center. I was invited to work with one of their research groups to develop new kinds of models and metaphors that could encompass the wide range of activities that would be included in the concept of telecommunications in the future.

Trouble in Paradise: Killing the Golden Goose

Places like PARC should be designated as national treasures. The range and depth of research nurtured there is amazing. Ultimately, some research will be fruitful both commercially and in more general cultural terms. PARC was one of the few places I have encountered where basic research was well-funded and supported. Still, as an outsider I could see certain tensions and stresses that might work against PARC's continuing contribution.

The book *Fumbling the Future* documented the way that Xerox, the corporate sponsor of PARC, had failed during the last decade to commercialize the innovations—such as the graphic user interface, PostScript, and Ethernet—developed at PARC.[6] Others had reaped the commercial benefit. I could see PARC struggling with this dilemma: How could it support researchers to pursue whatever lines of inquiry they found to be productive and at the same time make sure that every commercial opportunity was exploited?

I saw various attempts to connect parts of mainstream Xerox to elements of PARC research and even to "sponsor" lines of inquiry that might be relevant to the more mainstream work. I also saw a great emphasis on patenting. Bonuses and awards were publicly distributed at meetings to encourage researchers to develop patentable ideas. Even in the time I was associated with PARC, I saw researchers devoting increasing energy to thinking about what ideas would be potentially commercial.

People Get Fired?

Once Polle and I were discussing some line of research, and she mentioned that the researcher who used to have the office next to her was an expert on the topic. When I asked where he was, Polle indicated that he had been let go. I was shocked. I realized that I had a rather simple-minded notion of life at PARC. I assumed that researchers, once selected, could pursue any line of inquiry they thought worthwhile. Obviously, this wasn't true, and management made value judgments about what topics were worth pursuing.

Also, I noted the same forces at play in the dissolution of some research groups (to the disagreement of some researchers) and in the forces Polle and Jock alluded to in deciding how they should spend their time. Even a research setting like PARC had managers who had the responsibility for allocating institutional resources. I was not there long enough to understand how the system worked, but it was clear that some researchers did not consider it flawless. PARC's openness to supporting unusual research seemed to me to be one of its strongest assets, and I realized what a delicate balance was required between risk taking and ultimate corporate payoff. I wanted to warn PARC management to tread carefully and avoid killing the golden goose.

The Future of Research

PARC researchers pride themselves on being pioneers in their research fields. Yet I noted a potential crisis developing. Technology once was a field of interest only at universities and a few research-oriented companies but had become so integrated with the commercial life of our society that many resources are devoted to research. The topics of interest to PARC researchers were being pursued everywhere. New ideas were quickly being pushed into products. PARC researchers were reconsidering the ways they customarily thought about their work.

It was clear to me that the kind of work going on at PARC reached far beyond the technologies that were being investigated there. The research could have major impact on conceptions of work, education, commerce, entertainment, and even the nature of knowledge itself. As indicated in the lost treasures section, I wasn't sure that the researchers were aware of the full range of possibilities of their work. Our PAIR collaboration demonstrated in a small way the possible value of linking artists and researchers. Much more would be possible with more artists and researchers working together.

Notes

1. Stephen Wilson, "Dark and Light Visions," *SIGGRAPH Visual Proceedings, Art Show Catalog* (New York: ACM Press, 1993).
2. Thomas Kuhn, *The Structure of Scientific Revolutions* (Chicago: University of Chicago Press, 1970).
3. Stephen Wilson, "Industrial Research Artist: A Proposal," *Leonardo* 17, no. 2 (1984): 69.
4. Jock D. Mackinlay, Ramana Rao, and Stuart K. Card, "An Organic User Interface for Searching Citation Links," *Proceedings of CHI 95* (New York: ACM Press, 1995).
5. Polle T. Zellweger, "Scripted Documents: A Hypermedia Path Mechanism," *Proceedings of Hypertext '89* (Pittsburgh: The Association for Computing Machinery, 1989).
6. Douglas K. Smith and Robert C. Alexander, *Fumbling the Future : How Xerox Invented, Then Ignored, the First Personal Computer* (New York: Morrow, 1988).

11

Artscience Sciencart

Michael Black
David Levy
Pamela Z

One of the effects of the Xerox Palo Alto Research Center (PARC) Artist-in-Residence (PAIR) program has been to expose the strong connections between scientists and artists. Both do what they do because they need to do it. To be allowed to continue their work, they are often called on to justify their work to funders, sponsoring institutions, corporations, the government, and the public. They publish papers, teach workshops, and write grants touting the educational or health benefits of what they do. All of these benefits are to some extent valid, but artists and scientists do their work because they are driven to do it: they need to explore and create.

This chapter attempts to give a flavor of one multiway pairing between composer-performer Pamela Z and researchers Michael Black and David Levy. The three of us paired up because we found each other interesting. We chose each other. While most artists in the program are paired with a single researcher, Pamela jokingly calls herself a bigamist for choosing two PAIR "husbands" with different backgrounds and interests.

Although there are no rules to the PAIR program—no one told us what to do with our time—we all had a sense that we needed to produce something tangible during Pamela's year-long residency. In fact, Pamela kept extending her residency because she did not feel we had actually made anything concrete. But all along we were having great conversations, some of which Pamela recorded. We did not see at the time that these conversations between artists and scientists are at the heart of the PAIR program and were changing the way we thought about our own work and the relationships between science and art.

To give these conversations their due, and to allow readers into our PAIR interactions, we include two of our many conversations below.

———

Michael Black's work involves the analysis of visual motion by computers. One focus of this work is the automatic analysis of human gestures and facial expressions. Pamela Z is similarly interested in human gestures and uses them quite liberally in her compositions and performances. In particular, she uses a MIDI controller called The BodySynth™ (created by Ed Severinghaus and Chris Van

Raalte of San Francisco). This instrument, which uses electrode sensors worn against the skin and wired to a small device that translates the muscular activity into MIDI, allows Pamela to trigger or manipulate sounds simply by making physical gestures. Michael was intrigued by this idea of connecting sound with gesture, and the two of them discussed the possibility of creating another type of controller that wouldn't require the user to wear electrodes or be physically wired to anything. The computer would use a video camera to see the user's gestures or facial expressions and, after analyzing the data, would translate that to MIDI.

Here, science and art hit their first hurdle. The scientist in Michael was interested in creating a tool for capturing information about human motion. The artist in Pamela felt that the idea of creating yet another nonconventional MIDI controller was not creatively compelling. She was more interested in exploring randomness with a device that produces unexpected sounds. Through conversations about music, motion, and performance, Michael and Pamela started to think less about a controller that gave a specific result and more about a controller that involved an element of chance. The idea was to feed it data from Michael's motion analysis of various objects—anything from human gestures to the recorded movement of trees or plants—and see what kind of sound would result from translating this information into MIDI. Art and science were back on track.

Pamela was also influenced by other conversations going on at PARC. During her residency, she was working on a commissioned audio piece about language and found herself immersed in conversations at PARC that used a rich and unusual technical language. She began noticing certain phrases that she found intriguing or amusing and was delighted by the feeling that what she was hearing almost sounded like a foreign language. While she herself has been accused of being a technogeek, at PARC Pamela found herself listening in amazement to meetings in which practically no English was being spoken. Instead, there was a smorgasbord of phrases like *Hot Java, Toast,* and *Language Weenie,* seasoned with a string of unrecognizable acronyms. Pamela recorded these voices of PARC and sampled them to create a sound piece called *Geekspeak.*

Conversations at PARC inspired *Geekspeak,* and the piece itself was inspiration for more conversations, such as this one on the relationship between artists and scientists:

Pamela: Michael, I want to ask you why you're a scientist. First of all, *are* you a scientist?

Michael: Yes. It took me a while to realize that. And it wasn't entirely comfortable. It seemed somewhat preposterous and inconceivable to be a scientist. It would be interesting to go back and look at my tax records to see how I answered the question "What's your occupation?" At some point I started listing *scientist*, and it would be interesting to see when I did.

Pamela: What did it say before it said *scientist*?

Michael: It probably said *engineer* or *computer scientist* or something—*student* at some point. And now that I'm actually a manager, I still list scientist because that is what I am. It's funny, it took a while to become comfortable.

Pamela: So first you had to come out to yourself . . .

Michael: Yes.

Pamela: . . . And then you had to come out . . .

Michael and Pamela: . . . TO THE IRS!

Michael: And my parents were the last to know. OK, so how did I become a scientist? I didn't start out as one. I wanted to be an architect. And as an undergraduate I also studied psychology because I was interested in how space effects people's moods and interactions. But then I took this course in computer science because there was no other course that would fit in my schedule. And I figured that with architecture, computers were becoming all the rage.

Pamela: And you had to figure out how to design that little nook.

Michael: Yes! And it was all going to be on computers. And I suppose it is now. And so I took a Programming for Nonmajors computer course, and the rest is history. It was back in the days of

card punches, and I loved the card punches because they made such a great sound! There was a room full of people typing away on these card punches making keyboard-like clicking sounds, and then in the background people would be running their cards through the card reader. And it makes this sound when you put them in, and they all sort of fluff up and go "thr-r-r-r-r-rrrrr!" The card punches were great because if you made a mistake on your card, you could put in a new card, press the duplicate key, and it would run through and duplicate the card up to the point where you made the mistake. Then you could change the mistake and continue.

> Pamela: Oh, so it was a way of editing? It was the editing feature!

Michael: It was a way of saving typing. It was like editing back on paper!

> Pamela: Ah! Your answers to the questions always make me suspicious of you. I always suspect that you're partially an artist. Maybe just a little bit.

Michael: Maybe a tiny bit. So one of the things that really appealed to me about programming in that very first course was that I thought programs were pretty. They had spatial structure. When you write a program, it looks a certain way on the page. For instance, when I was an undergraduate I was working on an artificial intelligence program using a language called Lisp, which is a very pretty programming language. I was doing the final demo for my class project, and it was some game-playing program—chess or checkers. My professor was there, and the program crashed. This would normally be a bad thing, when you are demonstrating your final project, right? He asked me to show him where it crashed, and I brought up the piece of code where it had died.

He looked at it and said "Oh, that's beautiful!"—just the way it was structured on the screen. It just had a nice shape to it. There's an aesthetic to programming that was one of the things that drew me into it from the very beginning.

Pamela: Oh, my goodness!

Michael: You never knew! So this has been a very long-winded answer, and I still haven't answered your question. But you see, being a scientist is something more . . .

Pamela: . . . than being excited by the beauty of the thing on the page?

Michael: Right. It's something more than just—well I shouldn't say *just*—but something more than being a programmer. It means that you're seeking deep answers to deep questions. And you're seeking answers to questions that maybe no one else has ever asked. And it means sort of going out on a limb. Being in the frontier of something. And it took a long time to realize that I could go there. Early on I worked with Daryl Lawton before I got my Ph.D. He began to give me the inkling that what we were doing in trying to understand computer vision was actually exploring those deep questions. Once I realized that that's what I was doing, it changed my attitude about the whole endeavor. Science is something that involves rigor, and there is a methodology, a tradition, and a history that goes along with it. The realization that what I was pursuing was of scientific merit had a profound effect on my thinking about what I was doing. Scientists have tremendous freedom and tremendous responsibility. So realizing that you are a scientist, you have to step up to the plate and accept the responsibility that comes with the freedom.

Pamela: Do you think that most people at PARC see themselves as scientists?

Michael: Well, this is something that has really freaked me out recently because I thought that PARC was about science. I thought that was what our mission was. And I'm starting to think that not everyone has that view. People talk about technologists and researchers, and when I hear this term *researcher* I just think *scientist*.

Pamela: That's what I think, too.

Michael: But it's not. There are people here pursuing all kinds of different things. And some of the research they're doing in design, say, is much more like art than what I would traditionally associate with science. Maybe that's what's so great about PARC.

Pamela: The line is blurry.

Michael: The line is *really* blurry. And I think that creates opportunity, but it also causes some confusion. I may have a model in my head of the kind of things we should be pursuing, and someone else may have a completely different idea.

Pamela: But it could still all fall under science. I'm curious about what the dividing line is, if there is one, between science and things that are not science?

Michael: Well, there's a pat answer that involves invoking the scientific method. I don't think that it is a particularly compelling answer in the context of PARC. Science involves building on a body of work—rigorous approach to experimentation—and often involves the application of very formal methods. Some people try to bring those methodologies to design work here at PARC by making careful studies of people in the world doing what they do. They have developed method-

ologies for understanding people doing their work, and they try to abstract concepts from that process.

> Pamela: So it does seem blurry, this line between science and nonscience.

Michael: We talk a lot here about blurring. There's a recent emphasis on blurring the physical and virtual worlds. Blurring the boundaries between our real world and this electronic world. I think people see PARC as a place where blurring can happen because there are people from all different parts of the spectrum.

> Pamela: It's funny because I've been dealing with a lot of blurring where art is concerned, and it's mainly around computer arts. You've probably heard me railing on about this *multimedia* industry.

Michael: No, rail away.

> Pamela: My big complaint is that the *multimedia* industry stole this word *multimedia* from the arts. It used to mean "more than one medium." Surprising! In that context you may have performing going on with projected image, perhaps with sound and dance—all of these different media combined. If you were a visual artist, the expression *multimedia* meant the use of many visual media, combining paint with collage and other media. Then the computer industry stole the word, and now suddenly any "artwork" done on the computer is considered to be *multimedia*. So now *multimedia* means "one medium"! If you're using the computer to do it, that's multimedia! And supposedly because there is all this software that allows you to do visuals and sound and whatever, all you have to do is make some little director movie where some little thing dances across the screen and that's called *multimedia*. So I was sort of annoyed at the loss of that

word because now we have to say *interdisciplinary* or come up with new words because the original word has been rendered meaningless. If I billed performances as being *multimedia* these days, people would come expecting everything to be computer-based or computer-generated!

Then there's this new confusion about "What is art?" I never wanted to be one of those people who scowls and says, "That's not art!" or, "That's not music!" You can say that you don't like it, but how can you say that it isn't music? But I am noticing many people suddenly being *artists* because of the computer industry. I am questioning the level of artistry in what they're making. Is it art, or is it just a mastery of some software?

Michael: Can it be both?

Pamela: Well, the comparison I'm drawn to make is to the skill of drawing photorealism. This is the skill that the layperson often thinks is the most important skill related to visual art. But many great artists are unable to do this and would perhaps never desire to do it. Being able to do that is less about whether the person is a good artist and more about whether they've acquired a very specific skill used in art. There is a book by Shari Hart called *Drawing from the Right Side of the Brain* that was very popular at one point because it could teach nearly anyone to draw photo-realism. But whether or not the person who learns it would make great art or has any ideas about what they should make is an entirely separate issue.

Michael: What you're doing is separating the creative process from the mechanical process. The computer is just a different tool. If someone is truly creative, and you give them a paintbrush and teach them how to use it, or you give them a

computer and teach them to use it, they will master that skill and then apply their creativity.

Pamela: That's true. It's all art. You often wind up with bad painters, but they are still painters. But the difference is really because of the marketing for this industry. It has given people reasons, both financial and trend-wise, to want to learn to do this thing. It feels to me as if it's being driven not so much by deep-seated artistic tendencies as it is by industry and commercial motives. It's not that no one who is doing this is doing anything good. It's just that this current obsession with new media has brought about such a glut of work—both good and bad. And so much of it is tied to money that it is perhaps deepening the confusion about what art is—perhaps giving people too narrow a view of art.

Michael: I think time will sort this out. When photography first came on the scene, people probably thought, "Oh, this is great! What an artist!" You've got a new medium here, and it's hard to judge quality with a new medium.

Pamela: Oh, I agree. But I think, for one thing, that it needs a name that's more defining of what it is. I'd prefer something like *computer arts* or *digital media*. That way *multimedia* could retain its original, broader meaning that might *include* computer art but really includes anything that combines media.

Michael: But the industry's use of terms is really mainly about marketing.

Pamela: Yes, it reminds me of a performance work that I did with Randall Packer and New Music Theatre. We inhabited a booth at Mac Expo one year and created a show that looked like a product demo. We invented a fake product called *Art-O-Matic*. All you do is just plug it into your computer, and instantly you will be an artist! I didn't know

whether to be amused or distressed when people came up to the booth after the show and tried to order one!

Michael: So when did you know that you would become an artist? When did you start writing it on your tax form?

Pamela: I think I knew that I was a musician before I started doing tax forms, but there was a point where it shifted from *musician* to some kind of broader artist. On my tax forms the occupation line keeps changing. I think it was exciting when I eventually had the satisfaction of having it be what I do as an artist as opposed to saying I was teaching or what ever else I was doing for money. So that satisfaction came when I started making a substantial amount of my money from doing art, and I think it was less relevant whether it said *musician* or *performance artist* or whatever it said. But now what I'm writing on the tax form is no longer relevant because my identity is clear, and it's just this problem of how to justify or explain where the money is coming from. So it goes from saying *artist* to *consultant* to *instructor*. . .

Michael: *Consultant*! That's nice and vague.

Pamela: *Consultant* is good. This year I think it said *performer/instructor* because I teach this class one day a week at San Francisco State University. It doesn't pay that well, but it's still a substantial amount of my income. And then I teach people to use digital sound editing software. I freelance and consult with people and teach them how to use the computer. And of course I get gigs where I'm either commissioned to write music or perform somewhere. So my money comes from all of those things. But I think your question was "When did I figure out that I was an artist?"

Michael: Yes. Or when did you start calling your-
self an artist? Because I think, like, calling your-
self a scientist—that's a big leap.

Pamela: It *is* a big leap. I think that there's some
confusion with the word *artist*. If you say that all
arts professions—not arts administration but the
actual making of art—fall under that, then I would
say that I started calling myself an artist right out
of high school. I was already decided on profes-
sionally being involved with the arts by then. Even
before high school, I had already centered my iden-
tity around doing art. At that time it was specifi-
cally in the music area and not even in experimen-
tal music. When I later became interested in more
experimental work, I saw *that* change as being a
major shift for me.

Actually, this is a really interesting thing be-
cause you know that I have always compared
artists to scientists. And as you were defining what
it means to be a scientist, I realized that, more
specifically, I think that *experimental* artists are
similar to scientists. I think they're more similar to
scientists than artists who are doing conventional
work. I don't think that artists who are not experi-
mental are lesser artists, but I think that the exper-
imental ones are the ones who really have so much
in common with the scientists.

Michael: So let me see if I understand *experimen-
tal*. Is experimental that the output is something
new that no one's seen before, or is the methodol-
ogy that you use one of experimentation? "I'll try
this. Oh, that's not quite right." And through a
process, you . . .

Pamela: I think it's both. John Cage's definition of
it was something like "Artists who do not know
what the outcome of what they are making is going
to be." And then somebody else (David Weinstein)

made the joke that it's actually "Artists who do not know what the *income* is going to be!"

But I think that the spirit of it has something to do with part of what you said about being a scientist. And I hate to use buzz words, but I think of the expressions *cutting edge* and *avant garde* used in the sense of being on the front lines sticking the edge of your shovel into ground that no one else has penetrated yet. Others are also digging, but they're digging into something that has already been uncovered by somebody else before them. Like someone who decides to become a concert pianist, and they're only going to play common practice period work. They're not going to play modern work, or even if they do it's going to be tried and true concert piano work. Their challenge is to become strong and powerful at doing something that other people have already done. The yardstick that they're measured by is how other people are already doing it or have done it in the past. They could go pretty far on just doing what has been done before extremely well, but what will push them over the top is that they somehow do it in a way that nobody else has done it. They will have to do something different. So I guess in a way, conventional artists have that thing too, but for experimental artists, that thing is at the heart of what they are trying to do.

Michael: What if you did a PAIR program with a golf player? In golf, people are mainly trying to improve their game. They're not trying to do something radically different. They're probably not even allowed to swing a baseball bat or something else at the ball.

Pamela: Or just swing it in a different way. There's a form that they had to learn.

Michael: Right! You can't just go pick the ball up and throw it or something. You're refining, ever

refining with a fixed set of rules. It's not at all like scientists.

> Pamela: An experimental golf player goes out there and says, "OK, today we're still trying to get it in the hole, but you can't touch it with the club." You have to somehow use some other means.

Michael: Maybe we'll just look at the ball today . . .

> Pamela: . . . and try to see if we could move it into the hole telekinetically. Or maybe we'll use little blowers that somehow guide it along with wind.

Michael: I know! As opposed to being green, the fairways are covered with white golf balls! The whole way! So when you tee off, you hit your ball, and it lands someplace.

> Pamela: But now . . .

Pamela and Michael: . . . it could be any of them!

> Pamela: Conceptual golf!

Michael: But you see that doesn't happen in golf. It's more about being "better than everybody else" than just being on the edge of something very new.

> Pamela: I was reading that NASA is dealing with a vicious cycle concerning travel to Mars. It seems that the amount of fuel required for a round trip increases the weight of the craft so much that it then requires even more fuel. Someone suggested just taking enough fuel to get there and then stay there and live off the land. Perhaps more fuel could be manufactured once they settled in, like the early frontier people who came to the new world trusting that they could grow food or hunt to sustain themselves after they got here.
>
> Everybody knows that if you're going to be gone for this long, then you need this many sandwiches. I guess those space travelers will have to trust that they'll figure out a means to make more sand-

wiches when they get to Mars. It's a dangerous choice, but it will yield much more interesting results. If they weren't scientists, they might be stopped by that problem. They could only go as far as the moon because they could afford the weight of the round-trip fuel to get there. They would just have to work toward getting really *good* at going to the moon. It's like getting really good at playing the piano. So all this just made it more clear to me that experimental artists are just like scientists.

Michael: When I think about being a scientist—being out there on the edge—it *is* kind of dangerous. You might not succeed, but that doesn't actually happen a lot because when you're out exploring new territory, the thing you thought you were going to do may not work out at all, but you learn something completely different that you never expected. I'm always trying one thing and thinking, "That doesn't work, but wouldn't it be great if you could do this other thing!" And I'm off in some new direction.

Pamela: That's the same way that I am with my art, and I think it's the same way for a lot of other people who consider their work to be experimental. Maybe the essence of it is not just giving yourself permission to try things that have never been tried before: that's a given. Maybe it's more about being open to the fact that your direction will change. That what you find there may make you veer off of your original path. It's not that you don't have a plan; it's that your plan is open ended. Some artists are interested in imposing some rule that's outside of their control. John Cage often did this with the *I-Ching*. So whatever you happen to throw, you're bound by those numbers, and these external restrictions help to impose a certain newness on the work.

Michael: I can't think of any analogy to something I do that's like that. I start from "What do we know so far?" In the case of motion, which I've been working on for a long time, there are certain things we've learned over time. People will get focused on one of those things, and that is what they will pursue—forever! Yet there are all these things that we haven't really addressed that are still unexplored. So I typically pick one and think, "Well, let's just take a shot at that for a while and see where it goes."

Pamela: But everything you do, in a way, is like that because isn't that the scientific process? You have an idea, and it's going to interact with some law of nature or physics. You could guess what might happen if you apply it, but you have to let the numbers run their course and see what they make. Rather than doing the math yourself, you maybe let the computer use a certain set of factors or base it on some specific curve that exists in physics or nature to see how that affects it. You may have an idea of what you expect to happen, but if it starts veering from your idea, you don't just stop it and say, "Oh, we'll alter this number here. We'll add another point because it's going left and I thought it would go right." Instead you just watch to see where it goes, and maybe . . .

Michael: . . . you try to figure out why.

Pamela: For example, if we do this thing with the trees and try to just pick some parameter of sound that's going to be generated by the movement of the tree, then we have to stick with what the tree gives us. We're not going to say, "But I hope it sounds pretty! It's not sounding pretty. Maybe we shouldn't use the last ten minutes of the tree."

Michael: You gotta be honest to the tree!

Pamela: You gotta be honest to the tree and play it the whole way through and see what it sounds like.

Michael: If it sounds really bad, then we just don't play it anymore.

Pamela: Right!

Michael: So you start attacking some new problem that no one's ever tried before. And it's big and it's unknown and it's amorphous and you can't quite get yourself all wrapped around it, and maybe you don't have the math to understand it or whatever. Slowly you begin to explore this new territory by making mistakes, and I try not to get stuck by wanting to know the big picture too early. The big picture comes only when you look at a map of the new world once you've been out exploring it a bit.

Pamela: Sometimes I solve the problem of things being too big by just taking a smaller part. I keep taking as much as I think I can handle or do something with. It gets down to this microscopic thing, and then that becomes really big because it becomes a whole world in itself.

Michael: Yes, right.

Pamela: Maybe my original idea might be to make a sound piece about the city. So I've recorded a bunch of sound samples, and now I have ten hours of tapes of city sounds. All of a sudden I'm faced with the fact that I have to listen to ten hours of tape. And it takes an enormous amount of time to listen to and edit ten hours of tape. I don't mind having a different result than what I planned, but my fear is never having a result at all. I can't be a conceptual artist to the degree that I don't mind not having a result. I need a *thing*.

Michael: I do, too.

Pamela: And I'm afraid I'll never get to the thing if I have this huge amount of material, so I start whit-

tling away. Eventually it gets to be, "Well, I'm not going to make a piece about the whole city. Now it's just going to be this one particular cable car. Now it's just going to be the brake from this cable car." Pretty soon there might be an entire work that's just "eh-eh-eh-eh-eh"—the brake sound of this one particular cable car! I could stretch that and do things with it, and I start to realize that that one sound can be much bigger than this cluttered piece where I'd try to use everything.

Michael: You'd be a great scientist.

Pamela: And I'm always saying you'd be a great artist!

Michael: But I can't paint. I'll have to get myself a computer! I could be an artist too!

Pamela: Just buy a computer and you're an artist automatically! Art-O-Matic!

Michael: Well, I have a computer!

Pamela: Wait, have you bought the right software, though?

Michael: I don't have the software. But I'm a conceptual artist. I'm thinking about the software.

Pamela: So what about your motion studies? What makes you more interested in one motion than you are in another?

Michael: Well, when I started off with motion there was a well-understood core of stuff that people had been doing for a long time. As a graduate student I started there, and whittled away a little piece that people hadn't been working on. And then I whittled away some more pieces. But now I'm looking at problems for which all those core tools I had don't really seem to be appropriate. And that's why I'm really drawn to looking at these trees.

Pamela: Because there's nothing so far that's been designed that knows how to deal with that?

Michael: There really isn't. I think it's a new area.
Plus I can look out my window and see examples
of it.

Pamela: You don't have to go to some site.

Michael: I just try to push things in new ways.
Look for new problems. I have no idea what it will
be after plants.

Pamela: And it was faces and arms before that.

Michael: Yes, I spent a couple of years on faces and
arms. I figure I'll spend a couple of years on plants
and I'll figure that out.

Pamela: Then it's going to become carpet.

Michael: Yes. Paint drying is the next thing.

Pamela: Oh, I keep telling you I'm going to bring
you that film of the hair. A friend of mine (Helena
Kolda) made this beautiful film. Her husband was
standing on top of the Art Institute, and he had re-
ally fluffy, white, soft hair, and the wind was just
playing with it. And she just filmed the back of his
head for a really long time. Every once in a while
there was some sort of anomaly that occurred, or
she pans away from his head, but 90 percent of the
film is just the back of his head and his hair moving
in the wind, and it reminds me of your trees.

Michael: Yeah, I would love to have a film of hair.
Or maybe next I'll do birds.

Pamela: Once I did sound for a film by Barbara
Klutinas called *Wind Water Wings* and there were
birds, jellyfish, and windmills.

Michael: Ah, jellyfish! Great!

Pamela: When I looked at them, my feeling was
immediately that they breathe. There should be
breathing sounds. Like a lung. So the sound I put to
that section was a breathing sound that was my
own breathing.

Michael: When they do that motion, do they ac-
tually push water through or something?

Pamela: You know, I don't quite understand jelly-fish. But I guess they expand themselves, and I suppose that's how they propel themselves. So it's just this problem of going through the water? Except they've solved it by taking in the fuel and then. . .

Michael: Too bad there's not much stuff in outer space.

Pamela: Yes, they could just make a giant jellyfish, and they could get all the way to Mars.

Michael: Too bad. Jellyfish in a vacuum. It reminds me of the early days of film when they were trying to capture the movement of animals.

Pamela: You know, the more I talked to you and to David, the more it kept reinforcing for me that artists and scientists aren't really so dissimilar— at least if you guys are good examples of scientists. Scientists do make more money though!

Michael: Yeah, but artists have the potential to make far more than scientists.

Pamela: Right. It depends. Some artists, but very few of them, make more money than anyone! And then the rest of them make less money then anyone. The ones who make a lot should just share it with the rest of us!

Michael: Well, you know a lot of scientists have to get grants. We both have to apply for grants!

Pamela: That's exactly right! It's so much the same thing. The difference is that a lot of corporations are willing to employ large numbers of scientists. I guess the equivalent for artists is to become instructors because there are university positions.

Michael: Oh, but you have that also for scientists.

Pamela: Unlike law or medicine, for example. If you're good enough to get through school, you're probably not going to end up as a homeless, out-of-work doctor! But there's a high likelihood if you decide that you're going to go into the arts, you might

not be able to make money in your field. If you're smart and resourceful, you might do something that is vaguely related to your work, but more people will end up doing something outside their field to make money.

Michael: It's the same with scientists. You do your Ph.D., and you spend a number of years there focusing on something that you are really good at. Then you wind up getting an academic job, and there are all these other things you end up doing. These may be really valuable—for example, training the next generation of scientists—but it isn't the science that you love doing. Many of the academic scientists get very little time to actually do research.

Pamela: It's sad!

Michael: So one thing I would like to ask you about is collaboration. For me, it's absolutely critical. I almost never do work completely alone. I'm always working with other people, and it's great because you check each other and challenge each other. And it's fun. So do you collaborate with people a lot?

Pamela: I do, but for me it's not essential to always collaborate. I also like working alone a lot. But, by the same token, I always need feedback after I've made something or when in the midst of making something. I'm always dying to get somebody over to play it or perform it for them. Since a lot of my work is performance, the collaboration happens with the audience. I never really feel that my performance works are finished until I've done them in front of an audience. Performance is about interacting with an audience. It's not like painting, where you paint a picture and later some people look at it. You might not even be around when they view the work. If they don't like it, the painting

won't change; and if they like it a lot, the painting won't change. The next one might change if you read a review, and people almost see this as a weakness that the public reaction changes your work. But in performance, that's somehow a much more acceptable way of functioning. It's not about if they like it or don't like it; the instrument that you are playing is the audience. So if you play a violin, and the violin doesn't reverberate and sustain the tones that you're playing, then you work at manipulating this instrument until you get a vibration out of it. And with a performance artist, one of the instruments is the people you're playing to. If they don't react somehow then, in real time as you're doing it, you work it to make them react. Because their reaction is part of the piece.

Michael: There is also a huge performance component to what I do. And it's very similar to what you described. For example, I really like communicating with a group of people. Standing in front of a group of people you sense "Is it going over well?" And you can tailor your "performance" to the audience.

Pamela: You can raise your eyebrows more.

Michael: Yes. I think it's a real critical part of my job. It's important, and I really think about it a lot. One thing has sort of been freaking me out. I guess it shouldn't, but it is. The World Wide Web is changing things a little. So I have a Web page, and I realize that there are a whole bunch of people out there that are getting my software, getting my papers, that I don't know about. I don't know them. I don't have a counter so I don't know how many hits I have.

Pamela: You should put one on there!

Michael: I don't know how!

Pamela: Wait a minute! You're a programmer! People always say that sort of thing to me. Why can't you do that? You work with technology!

Michael: You're right. I could do that. It would take hardly any time. Do I have hardly any time?

Pamela: Do you care? Not really.

Michael: But I am starting to realize that I'll say something, and people will say, "Oh yeah, I saw that on your Web page." And I realize . . .

Pamela: . . . that they're looking at it!

Michael: Yes, that people are looking at it. Usually when I present a paper, there are people there with me, and I know maybe some people will get the proceedings and read about it, but I know I've shared my ideas with this one group of real people. And now there's this bigger group of anonymous people on the Web, and it's almost a bit awkward because I don't have control over—

Pamela: It's almost a little disconcerting at the same time that it's exciting. Because I get the same thing. I get emails from people. They start talking to me about my work, and I assume that they've attended one of my performances. And then at some point they say, "Let me know when you're going to perform in my area because I still haven't seen your work." And I say, "What do you mean? We've been discussing my work!" Then I realize that they only know about me through my site. And it's almost like there's a different level of respect because they see me as not a real person. Somebody once wrote me with a bunch of questions. I answered it the very next day, and they wrote back and said, "I can't believe you answered me! I didn't expect an answer!"

Michael: I get that too! I get these students writing me from Spain or something: "Dear Dr. Black." It's all very solemn and very formal. And I always write back. If students write me, I feel like

I want to help them figure things out. So the Web thing really expands your audience. And these people write to you thinking you're a big famous person.

> Pamela: Because you're on the Web! And it's weird because then there's Joe Smith who's like: "This is my cat, and this is my best friend's cat. And here's a picture of my wife's new job. We got a new mall in our neighborhood." They see those Web pages, so why don't they just think we're one of those?

Michael: Well, the great thing about the Web is that it's now actually hard to get indexed, right? It used to be that Altavista would index, or so you thought, everything that's on the Web. But now, only a relatively small percentage of Web pages get indexed.

> Pamela: But somebody's making decisions. Somebody's deciding if it's worthy or if it's not.

Michael: And sometimes it's a computer.

David Levy's voice was not among those used in *Geekspeak*. Interestingly enough, David is one of those people at PARC who doesn't consider himself to be a scientist. He calls himself a computer scientist gone bad. After finishing up doctoral work in computer science and artificial intelligence, he went to London to study calligraphy and bookbinding. It was a way of immersing himself in craftwork and counterbalancing the overly abstract, intellectual side of his computer training. At PARC he works closely with the anthropologists, some of whom were paired with two other artists—Jeanne Finley and John Muse.

David now calls himself a *document philosopher*. He thinks and writes about questions like "What is a document?" and "What is a copy?" and is busy writing a book on the subject. It was interests like these that first drew Pamela and David together. Some of Pamela's pieces make heavy use of repetition (a form of copying) and play on the juxtaposition of live and sampled sound. Early in her residency, Pamela created a short audio segment using

text that David wrote about breathing, meditation, and the fragmentation of modern life. Their conversations have also inspired Pamela to start another sound work about copies. In this work she recorded interviews with several people in which she asked them each questions like "What is a copy?," "What is a document?," and "Do you think a copy can ever be better than the original?"

Pamela explored the notion of a copy in a little practical joke performance. David has a piece of artwork in a Plexiglas frame on his bookshelf. The piece is a small, woven construction of handmade paper of various textures and patterns. While he was out of his office, Pamela took the picture out of the frame and made a copy of it on one of the color copiers. She folded the copy neatly so it would fit into the frame, numbered and signed it, and placed the whole thing back on David's shelf so that the copy was visible and the original was hidden behind it. David did not discover the fraud for over a year! He was thrilled and amused when he did, and it led to a conversation about copies:

David: There's a remarkable little book by Nelson Goodman called Languages of Art *that I not only read ten years ago but actually threw across the room at one point in frustration! In this book Goodman asks why, if you make a copy of a Picasso painting—or any painting, for that matter—that no matter how good the copy is, it still won't count as another example of that same work. However, if you make a copy of* War and Peace *or any novel, any copy of that novel will be just as much an example of the same work.*

Pamela: Well, to me the answer seems pretty obvious. Unless we're talking about an e. e. cummings poem, the visual appearance isn't really considered to be the substance of the work; the substance is in the words themselves. And the copy of it—even his first copy of it when he typed it—was a mere representation of the work itself, which is actually the words. And if we came up with some other phonetic alphabet and wrote out the whole thing that way, we would still be writing the same novel because the

words themselves are the art, not the fact that it's in Times nine-point font spaced in this way and justified left or right on the page and so forth. The Picasso painting isn't a representation of the work, though. It *is* the work.

> *David: Well, let's go a step further with this. What do you do with an artist who has produced a screen print— the case where someone has actually produced a master and then prints a bunch of images from it?*

Pamela: Right. Or someone like a photographer who can print as many photos as they like from the same negative!

> *David: Exactly.*

Pamela: This is a big question in the world of music and audio right now because now sound art has a lot more to do with recording than it used to. It used to be a clear-cut situation where musicians performed on instruments and technicians sometimes recorded them. Now the artists themselves are creating the work using these electronic devices, and sometimes the actual essence of the work is the recording itself. So you buy one of these recordings for $16.99 at the local record store, and somebody else buys another one for $16.99, and there's no difference between the two. That, to me, raises more puzzling questions than the one about the difference between copying a Picasso and copying *War and Peace*.

> *David: Well, Goodman's response is—and I'm paraphrasing—*

Pamela: You're making a *copy* of his response!

> *David: Well, let's say I'm doing an improvisation based on it. He says that whether or not something is a copy of something else is really governed by social convention. So what criteria does the culture use to determine identity and sameness at a given time? There are some arts— painting happens to be one and there are others—where*

there are no general criteria established by the culture except the fact that it has been made by the artist's hand. But on the other hand, there are art forms where the culture has come up with a notation for characterizing works.

Pamela: Right. That's exactly what I was talking about.

David: You were right on the mark there. In these cases, the culture has decided that all it takes to be an example of a particular work is to be spelled properly in this notation. And of course there could be equivalent notations and all that. These could be phonetic or whatever, as you said.

Pamela: And I think the criterion is that the form of notation has established enough of a convention that there is an accepted reading so that it is a recognizable representation of that particular thing. So I could write *War and Peace* in Katakana and have a Japanese person read it out loud, and no one would know, perhaps, that it wasn't being read from the original. And if you're doing conventional Western classical music, there is a standardized form of notation that allows it to be performed again and again, even 200 years after it is composed.

David: But it's still convention. We know that a musical score captures only certain aspects of a performance, and it's by social convention that we decide, if the notes are roughly the same, that it's the same work.

Pamela: But the thing is, there's a lot that musical notation can notate. It certainly isn't perfect—and I wonder if any notation is perfect—but musical notation can specify more aspects or dimensions of sound than most people realize. Not just the order and duration of the pitches, but the tempo, the tempo changes, the dynamic changes, and many other elements. So although the interpretation will

be slightly different from one performance to an-
other, the essence of the work is the same.

> *David: Ah, but there you are! How is it decided how*
> *different those interpretations can be and still have it be*
> *the same piece?*

Pamela: Well, it depends on what kind of music it
is. It's similar to trying to notate spoken language.
In our language we don't have certain sounds, so
our alphabet will be inadequate for transliterating
languages that have those sounds. And with mod-
ern music you have new techniques and new ideas
about what sounds are acceptable. And in some
cases, nobody has thought of how to represent
them yet. In fact, at times notating the music seems
to be irrelevant to the composer. Perhaps they don't
assume anyone beside them plans on performing it,
or they might consider the recording of the piece to
be the necessary notation for it.

> *David: This is great territory. But there are some sub-*
> *tleties I would challenge you on because it really is ulti-*
> *mately social convention that decides. You are suggest-*
> *ing that you can capture so much in musical notation*
> *that you can really make a good copy of the performance.*
> *But aren't there going to be cases where you can say that*
> *two different performances, although very close many*
> *ways, are actually different works?*

Pamela: I think it depends on what the work is. Let's
take Mozart, for example. He was using standard
musical notation as he composed each piece. You
know, if you spend all your time on the phone, you
learn to express yourself in ways that can be under-
stood by the ear alone. However, if you are used to
face-to-face communication, you might rely much
more heavily on visual input to get your point
across. And the composer who's spent a whole life
with the music flowing straight from their head
through a pen onto manuscript paper is writing stuff

that was intended to be understood fully through that notation. Whereas a composer who goes around listening to the sounds of the branches clacking against each other and incorporating those sounds into their work is not thinking directly about how they are going to notate this. Each time this work is performed it's going to be different, and, for these composers, that's not necessarily a problem.

David: Yes, and there are also improvisers, right?

Pamela: Yes! I think about John Zorn, who wrote a piece called *Cobra* that gets performed regularly in New York by downtown improvisers. It has several cues in the score, and the conductor puts on a red hat or something that causes certain things to happen. It's a structured improvisation in which the performers read the rules, and then they perform it according to the conductor giving these signals. And so all of it is *Cobra,* and yet every performance is different. Somebody once put out a compilation of all the performances of *Cobra* that had been done at the Knitting Factory in New York over a certain span of time. It was like a compilation CD with lots of different pieces on it.

David: Ah, great!

Pamela: If you knew the piece, you could probably listen to each recording and say, "Oh, this is the red hat" or whatever. If you don't know the rules, maybe you wouldn't know that there was any relationship between any of them.

David: Well, we're back to asking what are the conditions of sameness. Maybe in the case of Cobra *they're not necessarily determinable by the performances themselves, but the rulebook is what is giving this thing . . .*

Pamela: . . . its life . . .

David: . . . or its identity.

Pamela: And I love that because it breaks a lot of other rules that people have set up over the years as

to what makes something a composition and what doesn't. It challenges the idea that it isn't OK for a piece of music to be more like a game than a piece of music. Before there were conventions for notating music, and there wasn't this artificial separation between high art and low art. People learned songs from hearing other people sing them, and no one cared if every performance was the same. It wasn't an issue.

David: But now there is this highly developed notion of a work of art that has developed in Western culture. And along with it is a notion of the artist, or the author or creator—the one who actually created it.

Pamela: The one who had that magical touch to actually make these things.

David: Right. And what you're talking about is a time when works weren't so circumscribed.

Pamela: Everything in life was more integrated. Perhaps singing a certain song was connected to making bread. And there wasn't this notion of a work of art belonging to someone. But now we've all grown up in a society where this idea of ownership of an artwork is an important concept and the idea of the artist as somebody separate from the person who makes the bread.

David: Except usually that's what the artist has to do to make a living.

Pamela: Right! Which is why a lot of us have a certain attachment to this idea of owning our art. An artist would hate it if, right at the moment they gained enough notoriety to give up their day job at the bakery, the rules changed back and people said, "Let's go back to the time when . . .

David: . . . art was free!"

Pamela: But we're living in a time in which all these conventions are being challenged because the way in which art is being made has changed so much.

Even with artforms that involve reproduction, the methods for making those reproductions are changing. It used to be that the *mother*, or original, recording was always going to be the best and anything that came after it wouldn't be quite as good. Now that it is done digitally, they are all going to be the same.

David: Ah! Here let me challenge this one for a minute. Let's take this case that you are talking about now— where you have made a printing plate or a photographic negative or something like that. Let's call that a template, *and you are going to use that template to stamp out and create an arbitrary number of copies.*

Pamela: And sign and number them!

David: Quickly! And then destroy the template. So I'm interested in how it is that every time you stamp one of these things out that they are all the same? How is it that the template holds the identity or the sameness in such a way that it gets to pass it on to each of the copies? It's kind of a miraculous thing when you think about it—how it imparts or passes on a bit of its essence. Don't you think?

Pamela: Well, unless you're dealing with digital technology, which is a whole other ball of wax, they're *not* just the same. Every one is a little different. There's a little ink blob on this one; these came out kind of grainy. You know each one *is* different. But there are actually two questions here. One is a question of sameness, and one is a question of value judgment. Which was my question to a lot of the people I have been interviewing for the sound piece I'm doing about copies: Can there ever be a situation where the copy is better than the original?

David: And of course the answer is yes.

Pamela: That was my answer immediately! Of course the answer is yes. In fact, in my opinion, sometimes it

gets better every time it's copied! But most people said, "Oh no! The original is always best!"

David: But you have to ask, "Better for what purposes?" For example, I have a few books at home that are worth in the hundreds of dollars. And suppose I want to read one of those books on an airplane. I might not want to take the book with me. But if I made a copy of it, then the copy is actually better than the original for the purpose of my taking it and reading it on an airplane.

Pamela: So it depends on what it is. Suppose the image is not very interesting, but you run it on a copier machine and then make a copy of a copy and make a copy of a copy. And all the little striations and weird things that happen during the copying process start to create an interesting image. It was a perfectly good original as far as quality goes, but what you came up with is a work of art that became more interesting because the imperfections become magnified and distorted in the toner.

A friend of mine—a writer named Chris Bernard—wrote a really nice piece. He had a photograph of Kafka, and he just kept running copies of it. The name of the piece was *Kafka's Smile*. He wrote a paragraph of text about each image. The first paragraph was about the photograph itself, and the second paragraph was about the photocopy of the photograph, and on and on. And he did this many times and on a pretty bad copy machine that added some little blobs and blotches each time. And the last one was unrecognizable as Kafka. But his text was describing the image itself and ideas about how this image had changed from the original photograph of Kafka. I thought that it was so poetic, this text!

David: I can imagine that it would be!

Pamela: And then another composer, Richard Zvonar, and I collaborated with Chris on a perfor-

mance piece based on *Kafka's Smile*, and we pro-
jected slides of the images and I read the text.
Richard processed my voice as I read the text, so
that with each reading it was harder to understand
what I was saying. The processing was making the
sound of my voice get dirtier as the image was get-
ting dirtier. We projected this huge image—big
enough to cover the entire stage—of this picture of
Kafka's smile changing while I was reading this text
and strange things were happening to my voice. I
haven't thought of that in a while, but that piece
was actually about the idea of copying and this
whole other world that was created by just repeat-
edly copying something.

> *David: As you're talking, one thing that I am aware of
> is that there are at least two different ways to be using
> this word* copying. *One of them refers to something be-
> ing a copy if you use a copying device or technique. So
> regardless of what the output actually is, you will call
> it a copy.*

Pamela: And then people judge whether it's a good
one or a bad one by how close it is to the original.

> *David: Right. But suppose that you try to make a pho-
> tocopy of a page, and the copier screws up and you get this
> completely black page. From this point of view, you
> might still call that a copy. It's a pretty lousy one, but it's
> still a copy.*

Pamela: Well, it's kind of like the photograph with
the thumb in it. Or when somebody takes a picture
of you but forgets to take the lens cap off. They re-
ally didn't take a picture of you, they took a picture
of the inside of the lens cap. Is it a copy, or is it just
an attempt at a copy?

> *David: That's exactly the point I'm trying to make. One
> sense of copy is just saying, "I used this technology to copy
> something, so whatever comes out I'll call a copy because*

it was the result of this process." And then there's this other sense of . . .

Pamela: . . . of "I looked at it, and then I tried to make another one."

David: Right. This one is "like" the other one.

Pamela: And it seems like there is a lot of room for confusion in making judgements about that kind of copying. The other sense of the word probably has more clear-cut conventions.

David: Take, for example, making a photocopy of a legal document, like a contract. We know that if you make a copy of a contract with a signature, then the copy doesn't really count as a contract. But there are other circumstances when you might want to make a copy of a contract, and the copy would be just as good. If we're in the office together and I ask you to look at the wording of this contract, then the copy is just as good as the original. We make these kinds of distinctions all the time. So I'm saying that, in the context of use, we make important judgments and distinctions, but we may not be able to articulate them well.

Pamela: I guess we do when we're dealing with things that we're really clear about our purpose for. But I think that people are often very unclear in their own minds about their purpose for art.

David: That is a great point.

Pamela: One thing that I notice is—and you'll get different arguments from people in other media— that experimental music is more difficult for the average person to accept than any other experimental medium. People are OK about experimental film. They may not like it, but they don't ever even question whether or not it's a film. They'll just say, "This sort of film doesn't really appeal to me." And with visual art, they'll go to a gallery and look at something completely abstract and say, "Oh, it's not my cup of tea." On the other

hand, they may actually buy a print of it and put it on their wall. But you wouldn't catch them dead listening to experimental music.

David: Do you really think so?

Pamela: Yes, and I think it's because, of all the art forms, music is the one that is most integrated into people's lives, and they have very clear boundaries about what they think music is supposed to do for them in their lives. Either they feel very strongly that it should have a beautiful melody—something they'll remember so they can whistle it and sing it themselves—or it should have a certain kind of beat at a certain tempo so they can dance to it, if that's their purpose for music. Or it should be soothing or relaxing because they've had a hard day at work and the last thing they want is something aggressive to listen to.

David: They're looking for something they can enjoy while they're cleaning the house or catching up on some work.

Pamela: Right! Most people who are not coming to music as artists making it have functions for it. Companies like Musak thrive on the fact that there is a whole industry for music with a function. So they know how to judge it based on their opinion of what its function is. And for them all experimental music is bad music because it's not soothing, or there's no melody they can sing, or there's no beat to dance to. It doesn't meet the criteria they've set up for music that serves them in their lives.

David: And you don't think that's somewhat true with other art forms?

Pamela: It doesn't seem as much so. Like painting, for example. People don't seem to have a clear purpose in mind for that, although they do like having images hanging on their wall. They don't consider it something that has a major force in their life. If

they don't like it, they'll just turn away and not look
at it.

David: It doesn't ask too much of them.

Pamela: It may be a very challenging work, but it
can be in their house and not challenge them.

David: Right.

Pamela: And as a rule, I think that's true of most
art forms except music, because music is so much
in people's daily lives. Music is the art that most
people buy. Most people do not buy visual art, but
they buy music all the time. And they turn on the ra-
dio to listen to music. They don't have to go to a
concert hall to hear music, but they think they need
to go to a museum to see visual art. They're really
seeing visual art all around them, but they don't
think about it. They don't have to think about it. It
can be there without their having to think about it.
But music is like a smell. If it's there, you have to
hear it. You can't choose not to hear it if it's on, so
the listener is forced to deal with it whether they
are in the mood for a challenge or not.

*David: I wonder if it's also truer of music that people are
involved in its performance. When you're dealing with
recorded music, you actually have something to do with
the performance in your world. You have decisions that
you've made about where your speakers are. You decide
how loud it's going to be. You are actually required to
engage in some way in the construction of it, if only be-
cause it's going to have to show up in your living room at
some time.*

Pamela: Which brings me back to this question of
the sameness of each performance of something.
Even if you've made a recording of some piece of
music, and it's laid down and set, and the mix is the
way it's going to be, every time somebody plays that
back—depending on what equipment they play it
back on, and where they've placed their speakers,

and how loud they choose to play it, and how they've adjusted the tone controls on their stereo— all these things are affecting it, so it's never going to be exactly the same each time.

David: In fact, that's the point I was leading up to before about how templates actually work in the world. The template doesn't actually contain all the information needed to make the work. It can't. Much of the information is contained in the surrounding technical or social environment—in details like where the speakers are, how things are tuned, how the bass is set, and all of that.

Pamela: Or how the room is lit, if you're talking about visual work.

David: There are a huge number—probably infinitely many—other variables that will determine exactly what the nature of any particular performance is. And especially in the case of recorded music, the artist doesn't actually have control of all these variables, so there can be huge amounts of variation. You can imagine what it would be like to have your music played on some tinny little speakers.

Pamela: I have sat on peer panels for grants, and almost none of them have ever had good playback equipment. You walk into a panel for composer fellowships or something, and they have a boombox— a boombox that the speakers can't even be separated from! And some of these people are doing electronic music that is very subtle, and you're probably just not even hearing all of it.

David: And that's remarkable. Do you want to call that a copy when some of the parts that the composer thought are essential . . .

Pamela: . . . are missing! It's like somebody had one of those disposable cameras, went down to the art museum, took a snapshot of your sculpture, and then said "This is the sculpture. What do you

think? Should we give him the money? This is what he makes. This is his work." No! It's somebody's bad snapshot with bad color, and the thumb is probably in there too!

David: So now we're into the realm of politics. Who gets to make the copy? Who gets to decide whether it's a good enough copy? And what's going to be done with it?

Conduits: An Experimental Media Performance

Joel Slayton

Introduction

I am a conceptual artist who works with computer imaging, video, robotics, virtual reality, and networking to produce computer-based installations and performance artworks. *Conduits* is an experimental multimedia performance that I wrote and directed, that was commissioned by the city of Palo Alto for the culminating event of their 1994 centennial celebration. *Conduits* premiered on April 16, 1994.

The Xerox PARC PAIR Program

I was awarded a Xerox Palo Alto Research Center Artist-in-Residence program guest artist residency concurrent with the Palo Alto commission of *Conduits*. Steve Harrison, who conducts research into group work practice, was responsible for defining the scope and nature of Xerox Palo Alto Research Center's participation, including equipment and resources that made *Conduits* possible. Xerox PARC scientists Ken Pier, Mark Chow, and Brent Welch directly contributed to the performance event.

My large-scale collaborative performances relate to work models that enable group and individual productivity. In my PAIR interview, I described a particular collaborative strategy that I characterized as conceptual art. The strategy was based on the work of information theorists Paul Pangaro and Gordon Pask, who originated a conversational and learning systems model called DoWhatDo at MIT in 1980. DoWhatDo describes the evolutionary process of meaningful conversation for simulation by computers. Essentially, DoWhatDo demonstrates how meaning is the not necessarily intentional result of individuals and groups expressing their expertise through systematic interaction. The artistic application of DoWhatDo theory as performance denies the responsibility of an original concept. Rather, the strategy of applying a systems theory to the circumstance at hand results in the evolution of meaningful states of collaboration. I initiated the DoWhatDo Performance Company to explore the aesthetic dimensions of Pangaro and Pask's theory.

With the involvement of over 200 people, the *Conduits* collaboration was replete with ambitious personalities and agendas, both personal and public. Steve Harrison's input was valued on many levels. His perspective on the city of Palo Alto stimulated research into historical archives and city-planning documents. Steve Harrison and I discussed the many facets of the performance objective and collaboration that served as the catalyst for Xerox PARC's participation.

PARC scientists Ken Pier and Mark Chow coordinated an ISDN video-teleconference segment live from Xerox PARC. The scene involved a presentation by Albert Wilson, an eighty-seven-year-old Palo Alto citizen and gardening expert who discussed the City Hall Plaza landscape architecture and advocated a return of the *Conduits* installation site to its original purpose. Pier and Chow coordinated the live interactive event and facilitated installation of the necessary computing and telecommunications resources. PARC scientist Brendt Welch coordinated the use of the infamous Xerox LiveBoard, an interactive electronic white board used in networked corporate communications. Brendt customized LiveBoard software for the use by actors.

Conduits Description

Conduits presented a satirical reflection on Palo Alto's pride in its reputation as a model community. Palo Alto has built on the world-renowned reputation of Stanford University (established in 1885) to be internationally recognized as a significant cultural and research community. The explosive growth in the electronics industry that has taken place around Palo Alto in Silicon Valley has contributed to this reputation. Palo Alto has expressed a commitment to "embracing the future" through its city government, education, and business.

I conducted research prior to preparing a script, including an extensive review of historical archives and city planning documents and invited the participation of community arts organizations, civic groups, and Palo Alto government and service agencies.

Precipitous Events of 1994

Two events in 1994 receiving national news media coverage informed the thematic focus of the performance. An anonymous telephone call to the police reported that a highly poisonous black mamba snake, possessed illegally, had been released within the Palo Alto area. City agencies and local media warned the public about the safety hazard, and police and fire departments conducted comprehensive searches of buildings and parks. Urban mythology quickly grew. The black mamba was typified as a ferocious and deadly predator of extraordinary stealth, able to leap from trees onto unsuspecting bystanders. Whether hoax or reality, the missing black mamba was never recovered.

In a second nationally covered news event, a public sculpture called *Foreign Friends*, donated by Palo Alto's sister city Lingoping, Sweden, was repeatedly vandalized in what appeared to be a series of political statements. The Disneyesque painted wooden figures of a man and woman accompanied by a dog and bird had been savagely decapitated. More sympathetic supporters adorned the sculpture with scarves, hats, and miscellaneous clothing during poor weather. Offerings of food and flowers appeared frequently. Despite a video surveillance system installed and monitored by the Police Department, no arrests were or have been made.

The social politics of this affluent community, the city government response to these two events, and the news media attention set the stage for controversy within a skeptical and opinionated public. *Conduits* was conceived within this context.

Thematic Description

Following the black mamba and *Foreign Friends* episodes, the city of Palo Alto was immersed in a third controversial event—*Conduits*. The premise of *Conduits* is that the C-Machine, a hypothetical telecommunications public art sculpture of extraordinary dysfunction, is donated to Palo Alto by a consortium of sister cities as a centennial gift. The performance resulted in an inspiring, humorous, and insightful look at the roles of citizens and civic leaders as they debate the merits of this new form of public art.

The *Conduits* performance simulated a donation ceremony and demonstration of the C-Machine by renowned citizen advocates, resulting in an information disaster of epic proportions that included a search and hostage rescue operation by the Swat Team and Fire Department performed with fifty ballroom dancers. In the resulting mayhem, the Swat Team recovers the black mamba snake, now grown to a length of twenty feet, and a local resident of the C-Machine electronic infrastructure. The script and staging mimicked a film documentary production, complete with camera booms, dollies, and lighting rigs. A confused audience was never certain what they were witnessing—a theatrical performance or a film production. Neither was true; the audience simply became an element of the conceptual artwork. All facets of *Conduits*, from inception to implementation, were considered to be components of a system. The totality of the process of the system was intended to be understood as performance.

Conduits Scenes

The performance included five discrete scenes—Operatic Prelude, C-Machine Donation Ceremony, Sister City Teleconference, Public Use Demonstration of the C-Machine, and Unexpected Technical Failure of the C-Machine. The finale included a dramatic demonstration by the Palo Alto Fire Department, Rescue and Decontamination Units, and Swat Team accompanied by the fifty ballroom dancers. This scene involved a helicopter, fire trucks, and an ambulance. In an impressive entrance the Swat Team rappelled from the nine-story City Hall building into the performance site in full regalia, dropping acoustic grenades and supporting automatic weapons.

Each scene simulated a movie take, complete with camera crews, a motorized dolly, and scripted and unscripted retakes of scenes. A two-minute interlude between scenes was dedicated to technical preparation of the next scene and provided an opportunity for the stage manager (actor) and director (real) to interact directly with the audience. The performance was unrehearsed to preserve the spontaneous interactions of the crew operations, performers, and audience.

In this fictional scenario the sister cities commission the C-Machine. City Hall Plaza, the most prominent site in the community, is selected for the sculptural installation (as well as for the performance staging). The C-Machine is a high-bandwidth, networked, expert system supported telecommunications sculpture. Automatically composed messages reflecting public sentiment are derived from verbal input and made available over high-bandwidth networks. The improved digital multimedia message is accentuated by supporting information and data culled from City Hall archives and information resources. The C-Machine is, in effect, an online-all-the-time public resource. For the performance, Palo Alto was asked to imagine the potential of a machine that creates properly constructed multimedia messages on behalf of any input idea. The C-Machine translates what you say into what you mean.

Project Development

Conduits involved a one-year period of investigation, technical experimentation, and dialog with participants, sponsors, and city agencies. Concept development was shaped by the input of all participating individuals and organizations. Various city agencies provided logistical assistance, set con-

Figure 12.1
Joel Slayton, "Conduits," experimental multimedia performance, Palo Alto, 1994

struction, risk management, insurance, public safety, permits, and content. The Centennial Planning Committee provided seed funds of $20,000.

In-kind contributions from private industry exceeded $300,000. The local computer industry provided technical assistance and resources. Corporate sponsors of *Conduits* include Xerox Palo Alto Research Centers, Silicon Graphics Inc., SuperMac Inc., RasterOps Corp., and Fry's Electronics.

Riverview Systems Group coordinated staging and AV. *Conduits* showcased applications of interactive multimedia, computer graphics, digital video, electroacoustics, and high-bandwidth networking. Performance control software was developed at the CADRE Institute of San Jose State University.

Conduits required the collaborative efforts of twenty-seven computer artists, fifty technical crew members, and one hundred fifty performers. The performance involved actors and jazz musicians and featured a choral ensemble and operatic duo from regional arts organizations. The mayor of Palo Alto, the city manager, and the full city council provided cameo performances. A group of well-known citizens was selected to demonstrate the C-Machine's functionality. The Swat Team, Fire Department, and the Rescue and Decontamination Unit required additional technical staging.

Set Design

Palo Alto City Hall Plaza was selected as the performance site. The plaza is a pedestrian mall entrance to City Hall, bordered by trees and three major avenues. City Hall, a nine-story building, served as a literal backdrop for the event. Due to site lines it was determined that the audience would experience the performance with viewing accessible from three sides. The avenues were closed during the performance for this purpose. The set design established four staging areas that were technically integrated. From upstage to downstage these included Council Chambers located in City Hall, the C-Machine media sculpture, a master of ceremonies platform, and the citizen advocates interface area. An elevated walkway connected the four areas.

Conduits incorporated real-time performance control systems for computer graphics, digital video, and electroacoustics. Technical operation of the event required twenty computer workstations operating over an Ethernet LAN network. Local cable access was distributed from the City Hall audiovisual center. ISDN and Codec teleconferencing technology, provided by Xerox PARC, were used for interactive telecommunications. The event was distributed live over the Mbone, the internet's multimedia backbone.

The centerpiece of the performance was the C-Machine media sculpture (figure 12.1). Design of the sculpture began with creation of a concept prospectus. The concept prospectus describes the extraordinary absurdity of the C-Machine's purpose and functionality. According to the prospectus, "The C-Machine is a custom prototype multimatrix media communication system devised for interpersonal and infrasocietal public communication.

The current prototype is configured for up to five remote interface links routed to a central multi-interface hub. The C-Machine provides near real-time transmission in over seven different languages and simultaneous content translation and reinforcement (in text and image form) with the use of our latest Central Processing Array (COPMRA). The purpose of the C-Machine is to translate what is said into what is meant."

The actual computer-controlled sculpture was a twenty-four-by-ten-by-eighteen-foot metal fabricated structure, with seamless front and side rear projection scrims. Two Silicon Graphic Elan workstations and two Pentium based PCs generated real-time computer graphics representing internal processing. The C-Machine was topped with four armature-suspended monitors, a microwave transmitter, various antennae, and a microwave dish. The installation required the removal of twenty tons of dirt and construction of a specialized platform. Surrounding the C-Machine were twenty-four display monitors used to represent digital movie sequences of specific subjects, with processing controlled in real time using Macintosh 840AV computers. Two large-format projection scrims located down stage were used to display the messaging output of the C-Machine and live video cams of the event proceedings.

The master of ceremonies platform consisted of the LiveBoard interface and two large-format Barco monitors used to represent the C-Machine's status. The citizen advocates interface area incorporated live video cams and audio recording used to generate input for compositing of multimedia message output for cable, teleconferencing, and network distribution. Bleachers located adjacent to the citizen advocates interface area provided seating for distinguished Palo Alto citizens, who were encouraged to voice their supporting or dissenting views throughout the performance.

Summary

Conduits was an extraordinary conceptual art accomplishment involving hundreds of volunteers intensely working together over a one-year period. Corporate sponsors recognized the significance of this enterprise and contributed resources, technical assistance, and personnel. The city of Palo Alto worked closely with me and my staff to address the many difficulties involved in supporting an event of this magnitude.

Xerox PARC provided invaluable assistance that was discussed at a follow-up meeting with liaison Steve Harrison, participating scientists Ken

Pier, Mark Chow, and Brendt Welch, and PAIR program coordinator Rich Gold. It was generally agreed that PARC scientists found the project very daring, interesting, and rewarding, given the many technical snafus of live performance relying on heavy use of technology. It was agreed that public and political response to the performance was wide ranging and that the enabled controversy was beyond expectation. Interpretation of the public response was discussed at length in terms of how the objective of creating an artificial controversy reflected on Xerox PARC.

As intended, *Conduits* stimulated a divisive reaction in the audience and news media. To some the satire was clear; for others the illusion prevailed. Newspaper articles (not art reviews) covering the event stated, "Technological Failure Hits Palo Alto Centennial" and "Fellini Was Never So Bad." Accusations of conspiracy were floated publicly. Editorials surfaced comparing *Conduits* and my work to the Robert Mapplethorpe debate, where a small group of individuals attempt to polarize public opinion. In response to these reviews, City Hall, the Mayor's Office, and the Centennial Planning Committee were inundated with letters and phone calls applauding the experimental nature of the performance. *Conduits* became what it was about—debate, divisiveness, and polarization.

Conduits illustrates that we are human, that reliance on technology is not a cure for our cultural woes, and that our destiny is in our own hands. What better community to address the idea of "embracing the future" than that of Palo Alto, whether the citizens like it or not?

13

Art Shows at PARC

Marshall Bern

There was art at PARC before PAIR. With the advent of the PAIR program, however, the art at PARC became more interesting and prominent. This chapter describes four art shows associated with PAIR that I curated or cocurated, one each year from 1992 until 1995.

In general, the shows were lightly curated, meaning that we tried to include rather than to exclude and that we did not worry too much about overall coherence. The shows used more than one site within the PARC building, which has few proper gallery spaces, so achieving overall coherence would have been a challenge in any case. We kept the PARC community in mind while choosing the art, so we strove for variety, novelty, and technological cleverness. We favored artists with some PARC connection. Of course, the shows also reflected the tastes of the curators, jurors, and Rich Gold, who assumed an advisory role for the last three shows. My own aesthetic gravitates toward personal art with foremost meaning to the artist.

Art Before PAIR

Ever since its founding in 1970, PARC's research has contained a certain artistic component. In the early 1970s, Bob Flegal and Dick Shoup pioneered graphics and animation on raster displays. Other researchers worked on illustrators, page layout, color correction, and graphical user interfaces. The 1970s at PARC also produced a sort of mobile computing performance piece called *The Wheel*—a computer workstation gimbaled inside an enormous wheel, dragging a tether behind it.

There has also been extracurricular art at PARC. Every now and then throughout the 1970s and 1980s, employees mounted exhibitions of their own painting or photography. In general, the extracurricular visual art was the sort of art that could be seen in any organization of 300 people; it did not display the wild innovation that made PARC's research so influential.

Employee Art Show

Our 1992 employee art show relieved some pent-up artistic desires. PAIR was in its planning stages, and art was in the air. Several amateur artists around PARC, including show curators Debra Adams and myself, had recently taken up our paint brushes after long inactivity. (I was a fine arts major during my first two years of undergraduate education at Yale.)

The show spanned the spectrum from crafts to conceptual art. A number of PARC employees were revealed as practitioners of handicrafts, such as

Figure 13.1
Rich Gold, "Pony archipelago" and "Archipelago pony," from *Ten Objects Undergoing Intensive Research at GoldoGraphic Laboratories All over the World,* 1992

condom-package jewelry and country woodworking. One of our librarians turned out to be a master of Mataro dolls, a certain school of Japanese doll-making. There was an abundance of accomplished photography—some by professional photographers working at PARC—and skilled but staid paintings and drawings by Sunday painters like myself. One of my favorite pieces, an example of the sort of personal art I admire, was a backlit box incorporating an MRI scan and other medical imagery, commemorating a cancer scare.

Two conceptual works attracted a lot of attention. Mark Weiser, the lab manager who first brought PAIR founder Rich Gold to PARC, turned research into art. An experimental portable computer displayed a random pattern of black and white pixels. Every five seconds some pixels would flip, specifically those pixels within an image of Mark's own face. At any given time the pattern was random; only persistence of vision allowed a face to be (barely) discerned.

Rich Gold exhibited an exercise in structuralism entitled *Ten Objects Undergoing Intensive Research at GoldoGraphic Laboratories All over the World* (figure 13.1). This piece comprised 100 small cards forming a ten-by-ten matrix. Ten archetypes labeled the rows and columns—*pony, motel, pond,*

archipelago, and so forth. The card in row *i* column *j* illustrated the mixture of the *i*th and *j*th archetypes. Order mattered, so that *pony archipelago* was different from *archipelago pony.*

This work was a favorite of mine, partly because it presented a special installation problem. The facilities manager vetoed Rich's original conception, which called for 200 push pins stuck into the wall. In the actual implementation, the push pins went into popsicle sticks, which were then mounted to the wall with rubber cement. The connection to the textured vinyl wallboard proved problematic, however, and each night a few cards fell to the ground like autumn leaves.

Copy Art Show

Rich Gold suggested copy art as the theme for the next art show, a natural choice for a Xerox research center. Debra Adams and I again served as co-curators, but she left Xerox and moved to Seattle just before the show opened. We liberally defined *copy art* as any art created with the aid of a photocopier.

To find the art, we ventured outside PARC, advertising the show by email, ordinary (snail) mail, the San Francisco Bay Area art calendar *Artweek,* and word of mouth. We invited art in two categories—mail art (just send it) and juried art (send slides first). Debra Adams, Cynthia DuVal, Rich Gold, and myself constituted the jury.

We received a surprisingly good response, with about fifty submissions in each category. Only I experienced the mail art in the proper way: almost daily I found something wonderful in my mailbox amidst the form letters and advertisements. buZ blurr sent mail art and artistamps, some referencing Dada and Fluxus, a reminder of mail art's long roots. Paulo Bruscky's *Envelopoema* came all the way from Recife, Brazil (figure 13.2). I still do not know how he found out about our show.

Every few days I changed the mail art on the wall. Hanging all of it at once looked too messy; besides, mail art kept arriving well after the show had opened. In fact, I received more mail art almost a year after the copy art show closed, thanking me for the art show catalogs that I had sent to participating artists. These thank-yous made a minishow in 1994.

The most prevalent genre in the juried category was collage. A photocopier is a great tool for distorting, resizing, and assembling appropriated images and text. Michael Lewis seamlessly combines machinery, mastodons,

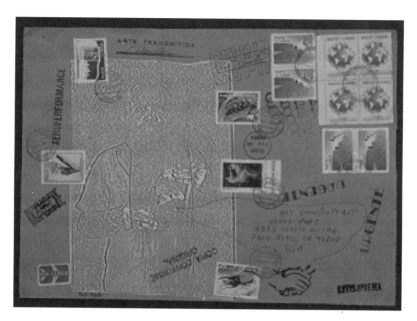

Figure 13.2
Paulo Bruscky, *Envelopoema,* mail art, 1993

and Japanese drummers in *Civilization 2* (figure 13.3). As artist Shirley Watts put it, "A photocopy machine turns an artist into a hunter-gatherer."

Many of the collages explored social issues; these pieces tended to be more personal and confrontational than art previously shown at PARC. An example was Yvonne Jongeling's *Repression* (figure 13.4). (Curiously, three or four pieces in the show superimposed eyes over images of women.) I was almost asked to remove a collage bearing the motto "*Slut* suggests: (Women) don't sell your sister out" for fear that this (decidedly feminist) piece might create a "hostile work environment." *Slut* turned out to be the name of a photocopy magazine, or 'zine, a representative of a popular underground genre that we displayed along with the mail art.

The most entertaining feminist piece was Trena Noval's *The Good Wife.* This multimedia work started with large color photocopies of Piero Della Francesca's Renaissance paintings of the Duke and Duchess of Umbrio. Noval transferred the photocopies to canvas and surrounded them with satirically elaborate gilt frames, incorporating plastic fruit, a wax hand with a fake diamond ring, and shiny surgical implements. Tape players with head-

Figure 13.3
Michael Lewis, *Civilization 2,* copy art, 1992

phones delivered tales of modern gender dilemmas beneath each of the paintings. A gushing female voice narrated the story of an overly self-reliant male doctor who performed surgery on his own head, while a disapproving professorial male voice narrated the story of an orgasmic female shopper.

Monoprints were probably the second most popular genre after collage. A copy art monoprint records a unique occurrence on the photocopier platen. The most familiar type of monoprint is the photocopy self-portrait—the artist's face squashed or rolled against the glass. Our show included several examples of this classic form. Another monoprint in our show was a color painting by Eleanor Kent made with black ink; the color came from the timing of the brushstroke relative to the copier's color passes. Other monoprint techniques involved handheld mirrors, aluminized mylar, broken eggs, and fresh seafood. Alas, our show did not include actual platen dancing, as in Jürgen Olbrich's *Photocopy Rock 'n' Roll.*[1]

Our inclusive definition of copy art let us hang pieces that were primarily some other medium. In this way our show[2] differed from other copy art shows.[3] I already mentioned Trena Noval's multimedia piece. We showed two acrylic paintings by the well-known Bay Area artist Joe DiStefano, which used tiled black and white photocopies as a sort of underpainting.

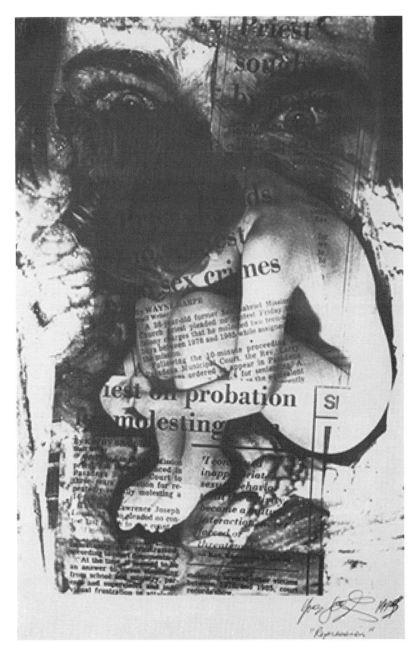

Figure 13.4
Yvonne Jongeling, *Repression,* copy art, 1993

Marshall Bern

There were also a number of primarily photographic pieces and paper and fabric "quilts" by Hannah Tandeta.

Some of the most interesting art came from within Xerox. Not only did the sophistication of the art surprise me, but I had previously been unaware of *any* copy art at Xerox. Gretchen Vander Plas, whose husband worked at PARC at the time, made fabric art after hours on a broken color copier that was giving interesting effects. Leigh Klotz of Xerox took the top off a fax machine and dragged a skeleton figurine across the scan bar to produce *Dia de la Faxistad* (figure 13.5).

Finally, the most impressive inside job came from Art Medlar (his real name!), who altered the software in a digital copier to create *The Work of Zippy in the Age of Mechanical Reproduction* (figure 13.6). This piece took a passage from Walter Benjamin's famous essay *The Work of Art in the Age of Mechanical Reproduction* and degraded it through 100 generations of photocopying. The degradation, however, is not the usual random disintegration but rather a purposeful hybridization of the copied image with a stored image of Zippy the Pinhead. As Art writes, "Each copy is a bit less like the original and a bit more like Zippy. . . . In the future, when all copiers are so equipped, all documents will gradually converge to Zippy."

At least two of the pieces by Xerox artists were made before the PAIR program existed, so we probably cannot credit PAIR with raising the level of sophistication among Xerox artists. PAIR did, however, create an environment more congenial to subversive art such as *Zippy* than had existed the previous year. After seeing the work of PAIR candidates, closet artists at Xerox were more inclined to make their explorations public. The copy art show in turn fed back into the environment; a number of employees felt the urge to make and contribute mail art after the show was already up.

Algorithmic Art Show

The theme of the 1994 show was algorithmic art, another natural choice for a computer research laboratory. In fact, my own research centers on the mathematics of algorithms. We advertised through the same channels as the copy art show. We also mailed to artists who had previously shown in the art shows at SIGGRAPH, the annual computer graphics conference.

The algorithmic art show presented more curatorial problems than the previous shows. The submissions were very diverse, much broader than our original interpretation of algorithmic art, and the jury (Paul De Marinis,

Figure 13.5
Leigh Klotz, *Día de la Faxistad,* copy art, 1990

The uniqueness of a work of art is inseparable from its being imbedded in the fabric of tradition. This tradition itself is thoroughly alive and extremely changeable. An ancient statue of Venus, for example, stood in a different traditional context with the Greeks, who made it an object of veneration, than with the clerics of the Middle Ages, who viewed it as an ominous idol. Both of them, however, were equally confronted with its uniqueness, that is, its aura. Originally the contextual integration of art in tradition found its expression in the cult. We know that the earliest art works originated in the service of a ritual--first the magical, then the religious kind. It is significant that the existence of the work of art with reference to its aura is never entirely separated from its ritual function. In other words, the unique value of the "authentic" work of art has its basis in ritual, the location of its original use value. This ritualistic basis, however remote, is still recognizable as secularized ritual even in the most profane forms of the cult of beauty. The secular cult of beauty, developed during the Renaissance and prevailing for three centuries, clearly showed that ritualistic basis in its decline and the first deep crisis which befell it. With the advent of the first truly revolutionary means of reproduction, photography, simultaneously with the rise of socialism, art sensed the approaching crisis which has become evident a century later. At the time, art reacted with the doctrine of l'art pour l'art, that is, with a theology of art. This gave rise to what might be called a negative theology in the form of the idea of "pure" art, which not only denied any social function of art but also any categorizing by subject matter. (In poetry, Mallarmé was the first to take this position.)

An analysis of art in the age of mechanical reproduction must do justice to these relationships, for they lead us to an all-important insight: for the first time in world history, mechanical reproduction emancipates the work of art from its parasitical dependence on ritual. To an ever greater degree the work of art reproduced becomes the work of art designed for reproducibility. From a photographic negative, for example, one can make any number of prints; to ask for the "authentic" print makes no sense. But the instant the criterion of authenticity ceases to be applicable to artistic production, the total function of art is reversed. Instead of being based on ritual, it begins to be based on another practice--politics.

Figure 13.6
Art Medlar, "Generation 15," *from The Work of Zippy in the Age of Mechanical Reproduction,* copy art, 1992

Andrew Glassner, Rich Gold, Natalie Jeremijenko, and myself) had trouble deciding whether certain pieces qualified. Furthermore, there were many submissions we did not like, in particular most of the SIGGRAPH art, which did not look very fresh to our eyes. Algorithmic art often owes its interest to novelty, which of course fades with repeated exposure. Recall that in about 1985 fractals were everywhere, in 1993 it was random dot stereograms, and so forth.

Despite the jaded jury, we did have a sufficient number of submissions— something like sixty-five—to assemble a successful show. In fact, algorithmic art turned out to be more popular with PARC at large than it had been with the jury. Several PARC employees told me that the show was an improvement over the previous year's effort. As before, we opted for an inclusive interpretation of the artistic genre, and the show spanned the spectrum from mathematical art to computer graphics, with "true" algorithmic art sitting somewhere in between.

The best representative of the ancient connection between art and mathematical form was a sleek topological sculpture by Ahmad Osni Peii. This fiberglass sculpture—actually a maquette for bronzes—realized a twisted surface related to a Möbius strip. Unfortunately, the sculpture cracked in transit, and I had to repair it with auto body putty and a precise shade of '71 Ford metallic green paint.

Algorithmic art adds the dimension of time to mathematical art. The appearance of algorithmic visual art should raise the temporal questions of "How is this made?" and "Can this be extended?" For example, the self-similarity of fractals answers the second question right before our eyes. Although fractals are quintessential algorithmic art, the jury turned away most fractal submissions on the grounds of overexposure. An exception was an irresistible knit baby blanket by Eleanor Kent; to us it represented mathematics become kitsch.

The jury was happy to accept algorithmic art less familiar than fractals. Yoshiyuki Abe's *LS-51* was the product of some ingenious mathematical manipulations. Abe used ray-tracing to compute illumination intensity across a surface lit by many light sources; the illumination is then remaindered by a modulus—separate moduli for each of red, green, and blue—to obtain agatelike bands and whorls (figure 13.7, plate 6 in the color pages). Adam Finkelstein and Sandy Farrier's *JFK/MM* was a picture of John F.

Figure 13.7
Yoshiyuki Abe, *LS-51,* algorithmic art, 1994 (see Marshall Bern, "Art Shows at PARC")

Kennedy in which each pixel was cut from a picture of Marilyn Monroe. This mosaic was assembled by a computer program, but the artist admitted to a bit of human postprocessing (figure 13.8). This witty and slightly nasty piece stood out in a show that was mostly cool and abstract.

Computer graphics has a different focus than algorithmic art. Computer graphics uses algorithms—duplication, warping, ray tracing, and texture mapping—as tools, but does not invent a new algorithm for each artwork or leave the algorithms visible and prominent. I would place most Photoshop art in this category. Typically, a computer artist cedes less (or at least later) control to automatic processes than does an algorithmic artist. We accepted

Figure 13.8
Adam Finkelstein and Sandy Farrier, *JFK/MM,* algorithmic art, 1994

only the most impressive computer graphics, notably Stewart McSherry's amazingly realistic pictures of nonexistent objects resembling icicles and metal pipes.

Finally our show included some art *about* algorithms, rather than made by algorithms. My favorite piece in this category—another example of personal art—was *Portrait of TKM*, a plan for a golf course, perfectly executed in watercolor by Kerny McLaughlin. This picture was the output of a well-defined algorithm that transforms a person—in this case, the artist's father—step-by-step into a golf course. Pseudocode for the algorithm was calligraphed below the layout of the holes; a typical step translates a score from a personality test into a page number in a book of great golf courses of the world. *Portrait of TKM* illuminated the precise meaning of *algorithm*—a sequence of steps for transforming an input into an output—even while it exploded our preconceptions of algorithmic art.

Taken together, the 1993 and 1994 art shows revealed an interesting contrast. As PARC computer scientist Dan Greene put it, "Algorithmic art is modern, but copy art is postmodern." Algorithmic art tends to be clean, cool, and optimistic, whereas copy art is more often messy, witty, and ironic. Computer art tends to be the product of a fairly elite group; copy art is more democratic. Currently, computer art is relatively more popular in United States, copy art more popular in Europe. Perhaps the easy accessibility of computers in United States has lured away would-be copy artists.

Twenty-fifth Anniversary Art Show

In September 1995, we celebrated the twenty-fifth anniversary of the founding of PARC. The centerpiece of the celebration was a fantastic variety show directed by Rich Gold, described at greater length in chapter 9 by Paul De Marinis. To accompany the anniversary celebrations, we mounted another art show, including both copy art and PAIR art.

This time we invited the copy art, rather than issuing an open call. We aimed for large works by a small number of especially good artists, so that the copy art could stand up to the more sophisticated PAIR art. The artists who accepted our invitation were Sarah Jackson, Michael Lewis, Debra Swack, and Hannah Tandeta—who had all participated in our 1993 copy art show—and Yuri Nagawara, whom we found through Monique Brunet-Weinmann, a curator in Quebec. We also invited and received mail art from buZ blurr, Paulo Bruscky, Ben Mahmoud, Johanna Tesauro, and René Yañez.

Figure 13.9
Michael Lewis and Nena St. Louis, *Humanscapes,* collage, 1995

We showed five life-sized *Humanscapes* by Michael Lewis and Nena St. Louis, who is Michael's wife and an anatomist. These skinned people were actually meticulous collages composed entirely from architectural and landscape elements (figure 13.9).

Yuri Nagawara's *Lake Side: Translucent* was a large piece—about six-feet square—consisting of two superimposed ink-jet prints of the same photograph of a lake shore. The back picture was in black and white on Japanese paper; the front picture was in color (mostly blue) on three strips of transparent fabric. Air motion made the fabric ripple and the lake come alive (figure 13.10, plate 6 in the color pages).

The copy art part was nice, but the PAIR part of the show was necessary. The PAIR program was well known around PARC, but the art itself—videos, Web pieces, and music for matchbook-sized computers called ParcTabs—was largely invisible. The twenty-fifth anniversary show gave

Figure 13.10
Yuri Nagawara, *Lake Side: Translucent,* photography and copy art, 1995

PAIR a more public forum. There were four pieces in the PAIR part of the show—*Forward Anywhere*, by Judy Malloy and Cathy Marshall, *General Hospital* by Margaret Crane and Jon Winet with help from PARC researcher Scott Minneman, *Neighboring Lands* by John Muse, and *Solo for Two* by Paul De Marinis.

A cafe table in the corner of the PARC lobby set the scene for the hypertext piece *Forward Anywhere*—two women talking, trading experiences. A portable computer—the same one used in Mark Weiser's piece from 1992—offered access to the experiences. Unfortunately, this computer rarely worked, so I had to include a paper link—a sign giving the World Wide Web address of the initial page.

General Hospital took over an executive office for a week. The office—empty except for a workstation used to access the Web and some still images mounted around the walls—provided a fitting (though ephemeral) physical space for this Web work, which takes a clinical look at American society.

Neighboring Lands by John Muse was a site-specific installation in the PARC lobby (figure 13.11). The piece consisted of ten sewn paper houses, attached by a bundle of wires to the imposing brushed stainless steel corpo-

Figure 13.11
John Muse, *Neighboring Lands,* installation, 1995

rate logo, which hangs above the receptionist's desk. On the way to the logo, the wires pass through pages from a 1950s school atlas, depicting our "neighboring lands" (Canada and Mexico). The images and text on the paper houses were drawn from a Web journal kept by John Muse and Jeanne Finley as they worked with Lucy Suchman's group on *Fear and Family Values.* John stated that *Neighboring Lands* expressed his and Jeanne's ambivalence "in being on the inside of something that we'd normally study from the outside." With the appropriated images and text, this work formed a nice bridge between the PAIR art and the copy art.

Paul De Marinis's *Solo for Two* was made from two violins, piano wire, and a hidden CD player and step-up transformer (figure 13.12). The viewer-listener stroked his fingers across the piano wires and (after a bit of practice) was rewarded with a tingling sensation and a scratchy violin partita. *Solo for Two* relied on a mysterious effect of alternating current on organic material, first discovered in the Victorian era. In the 1870s, this effect was considered as a possible basis for telephone technology, but now it is a mere curiosity. *Solo for Two* thus reminded its viewers that technology is inextricably embedded in an ephemeral social and intellectual context.

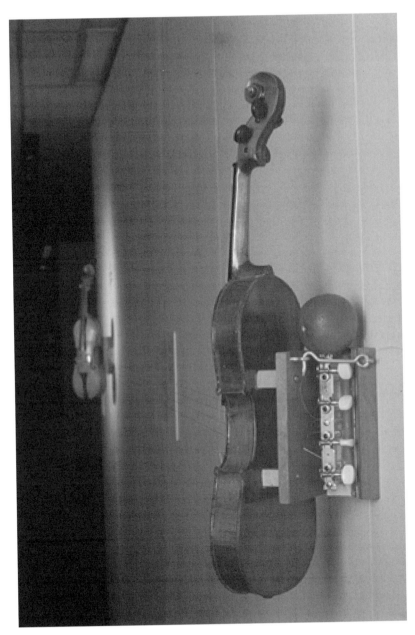

Figure 13.12
Paul De Marinis, *Solo for Two,* installation, 1995

Solo for Two engendered a rich response at PARC. For the eight weeks that the art show was up, the violins were played dozens of times per day. The engineers and scientists debated explanations of the effect—does electricity change the skin's coefficient of friction?—while the less technological employees simply wanted to improve their violin skills.

Art Shows at Work

The enthusiastic response to *Solo for Two* at PARC points out one of the advantages of hosting an art show within a workplace: the best art improves with repeated viewing. (I also saw *Solo for Two* at the Yerba Buena Center in San Francisco, where only the security guard had mastered the art of the partita.) What are the other benefits of art shows at work?

The most obvious benefit is that an art show enhances the workplace. An art show impresses visitors and energizes employees. The larger and more unusual the artworks, the better. By this measure, our twenty-fifth anniversary show was the most successful; of the four shows, only this one took over the most prominent spaces within PARC—the main lobby and the auditorium foyer.

Second, an art show is a great ice-breaker, promoting conversations between employees who rarely talk to each other. Shows with employee participation, such as the first three described above, are particularly effective at breaking down barriers. From the viewpoint of a corporation, this somewhat superficial benefit may actually be the foremost. Management expends a great effort to keep different groups within PARC talking to each other. Technologists tend to specialize and segregate, and this trend can rob a research lab of fruitful collaborations.

Third, art shows at work bring art to people who do not normally view it. Some art, such as the SIGGRAPH pieces, can be more interesting to an innocent audience than to a sophisticated one. Moreover—in a reversal of my first point—art can be enhanced by its setting, even for sophisticated viewers. Artworks the least bit confrontational may be genuinely shocking at work.

Fourth, an art show at a certain type of workplace, such as a computer research laboratory, really does bridge the two cultures of art and technology. We held opening receptions for our art shows, usually from 4 to 7 on a Friday evening. The meeting of the two cultures was always interesting to watch. In general, the artists surprised the technologists with their intelli-

gence and breadth of knowledge. Nobody ever voiced this opinion, but at least one technologist thought to himself: this person could make a lot more money doing something else.

Some of the connections formed by the art shows continued after the shows came down. I had been only a very occasional gallery-goer before 1992, but now I make it a point to see exhibitions by artists who participated in PARC art shows. PAIR was even more effective at forging ties; many PARC employees attend shows by PAIR artists.

Finally, to be fair, I should mention certain disadvantages of art shows at workplaces like PARC. These are disadvantages from the artist's point of view. I cannot think of any disadvantages from the company's point of view, aside from a small amount of lost work time. Our shows were not open to the public, except during the opening receptions or by special arrangement with me. We did not publicize the shows, except for a catalog of the copy art show that we printed after the show had closed. Our shows were not reviewed by critics, and hence they did not become part of the art world's discourse. Last, our shows resulted in very few sales. On the other hand, we did not charge a gallery commission.

Notes

1. Georg Mühleck and Monique Brunet-Weinmann, *Medium: Photocopy*. Goethe-Institut, Montreal (1987).

2. Marshall Bern, *Copy Art Show: Xerox PARC 1993*, catalog available from Xerox Palo Alto Research Center.

3. Monique Brunet-Weinmann, *La Copigraphie et ses Connexions*, catalog of the show *Interconnexions copigraphiques,* Ville de Hull, Galerie Montcalm et CRITIQ, S.C.C. (1993); Georg Mühleck and Monique Brunet-Weinmann, *Medium: Photocopy*, Goethe-Institut, Montreal (1987); *Copy Europe*, ART Nürnberg 5 (April 1990); *Copy Europe*, ART Nürnberg 7 (April 1992); *COPY ART: Trocken Schreiben—It's a Copy World*, Pfalzgalerie Kaiserslautern (1993).

Selected Bibliography

Anderson, Yduj. "*LambdaMOO* Tutorial." http://www.cs.reading.ac.uk/people/mkh/virtual_worlds/MOO/tutorials/ducktutorial.html.

Bartle, Richard. "Interactive Multi-User Computer Games." MUSE Ltd. Research Report (December 1990).

Bern, Marshall. *Copy Art Show: Xerox PARC 1993*, Catalog available from Xerox Palo Alto Research Center.

Brunet-Weinmann, Monique. *La Copigraphie et ses Connexions*. Catalog of the show *Interconnexions copigraphiques*. Ville de Hull, Galerie Montcalm et CRITIQ, S.C.C. (1993).

Buxton, William, et al. "The Evolution of the SSSP Score Editing Tools." *Computer Music Journal* 3, no. 4 (1985): 14–25. Reprinted in C. Roads and J. Strawn, eds. *Foundations of Computer Music*. Cambridge, MA: MIT Press, 1985.

Buxton, William, et al. "An Introduction to the SSSP Digital Synthesizer," *Computer Music Journal* 2, no. 4 (1979): 28–38. Reprinted in C. Roads and J. Strawn, eds. *Foundations of Computer Music*. Cambridge, MA: MIT Press, 1985.

COPY ART: Trocken Schreiben—It's a Copy World. Pfalzgalerie Kaiserslautern (1993).

Copy Europe, ART Nürnberg 5 (April 1990).

Copy Europe, ART Nürnberg 7 (April 1992).

Curtis, Pavel. "The LambdaMOO Programmer's Manual." file://parcftp.xerox.com/pub/MOO/ProgrammersManual.

Curtis, Pavel. "Mudding: Social Phenomena in Text-Based Virtual Realities." Xerox PARC CSL-92-4 (April 1992).

Curtis, Pavel, and David A. Nichols. "MUDs Grow Up: Social Virtual Reality in the Real World." Xerox PARC (May 5, 1993).

Deleuze, Gilles, and Felix Guattari. *A Thousand Plateaus,* Translated by Brian Massumi. University of Minnesota Press, 1987.

DeRose, S. J. "Expanding the Notion of Links." *Proceedings of Hypertext '89.* New York: ACM, 1989.

Duval, Cynthia. "The Use of Artifacts as Tools for Thinking: A Sociological Study of Creative Work." Manuscript, 1996.

Giedion, Siegfried. *Mechanization Takes Command.* New York: Norton, 1948.

Guyer, Carolyn, and Martha Petry. "Notes for Izme Pass Exposé." *Writing on the Edge* 2, no. 2 (Spring 1991): 82–89.

Harris, Craig, ed. *The Leonardo Almanac: International Resources in Art, Science and Technology.* Cambridge, MA: MIT Press, 1993.

Jupiter Project Team, Xerox Palo Alto Research Center. "Not a Highway, but a Place: Joint Activity on the Net." *CPSR* [Computer Professionals for Social Responsibility] *Newsletter* (Fall 1994).

Kantarjiev, Christopher Kent, Alan Demers, Ron Frederick, Robert Krivacic, and Mark Weiser. "Experience with X in a Wireless Environment." Xerox PARC CSL-93-9 (September 1993).

Kendall, Lori, "MUDder? I Hardly Know 'Er! Adventures of a Feminist MUDder." In Lynn Cherny and Elizabeth Weise, Reba, eds., *Wired Women: Gender and New Realities in Cyberspace.* Seattle: Seal Press, 1996.

Kuhn, Thomas. *The Structure of Scientific Revolutions.* Chicago: University of Chicago Press, 1970.

Landow, G. P. *Hypertext: The Convergence of Contemporary Critical Theory and Technology*. Baltimore: Johns Hopkins University Press, 1992.

Mackinlay, Jock D., Ramana Rao, and Stuart K. Card. "An Organic User Interface for Searching Citation Links." *Proceedings of CHI 95*. New York: ACM Press, 1995.

Makkuni, Ranjit. "A Diagrammatic Interface to Database of Thangka Imagery." In Toshiyas Kunii, ed. *Visual Database Systems*. Amsterdam: Elsevier, 1989.

Malloy, Judy. "Artist on the Net." Paper presented at the Third Conference on Computers, Freedom, and Privacy, March 1993.

Malloy, Judy. "Electronic Fiction in the Twenty-first Century." In Cliff Pickover, ed., *Visions of the Future*. Northwood, Eng.: Science Reviews, 1992.

Malloy, Judy. *its name was Penelope*. Cambridge, MA: Eastgate Systems, 1993.

Malloy, Judy. "OK Research/OK Genetic Engineering/Bad Information, Information Art Defines Technology," *Leonardo* 21, no. 4 (1988: 371–375.

Malloy, Judy. "Thirty Minutes in the Late Afternoon." *Art Com Magazine* 42, no. 10 (1990).

Malloy, Judy, "Uncle Roger: An Online Narrabase." *Leonardo* 24, no. 2 (1991): 195–202.

Malloy, Judy. "Wasting Time: A Narrative Data Structure." *After the Book* (Perforations 3, Summer 1992).

Malloy, Judy, and Cathy Marshall. *Forward Anywhere*. Cambridge, MA: Eastgate Systems, 1996.

Marshall, C. C., and F. M. Shipman. "Spatial Hypertext: Designing for Change." *Communications of the ACM* 38, no. 8 (August 1995).

Maxwell, John, and Sgvero Ornstein, "Mockingbird: A Composer's Amanuensis." *Proceedings of the International Computer Music Conference*. San Francisco: ICMA, 1981.

Monumental Women, SOMAR Gallery Space, San Francisco, September 18–October 31, 1987.

Moser, Mary Anne, and D. MacLeod, eds., *Immersed in Technology: Art and Virtual Environments.* Cambridge, MA: MIT Press, 1996.

Mühleck, Georg, and Monique Brunet-Weinmann. *Medium: Photocopy.* Goethe-Institut, Montreal (1987).

Noll, A. Michael. "Art ex Machina." *IEEE Student Journal* 8, no. 4 (September 1970): 12.

Nye, David E. *American Technological Sublime* (Cambridge, MA: MIT Press, 1994).

Orr, Julian. *Talking About Machines: An Ethnography of a Modern Job.* Ithaca, NY: ILR Press, an imprint of Cornell University Press, 1996.

Pope, Stephen. "The Interim DynaPiano: An Integrated Computer Tool and Instrument for Composers." *Computer Music Journal* 16, no. 3 (1992): 73–91.

Schwartz, Lillian. *The Computer Artist's Handbook* (New York: Norton, 1992).

Shanken, Edward A. "Gemini Rising, Moon in Apollo: Attitudes on the Relationship Between Art and Technology in the United States, 1966–71." *Proceedings of the 1997 International Symposium on Electronic Art.* Chicago: School of the Art Institute of Chicago, 1997.

Smith, Douglas K., and Robert C. Alexander. *Fumbling the Future: How Xerox Invented, Then Ignored, the First Personal Computer.* New York: Morrow, 1988.

Snow, C. P. *The Two Cultures and the Scientific Revolution.* Cambridge: Cambridge University Press, 1959.

Snow, C. P. *The Two Cultures: A Second Look.* Cambridge: Cambridge University Press.

Turkle, Sherry. *Life on the Screen: Identity in the Age of the Internet.* New York: Simon & Schuster, 1995.

Weise, Elizabeth, and Lynn Cherny, eds. "Closure Was Never a Goal of This Piece." *Wired Women: Gender and New Realities in Cyberspace.* Seattle: Seal Press, 1996.

Weiser, Mark. "Some Computer Science Issues in Ubiquitous Computing." *Communications of the ACM* 36, no. 7 (July 1993): 75–84.

Wilson, Stephen. "Dark and Light Visions." *SIGGRAPH Visual Proceedings, Art Show Catalog*. New York: ACM Press, 1993.

Wilson, Stephen. "Industrial Research Artist: A Proposal." *Leonardo* 17, no. 2 (1984): 69.

Zellweger, Polle T. "Scripted Documents: A Hypermedia Path Mechanism," *Proceedings of Hypertext '89*. Pittsburgh: ACM.

Contributors

Marshall Bern
Xerox Palo Alto Research Center
3333 Coyote Hill Road
Palo Alto, CA 94304
Tel: (650) 812-4443
Email: bern@parc.xerox.com

Dave Biegelsen
Xerox Palo Alto Research Center
3333 Coyote Hill Road
Palo Alto, CA 94304
Tel: (650) 812-4137
Email: biegel@parc.xerox.com

Michael Black
Xerox Palo Alto Research Center
3333 Coyote Hill Road
Palo Alto, CA 94304
Tel: (650) 812-4745
Email: black@parc.xerox.com

Jeanette Blomberg
Xerox Palo Alto Research Center
3333 Coyote Hill Road
Palo Alto, CA 94304
Tel: (650) 812-4751
Email: blomberg@parc.xerox.com

John Seely Brown
Xerox Palo Alto Research Center
3333 Coyote Hill Road
Palo Alto, CA 94304
Tel: (415) 812-4028
Email: Richgold@parc.xerox.com

Margaret Crane
649 Page Street, Suite 6
San Francisco, CA 94117
Tel: (415) 255-8505
Email: mcrane@igc.apc.org

Paul De Marinis
P.O. Box 424323
San Francisco, CA 94142-4323
Tel: (415) 626-4219
Fax: (415) 626-0219
Studio: (415) 642-4029
Email: demarini@well.sf.ca.us

Jeanne Finley
103 Park Place
Brooklyn, NY 11217
Tel: (718) 622-7219
Email: finley@parc.xerox.com

Rich Gold
Xerox Palo Alto Research Center
3333 Coyote Hill Road
Palo Alto, CA 94304
Tel: (650) 812-4028
Email: Richgold@parc.xerox.com

Craig Harris
Leonardo Electronic Almanac
718 Sixth Street SE
Minneapolis, MN 55414
Tel: (612) 362-9390
Email: craig@well.com

Steve Harrison
Xerox Palo Alto Research Center
3333 Coyote Hill Road
Palo Alto, CA 94304
Tel: (650) 812-4392
Email: harrison@parc.xerox.com

David Levy
Xerox Palo Alto Research Center
3333 Coyote Hill Road
Palo Alto, CA 94304
Email: dlevy@parc.xerox.com

Constance Lewallen
787B Castro Street
San Francisco, CA 94114
Tel/Fax: (415) 285-8204
Email: comaelew@aol.com

Dale MacDonald
Xerox Palo Alto Research Center
3333 Coyote Hill Road
Palo Alto, CA 94304
Tel: (650) 812-4914
Email: macdonal@parc.xerox.com

Judy Malloy
5306 Ridgeview Circle, Suite 5
El Sobrante, CA 94803
Tel: (510) 758-1878
Email: jmalloy@well.com

Cathy Marshall
Xerox Palo Alto Research Center
3333 Coyote Hill Road
Palo Alto, CA 94304
Tel: (650) 812-4288
Email: marshall@parc.xerox.com

Scott Minneman
Xerox Palo Alto Research Center
3333 Coyote Hill Road
Palo Alto, CA 94304
Tel: (650) 812-4353
Email: minneman@parc.xerox.com

John Muse
156 Wool Street
San Francisco, CA 94110
Tel: (415) 285-7687
Email: jmuse@well.com

Susan Newman
Xerox Palo Alto Research Center
3333 Coyote Hill Road
Palo Alto, CA 94304
Tel: (650) 812-4756
Email: newman@parc.xerox.com

Joel Slayton
CADRE Institute, Department of Art
and Design
San Jose State University
One Washington Square
San Jose, CA 95192
Email: slayton@sjsuvm1.bitnet.edu

Lucy Suchman
Xerox Palo Alto Research Center
3333 Coyote Hill Road
Palo Alto, CA 94304
Tel: (415) 812-4340
Email: suchman@parc.xerox.com

Randy Trigg
Xerox Palo Alto Research Center
3333 Coyote Hill Road
Palo Alto, CA 94304
Tel: (650) 812-4863
Email: trigg@parc.xerox.com

Steve Wilson
San Francisco State University
74 Coleridge Street
San Francisco, CA 94110
Email: swilson@sfsuvax1.sfsu.edu

Jon Winet
San Francisco Art Institute, California
College of Arts & Crafts
1508 Grant Street
Berkeley, CA 94703
Tel: (510) 526-5495
Email: jawinet@ucdavis.edu

Pamela Z
540 Alabama Street, Studio 213
San Francisco, CA 94110
Tel: (415) 861-3277
Email: pamelaz@sirius.com

Index

Index